COLORED BY

CIZO

ASSISTED BY

FREDERIC BONIAUD
THOMAS BERNARD
FREDERIC FELDER

LAST GASP

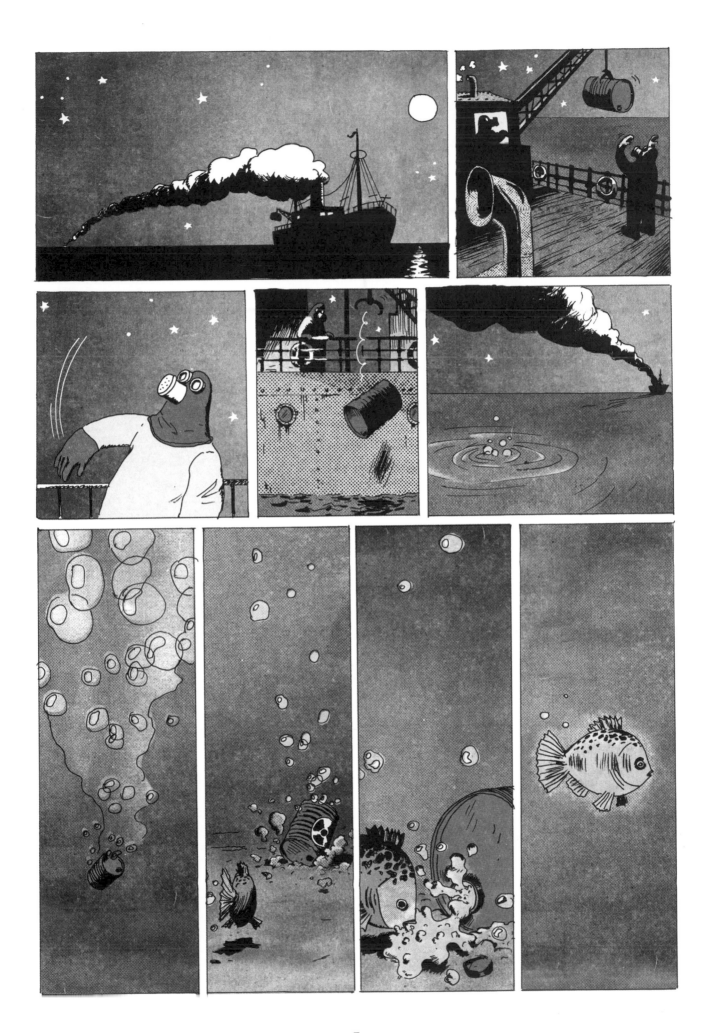

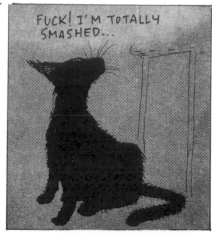

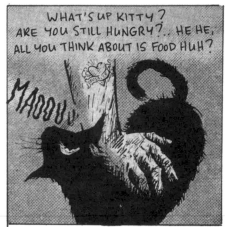

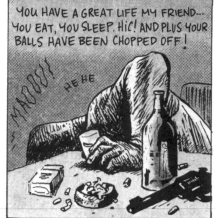

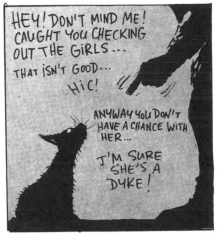

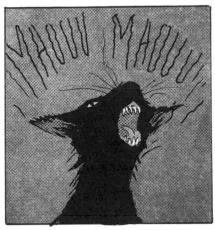

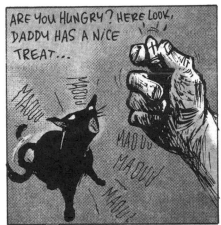

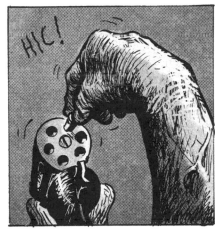

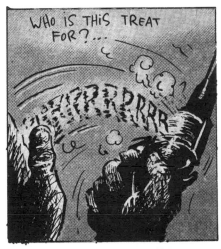

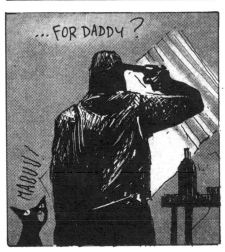

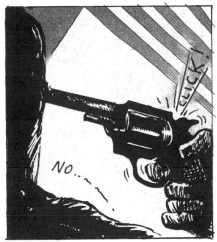

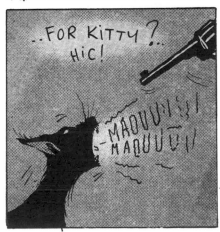

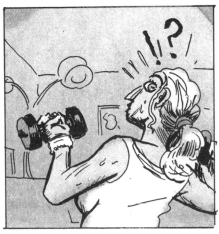

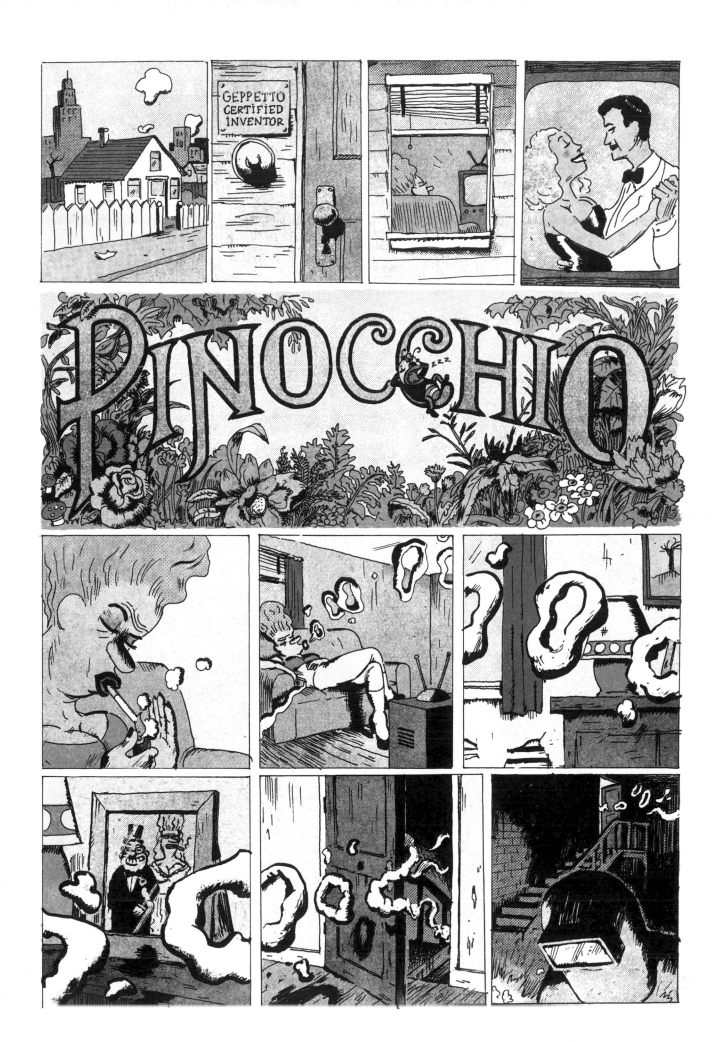

PINOCCHIO

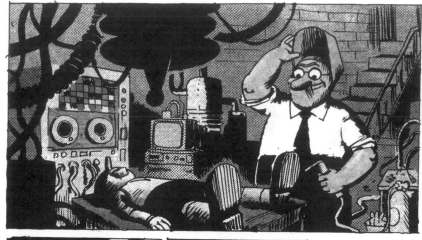

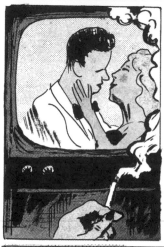

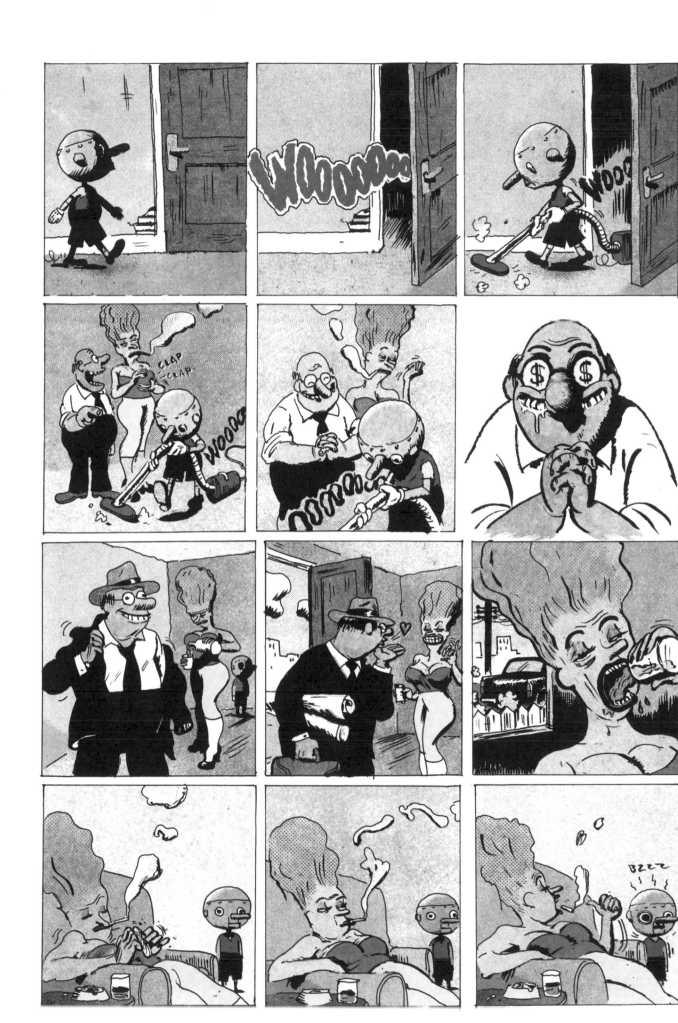

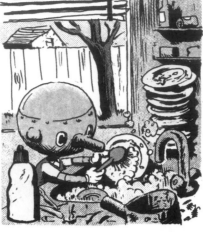

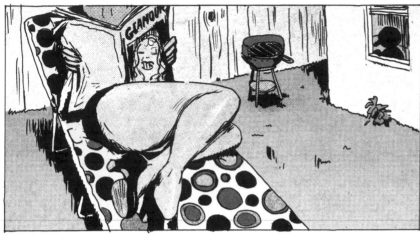

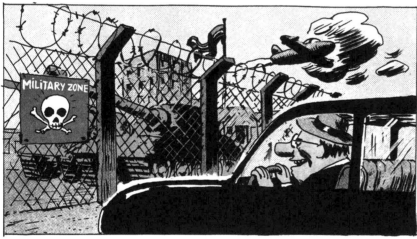

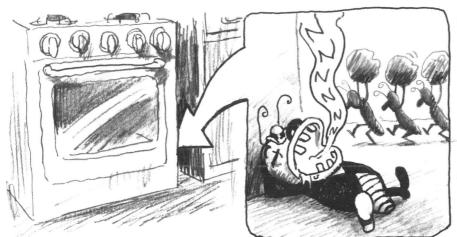

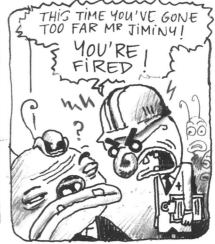

THIS TIME YOU'VE GONE TOO FAR MR JIMINY! YOU'RE FIRED!

GIVE ME ONE MORE CHANCE, I BEG YOU! PLEASE BOSS!

OK! BUT DON'T LET ME CATCH YOU AGAIN! OH THANK YOU

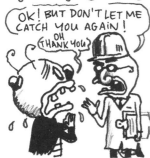

SACKED!! HIC!.. THROWN OUT! ME, I'VE GIVEN THE BEST YEARS OF MY LIFE TO THAT COMPANY!! HIC! YEAH

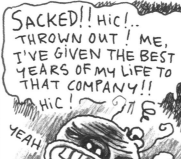

LATER... YOO-HOO... GUESS WHO'S HERE NAUGHTY GIRL? HE HE HE HIC!

PISS OFF!

"Jiminy was over 30 and felt his life was drifting away from him. He could already see himself living out the end of his days in a filthy shelter, acting as wife to some psychotic tramps...

...But fate had decided something else!

BONG!

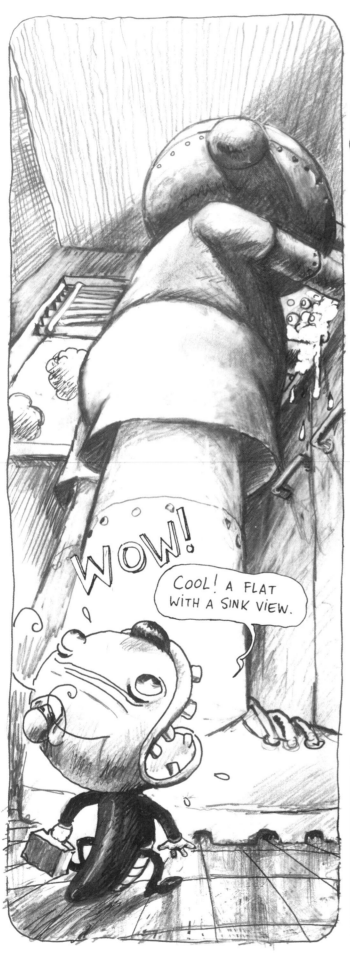

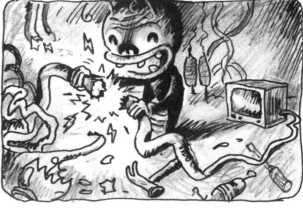

14

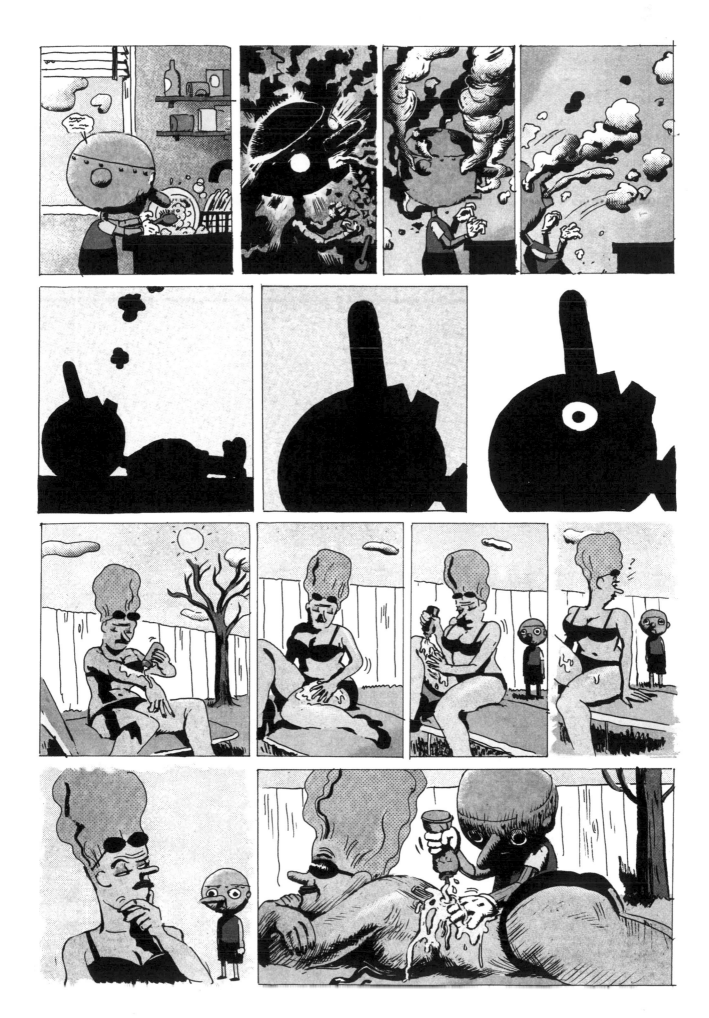

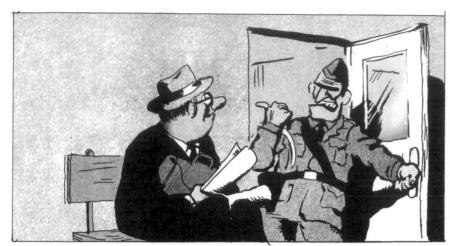

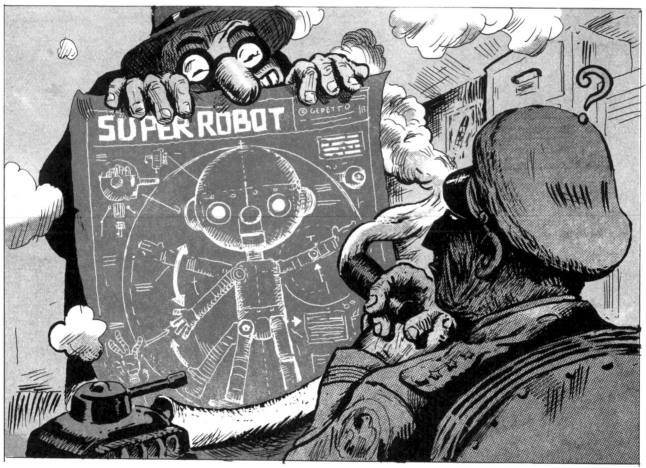

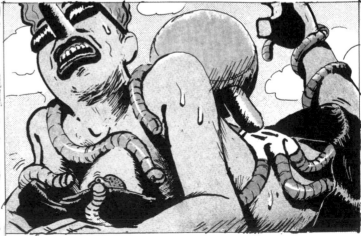

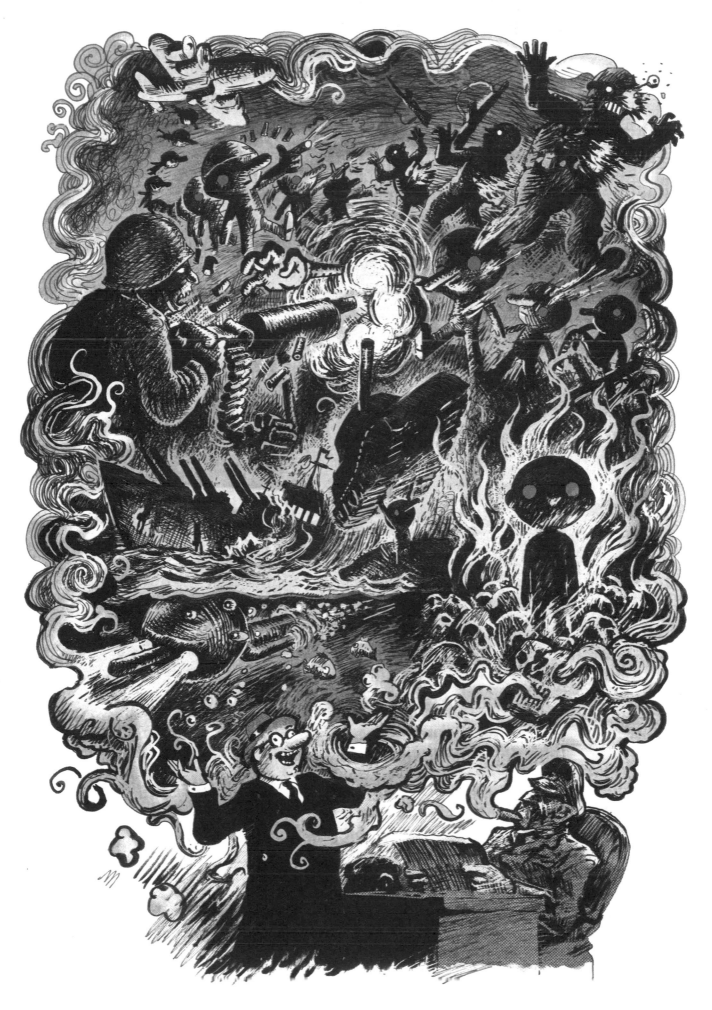

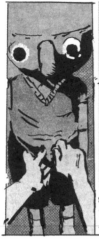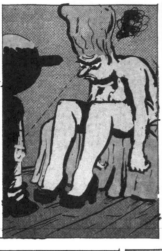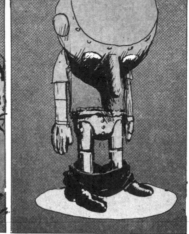

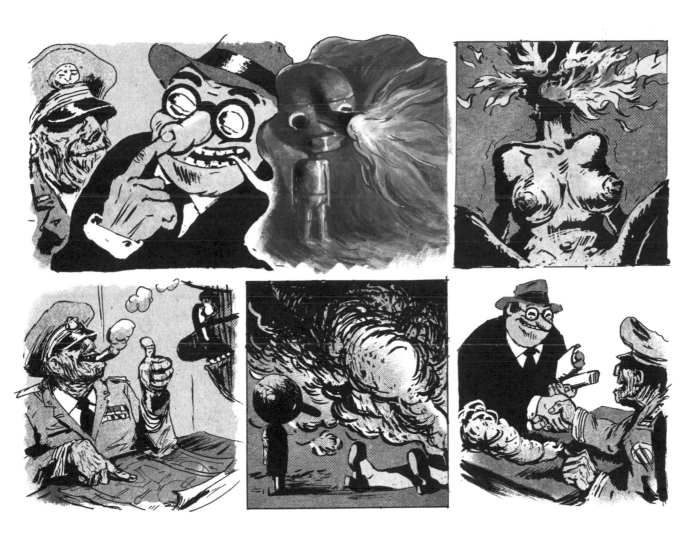

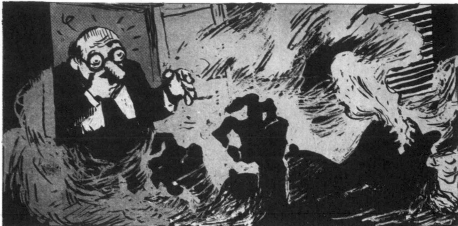

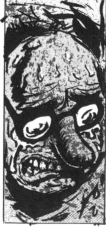

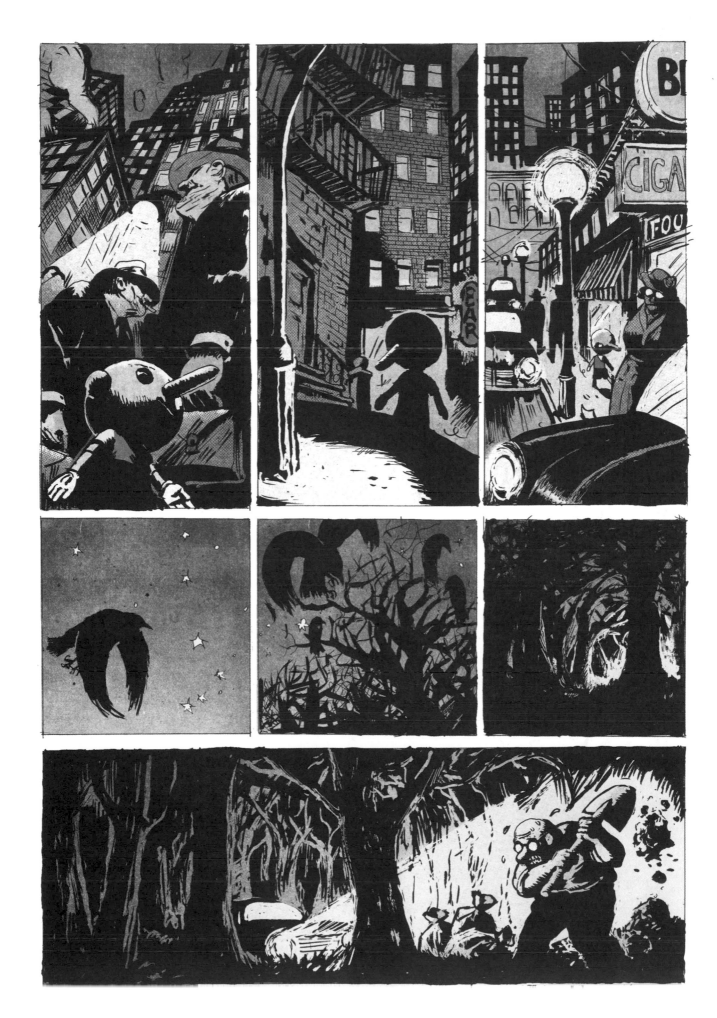

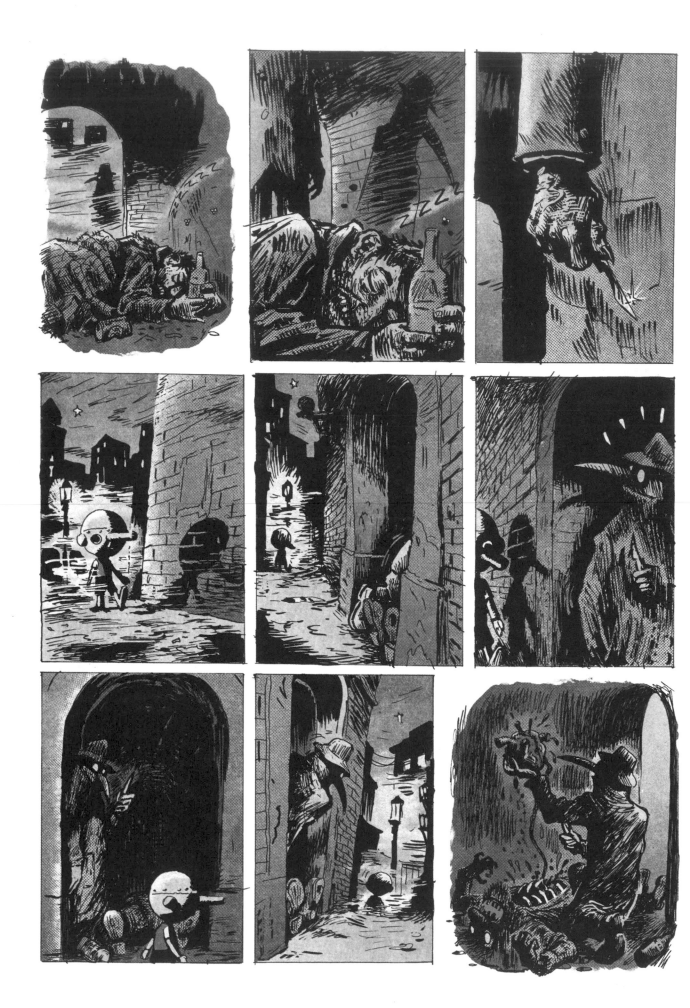

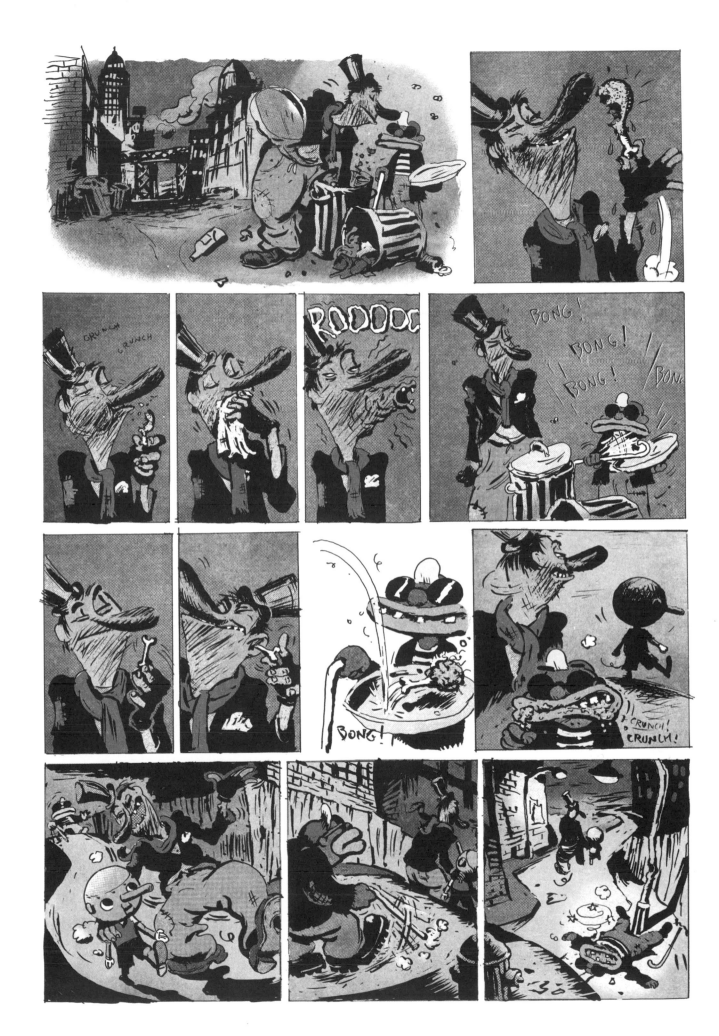

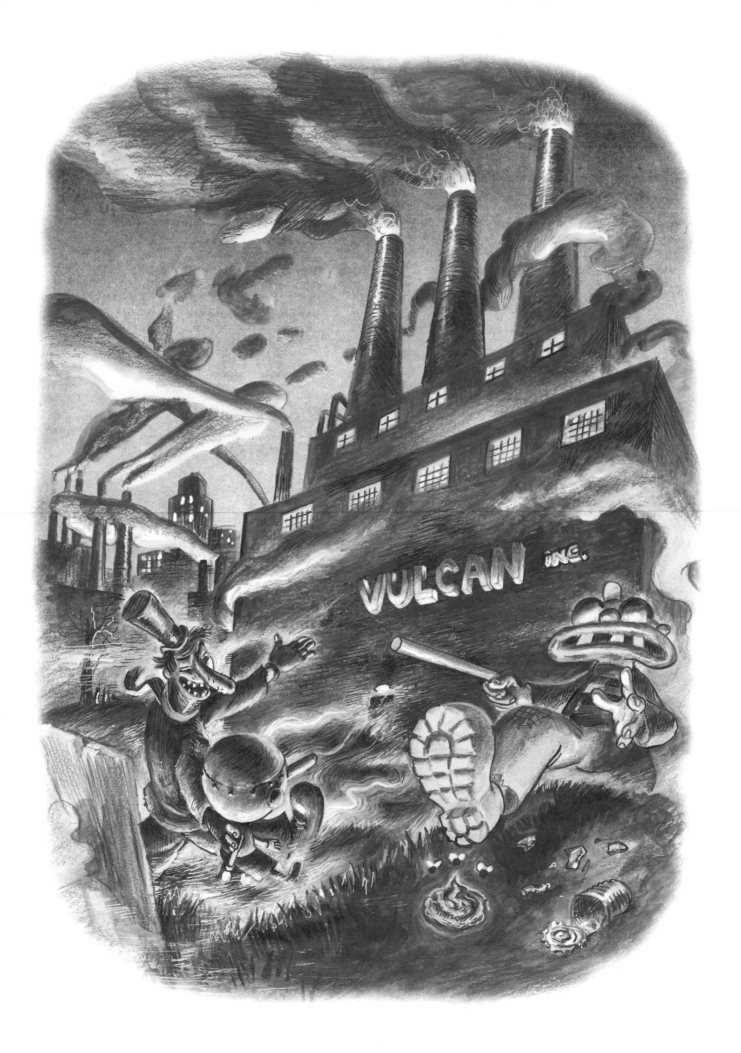

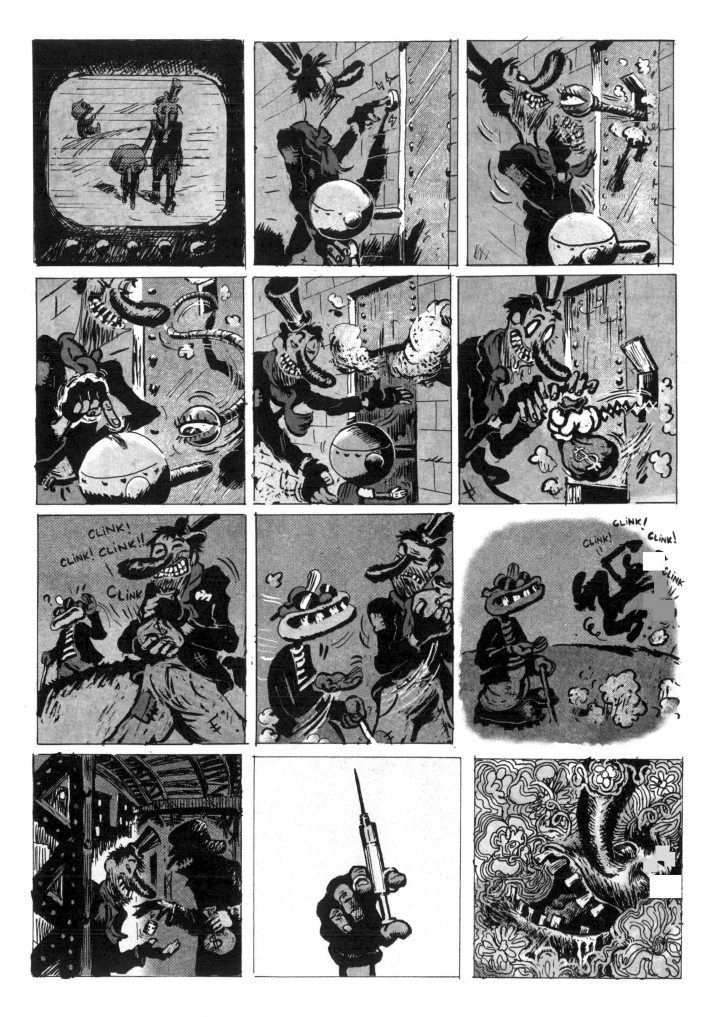

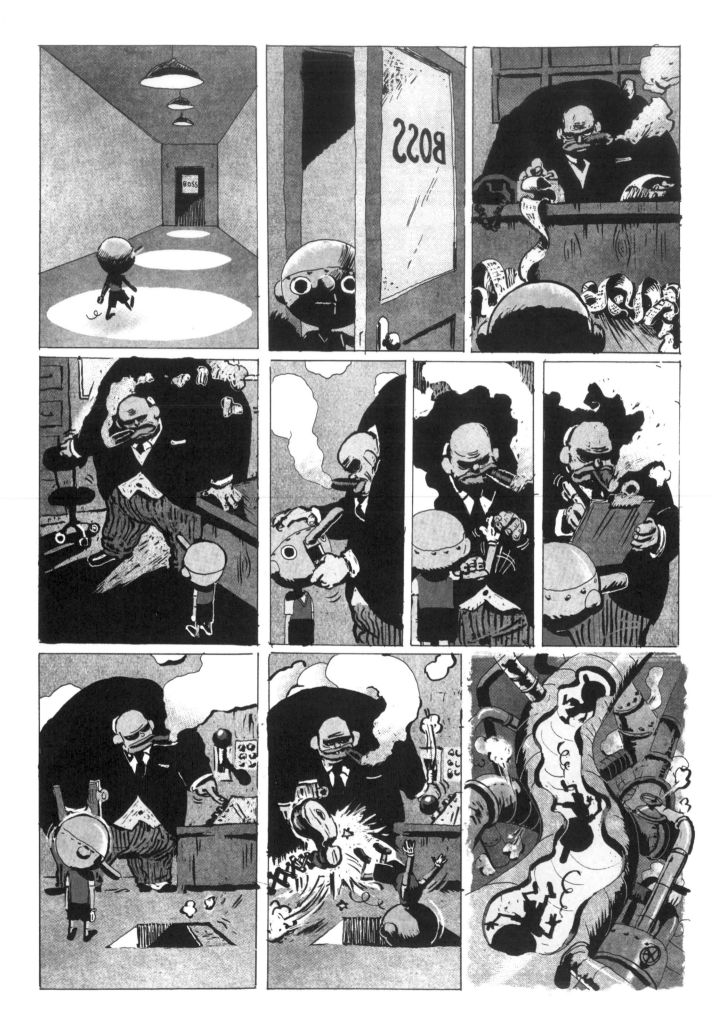

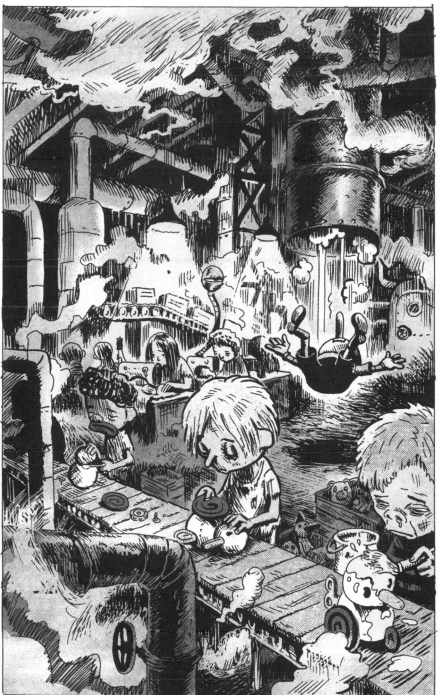
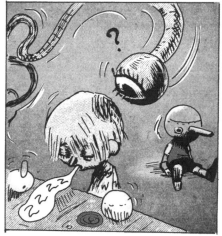
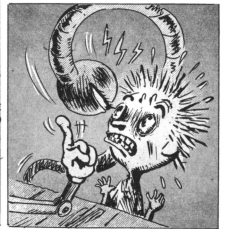
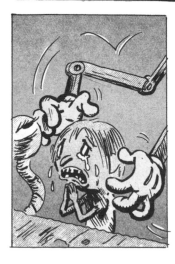
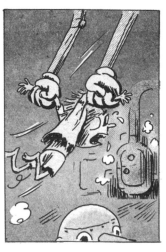
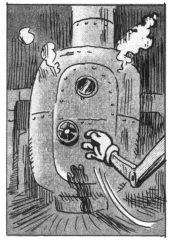
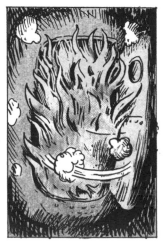

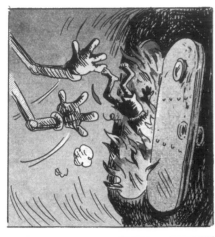

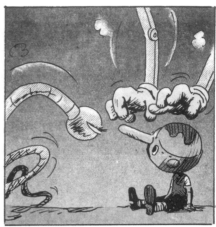
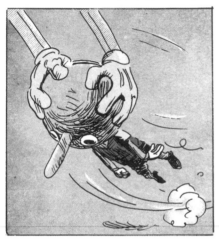
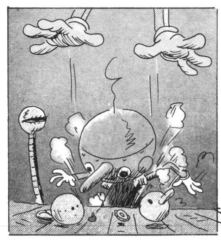
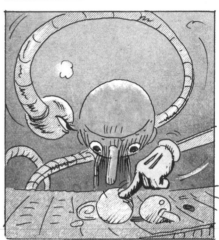

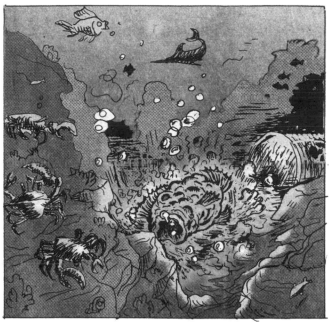
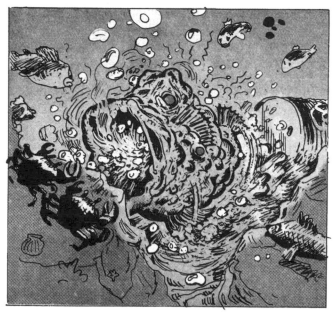
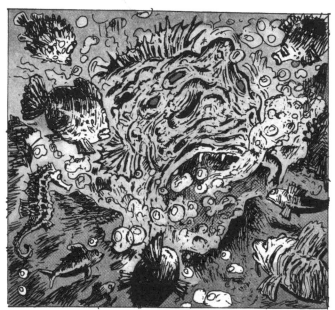
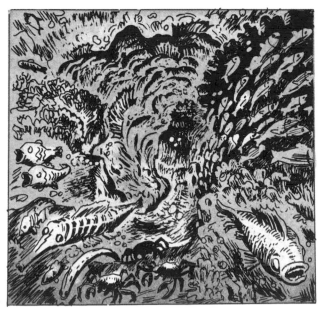
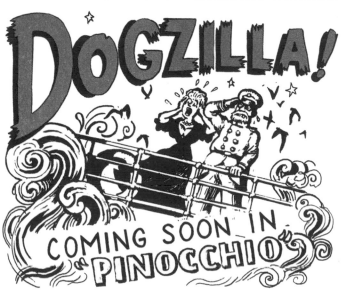

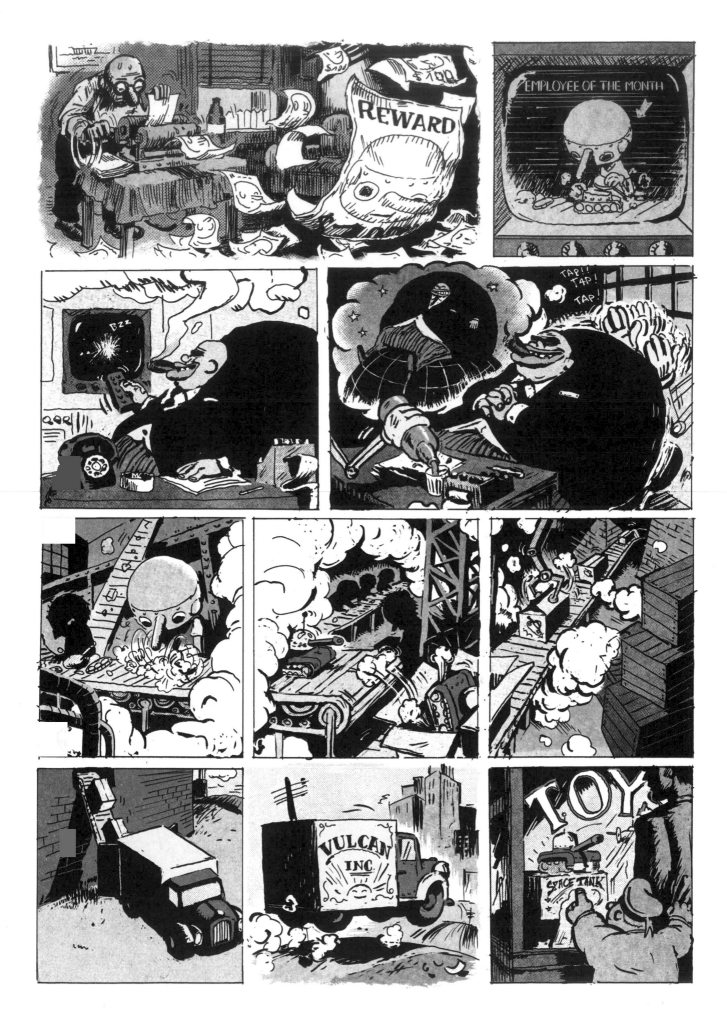

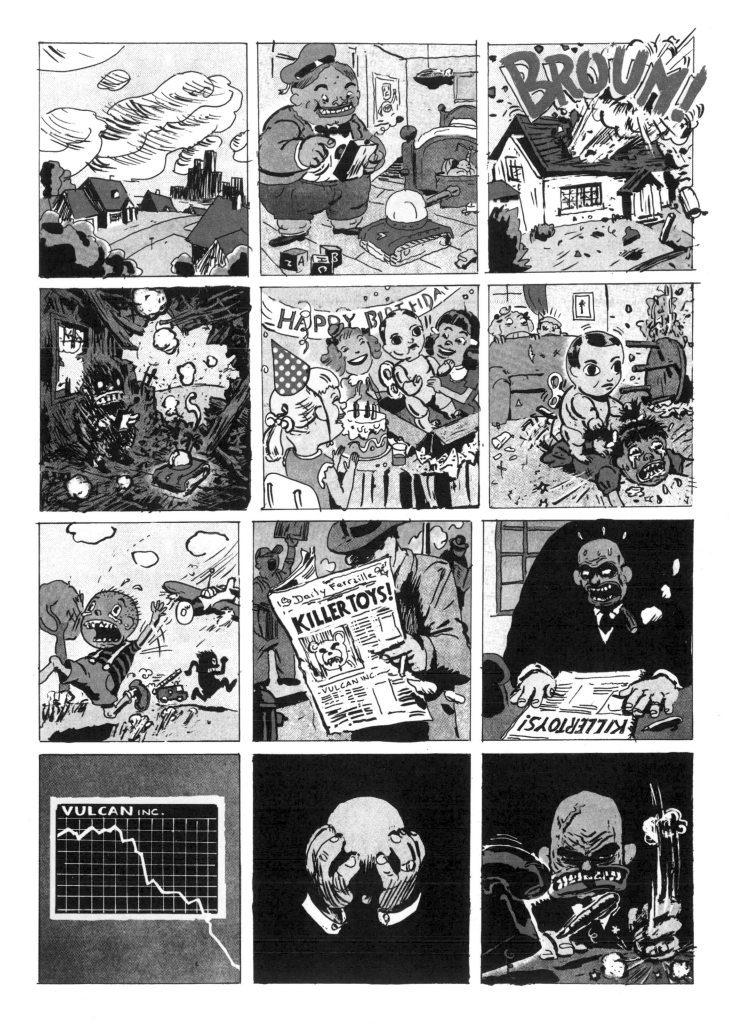

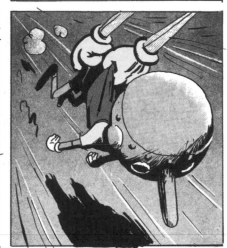
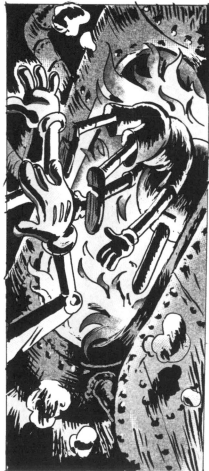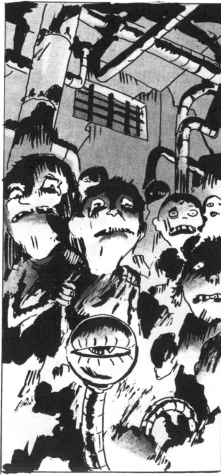

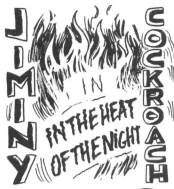

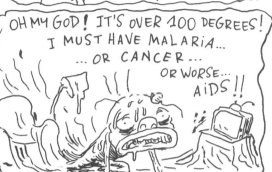

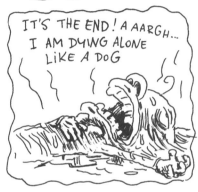

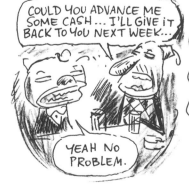

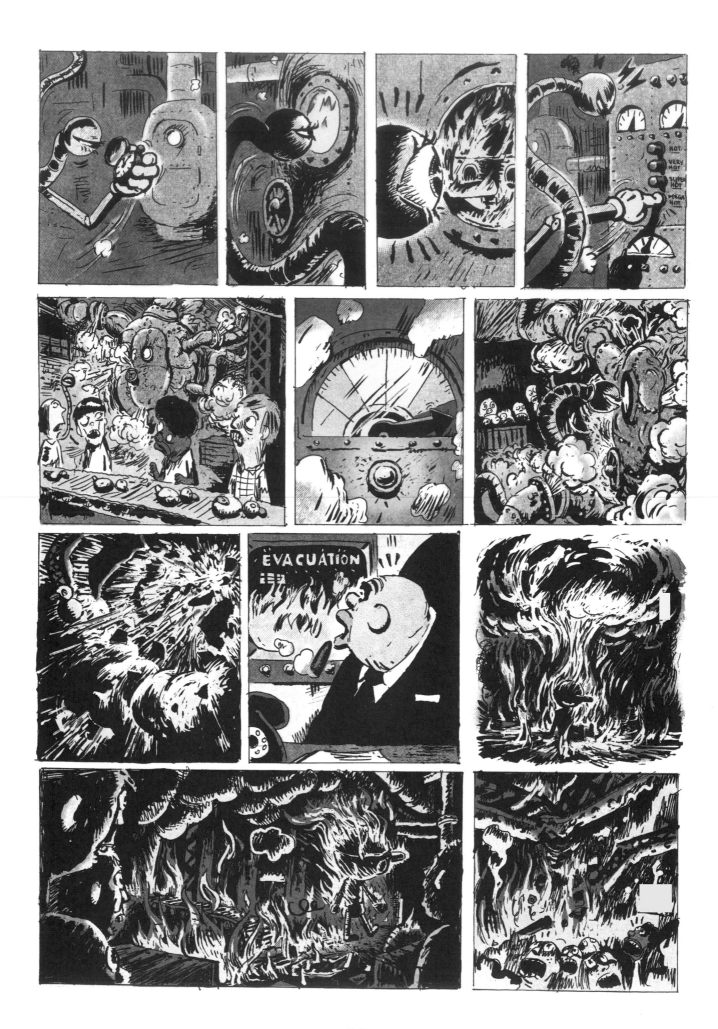

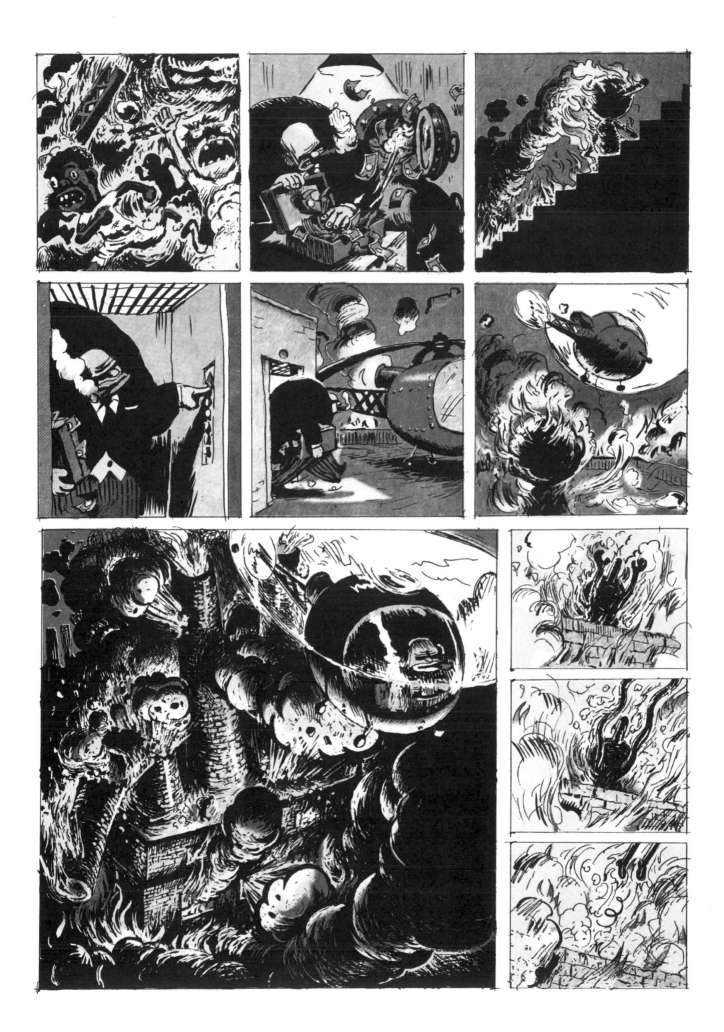

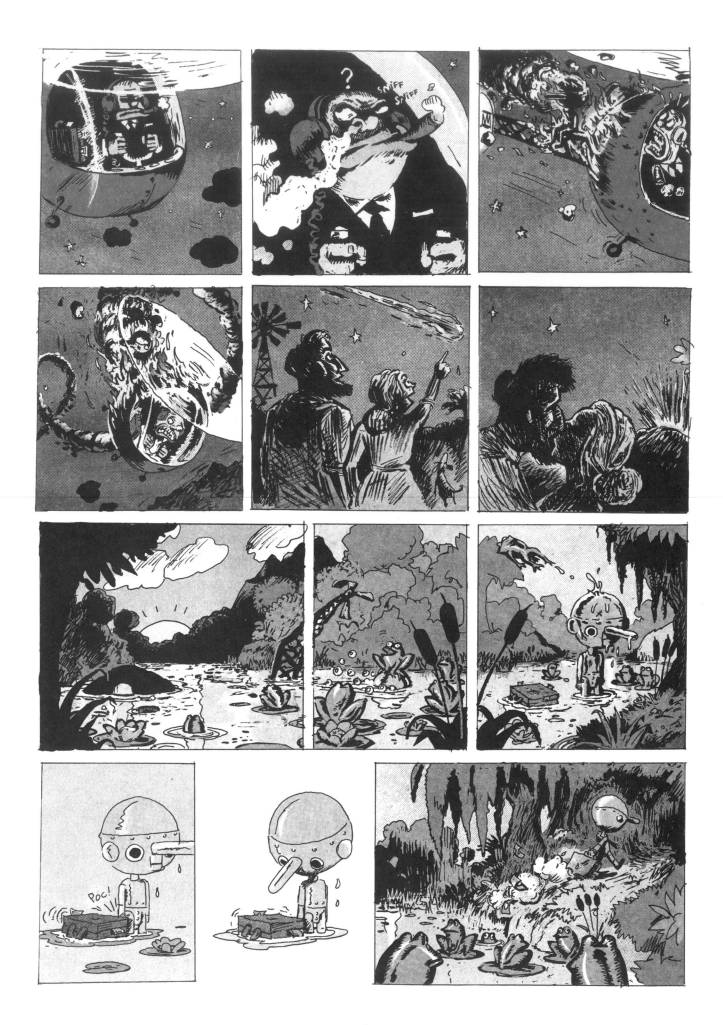

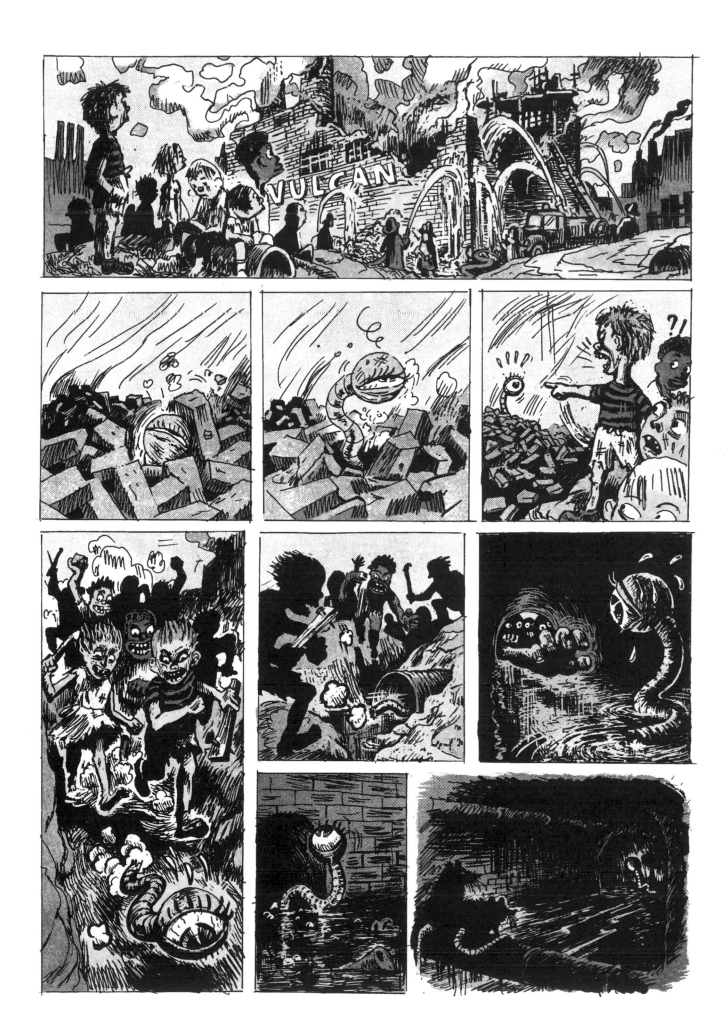

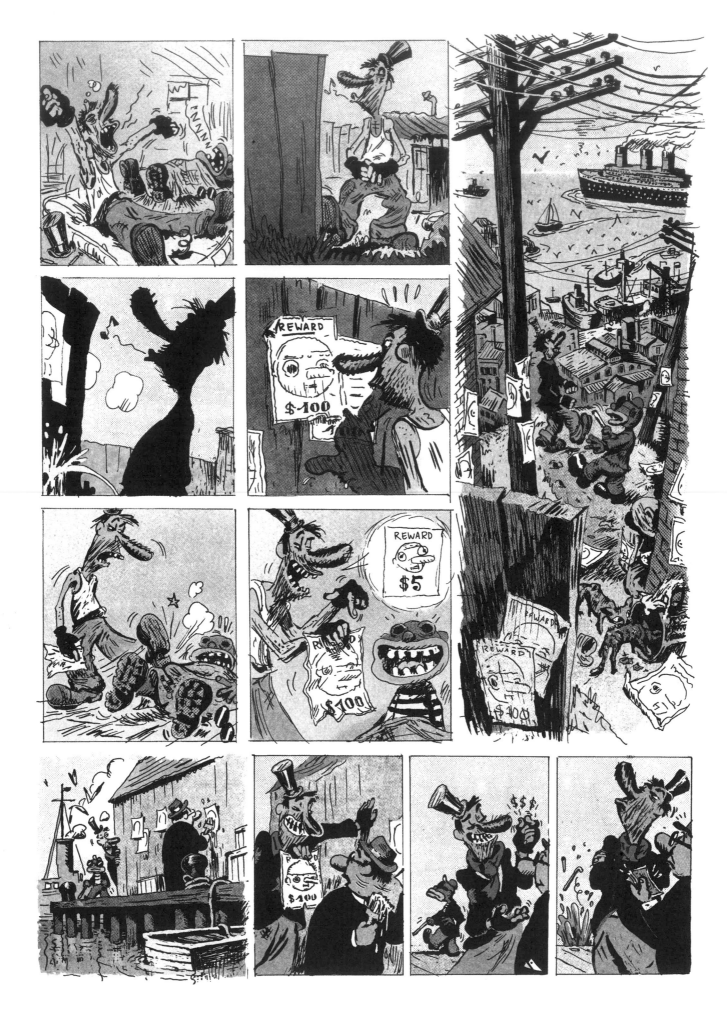

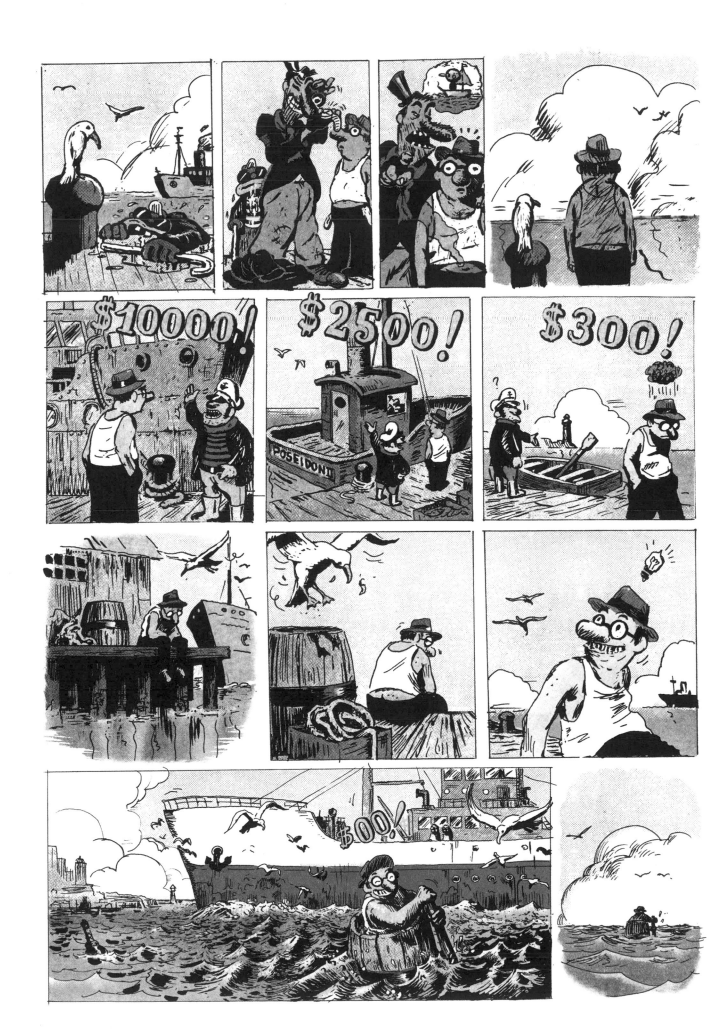

JIMINY COCKROACH in "THE MOMENT OF TRUTH!"

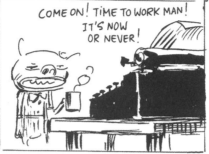

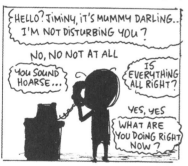

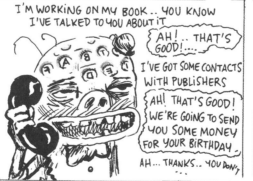

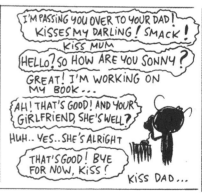

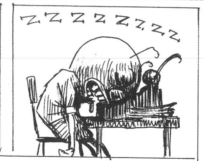

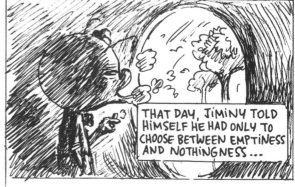

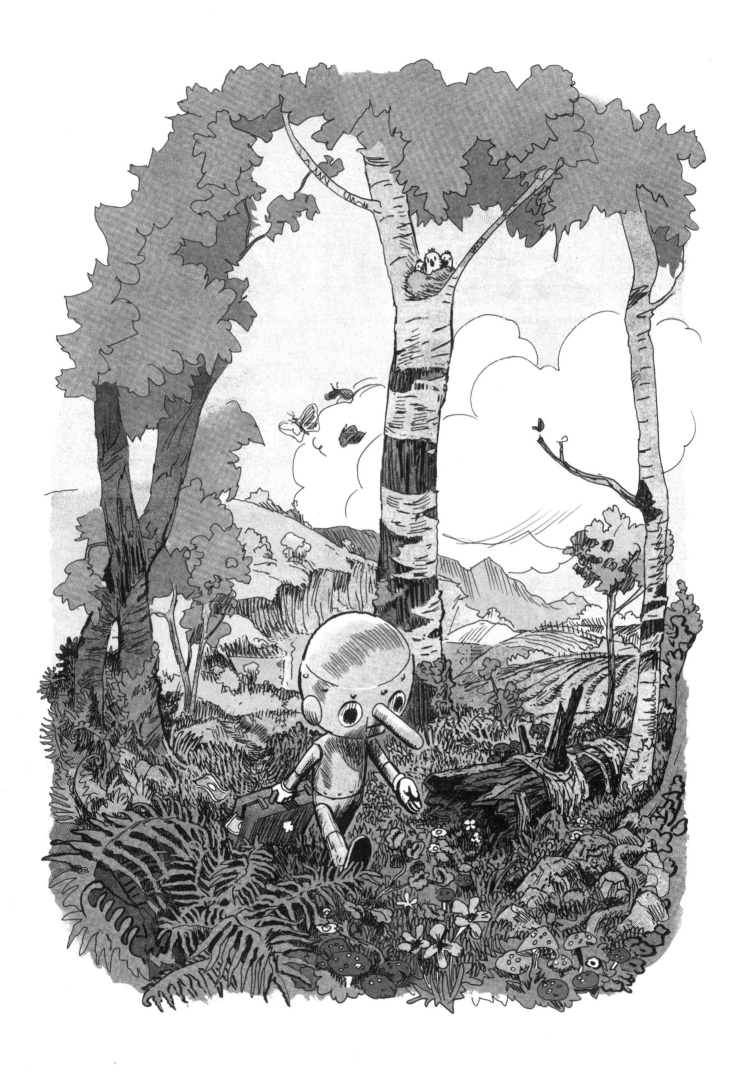

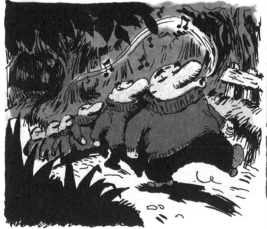
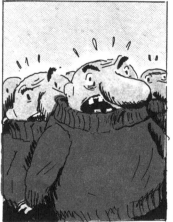
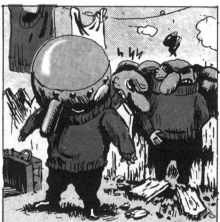

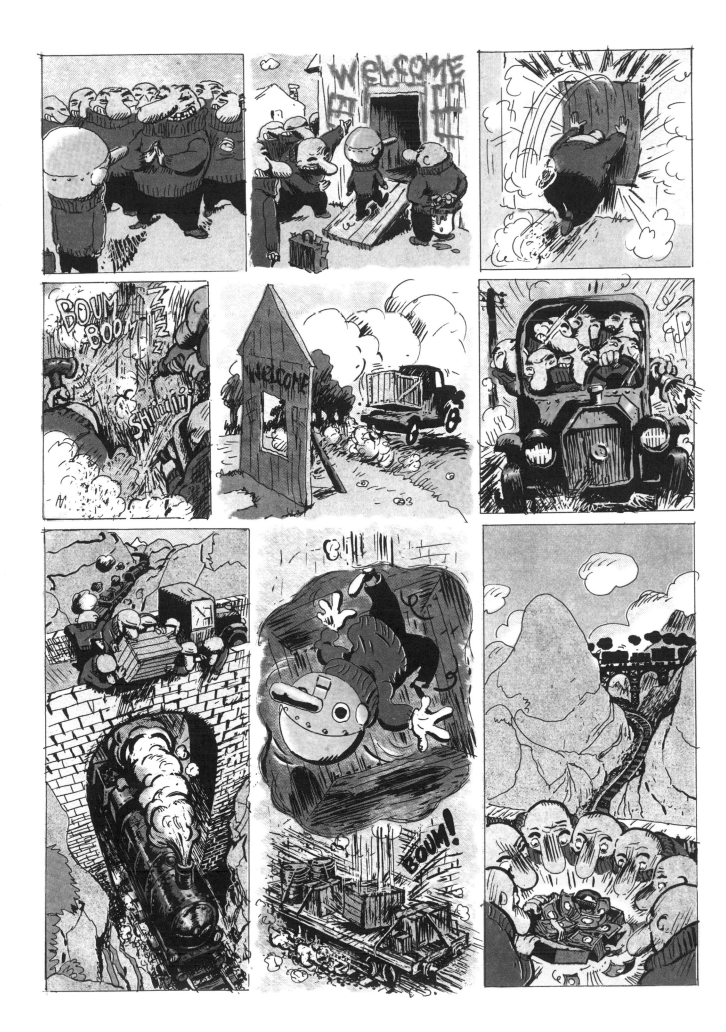

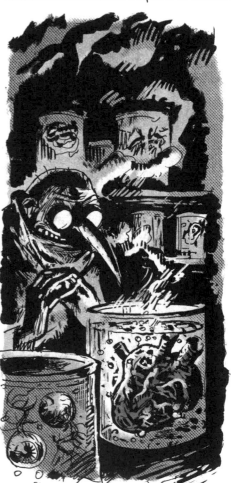
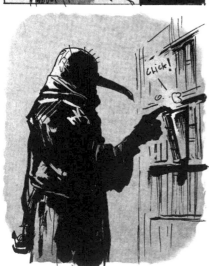
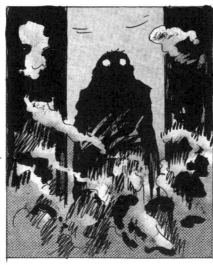

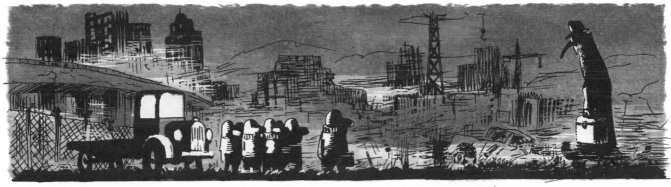

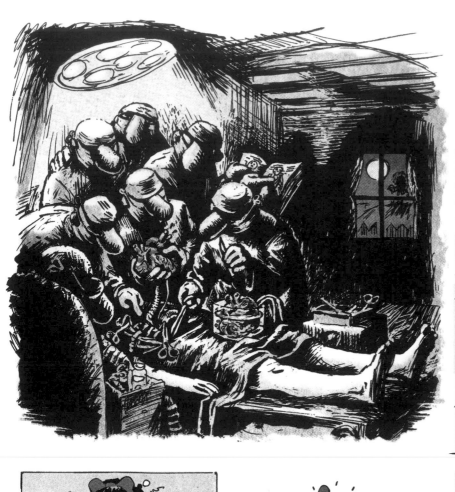

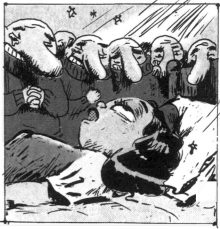

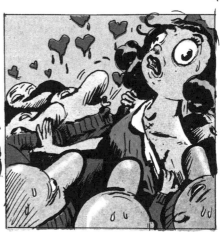

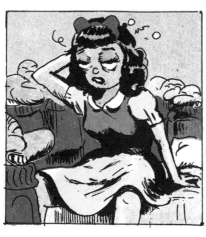

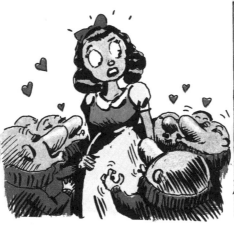

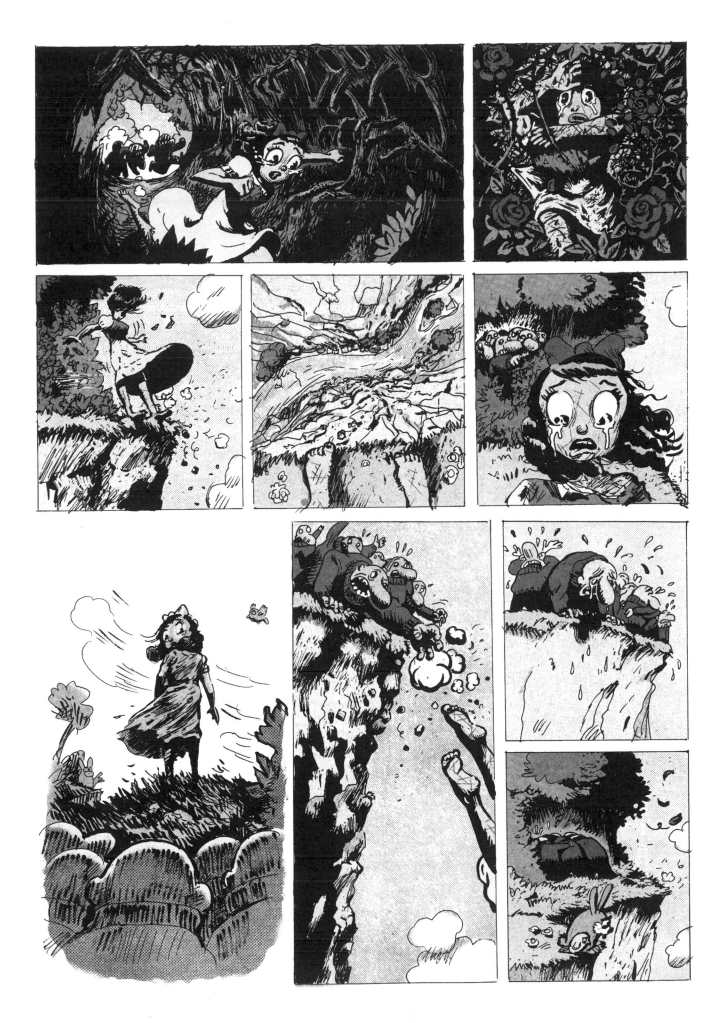

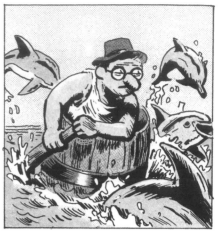

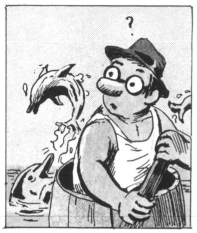

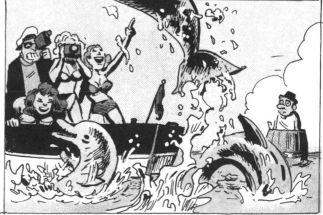

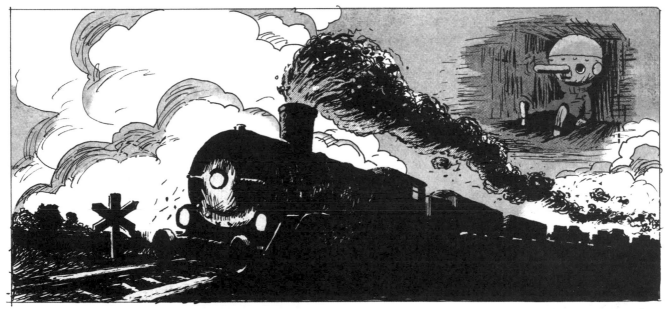

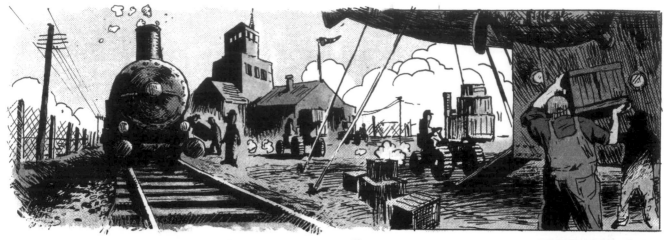

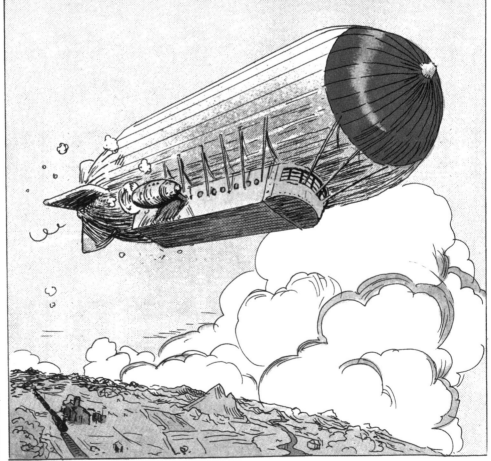

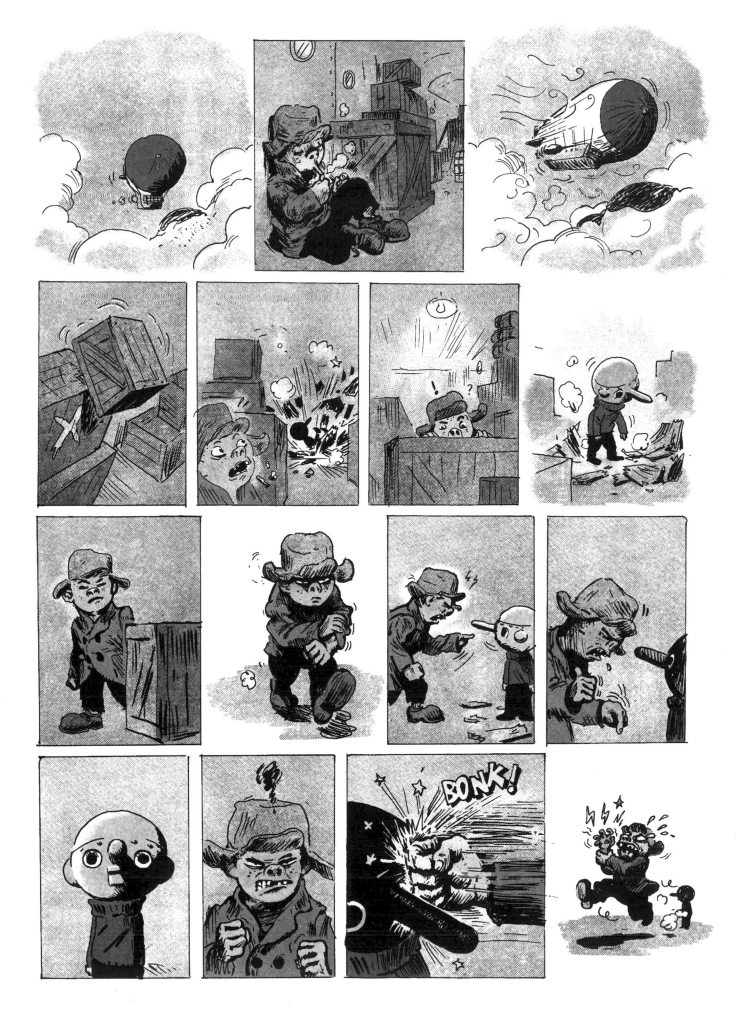

JIMINY COCKROACH
BZZZ~
in
"THE BBQ FROM HELL"

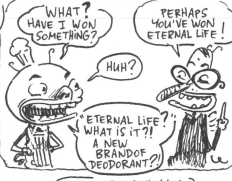

BZZ

KNOCK!
KNOCK!

SIZZLE

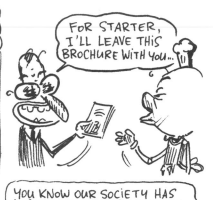

YEEES ??

HELLO! I AM SORRY TO DISTURB YOU BUT I HAVE SOME EXTRAORDINARY NEWS TO ANNOUNCE!

WHAT? HAVE I WON SOMETHING?

PERHAPS YOU'VE WON ETERNAL LIFE!

HUH?

"ETERNAL LIFE?" WHAT IS IT?! A NEW BRAND OF DEODORANT?!

FOR STARTER, I'LL LEAVE THIS BROCHURE WITH YOU...

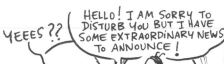

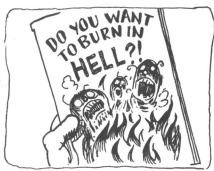

DO YOU WANT TO BURN IN HELL?!

HMMM... I HAVEN'T WON ANYTHING HAVE I?... HUH? IS THAT IT?

HA HA

WHAT I'M BRINGING TO YOU GOES BEYOND THE MATERIAL THINGS OF THIS WORLD!

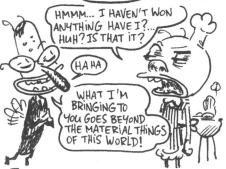

YOU KNOW OUR SOCIETY HAS LOST ITS BEARINGS AND MANY OF US ASK OURSELVES WHAT IS THE MEANING OF OUR EXISTENCE..

YOU SAID IT MAN!

SHIII

THAT IS THE REASON I AM HERE TODAY! TO HELP YOU FIND THE PATH THAT WILL TAKE YOU TO OUR LORD!

I AM HIS ENVOY!

I CARRY HIS WORD OF PEACE!

I AM GOODNESS!

I AM MERCY!

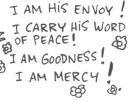

... I AM ALL LOVE!

HMM...

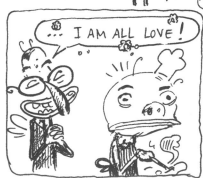

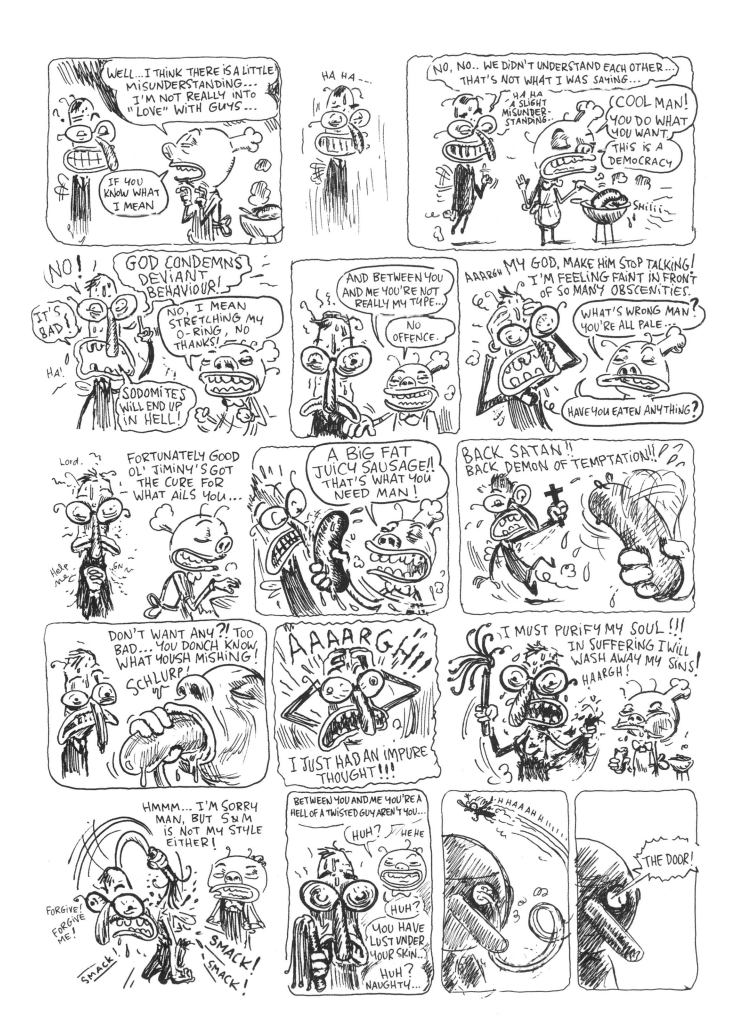

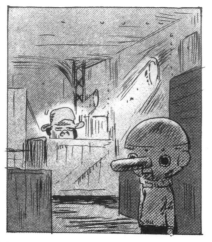

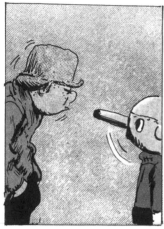
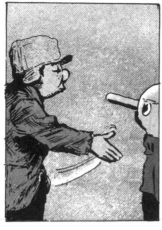

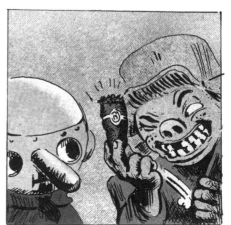

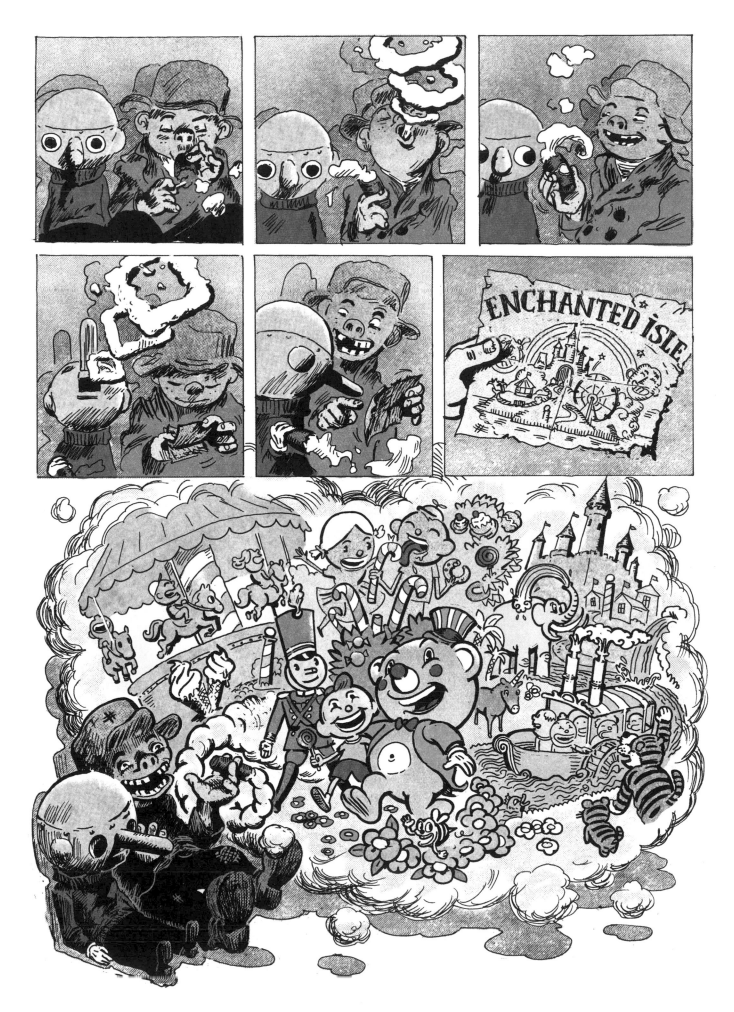

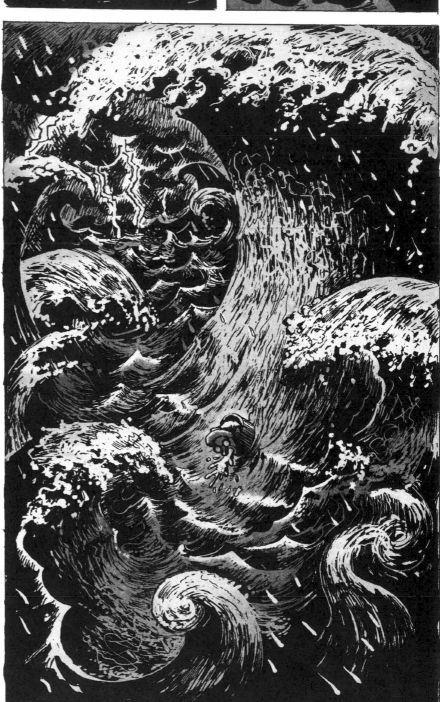

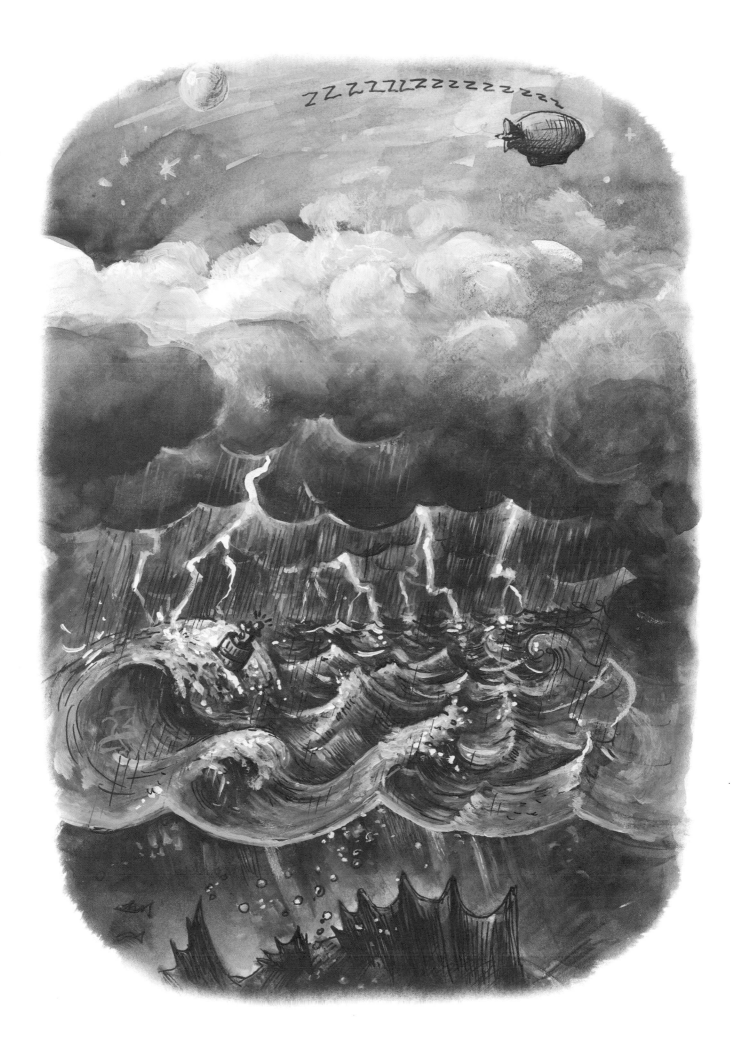

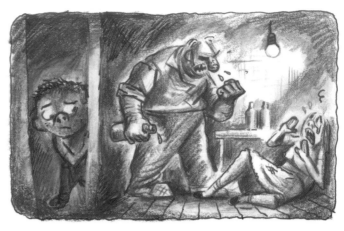

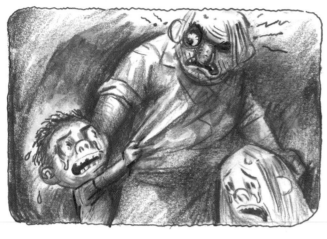

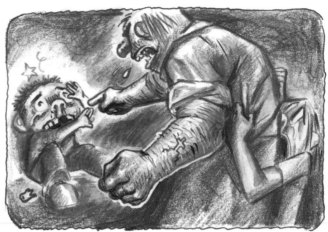

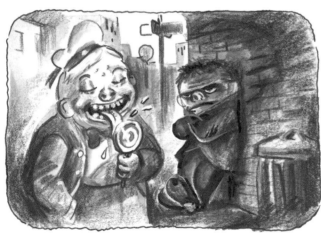

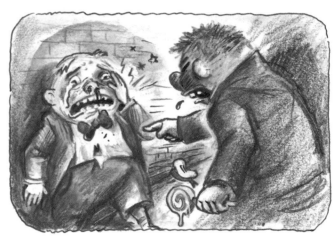

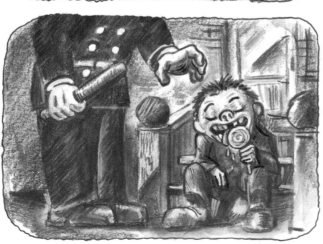

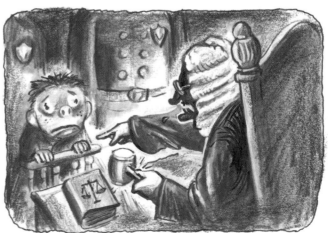

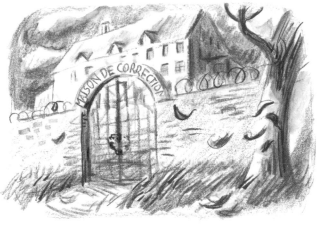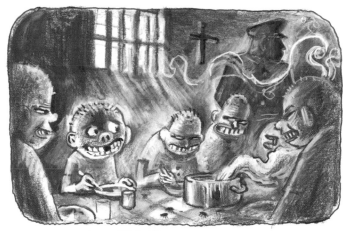

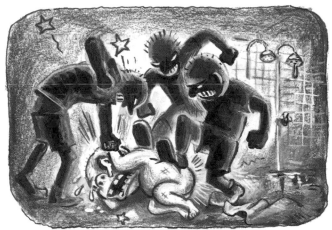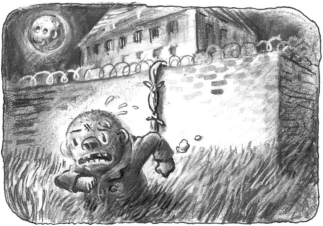

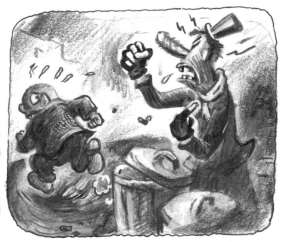

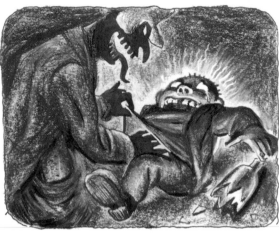

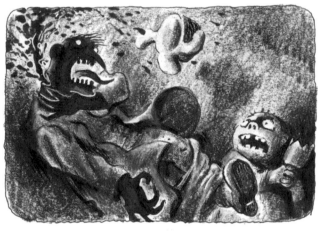
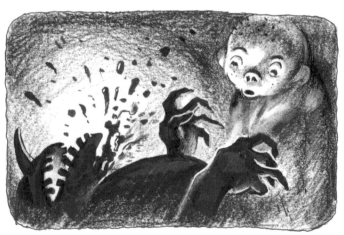

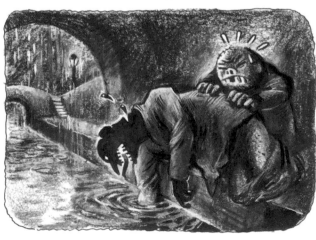
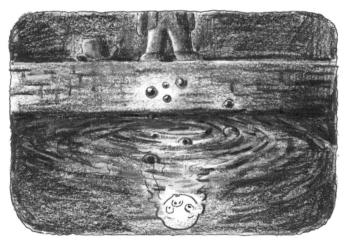

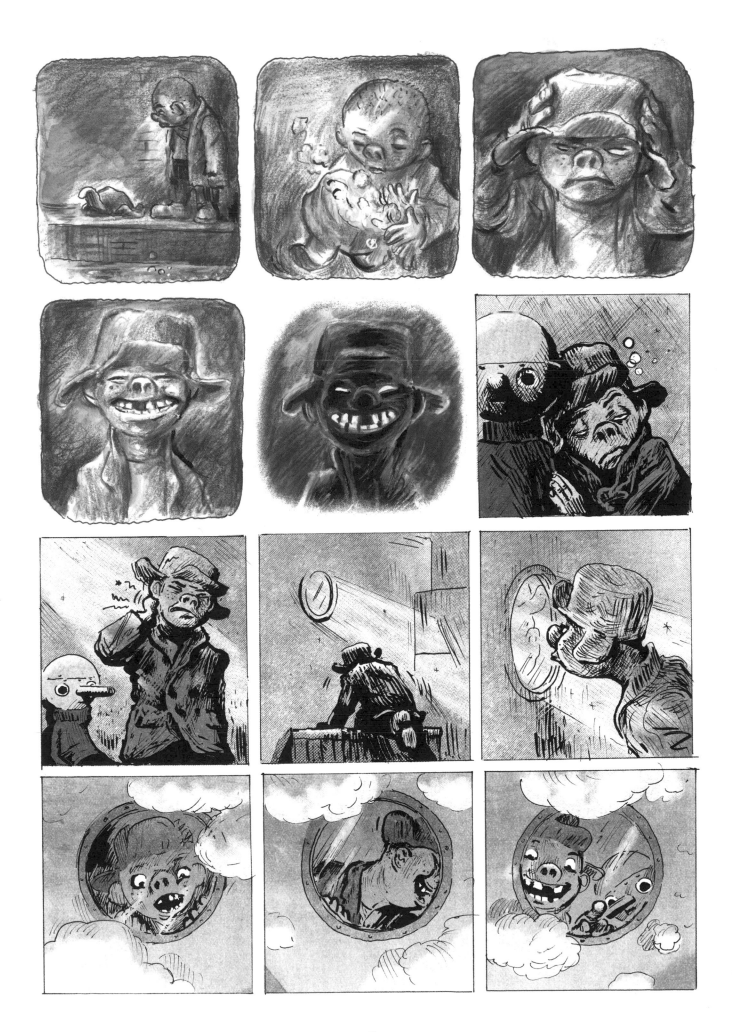

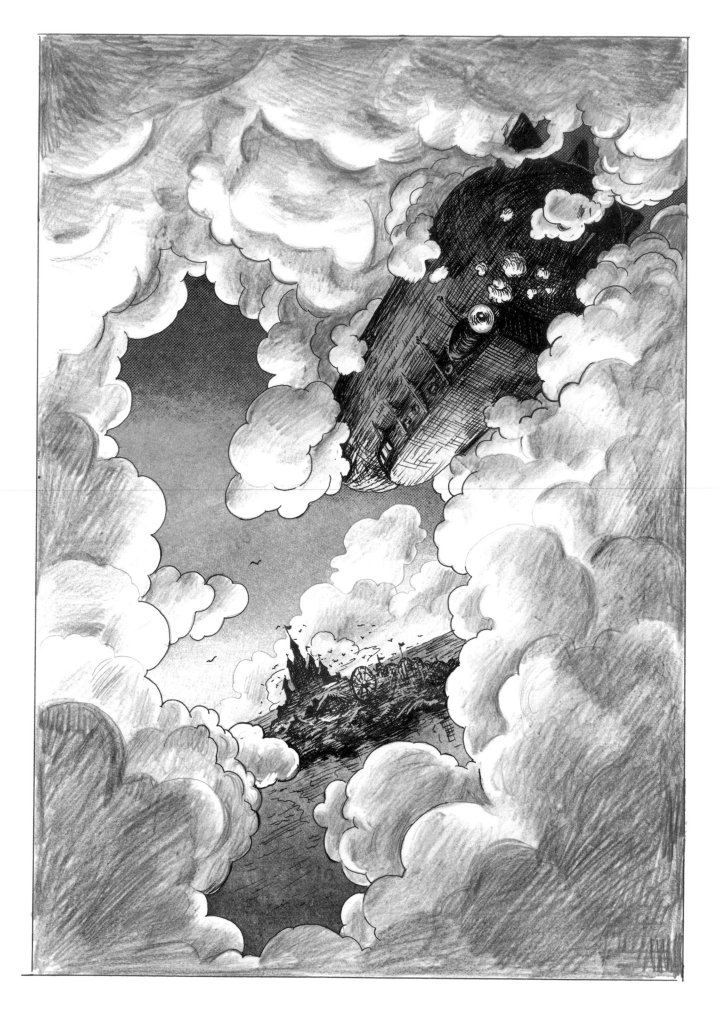

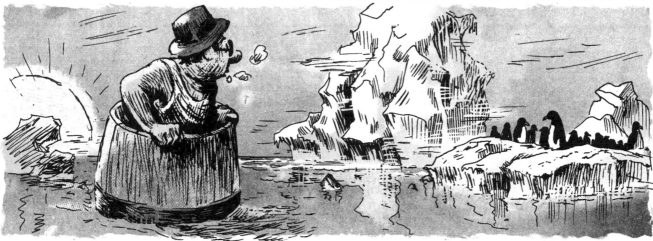

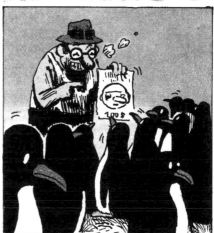
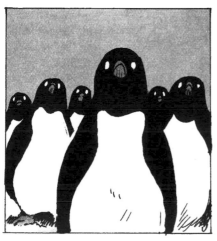
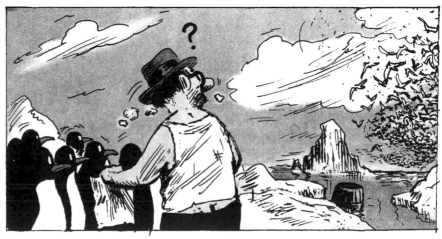

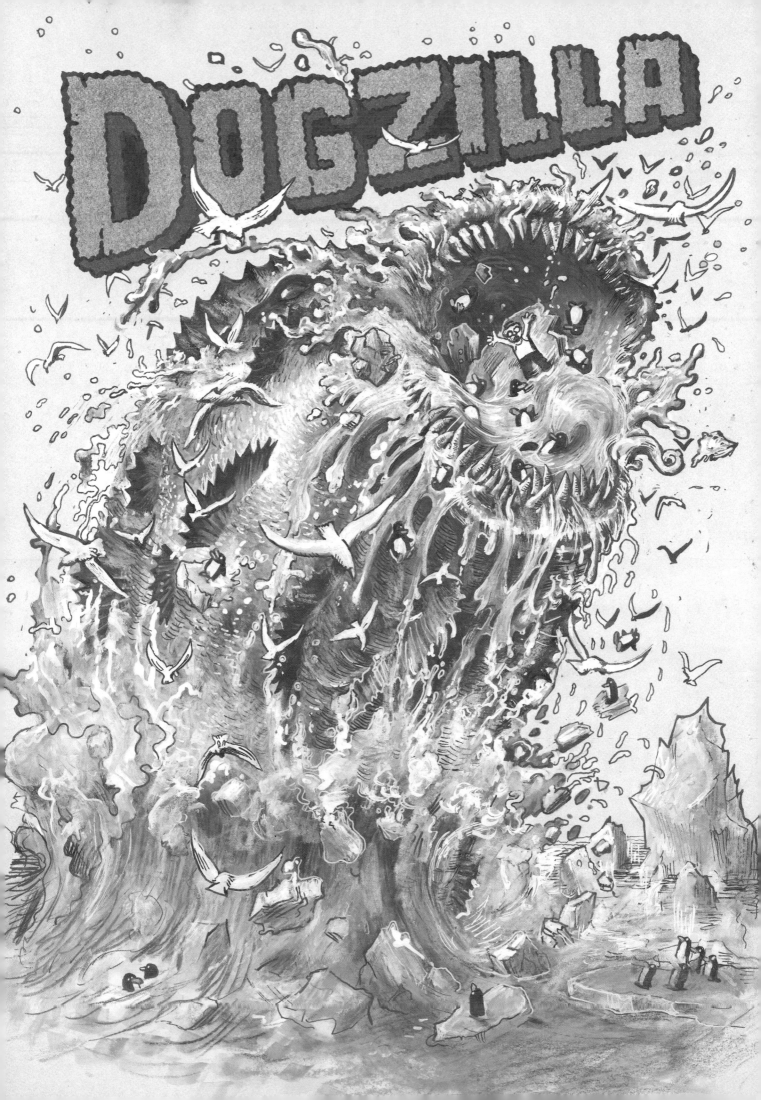

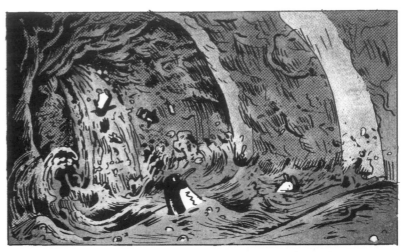
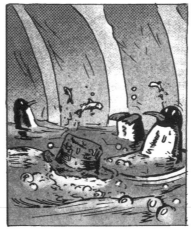
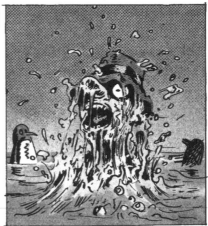
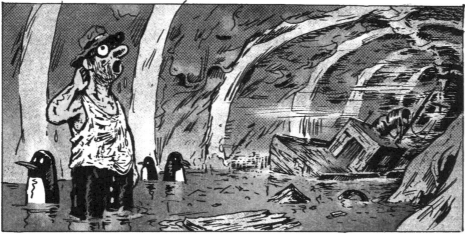

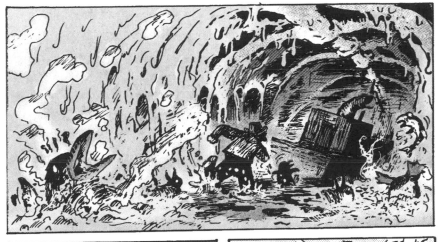

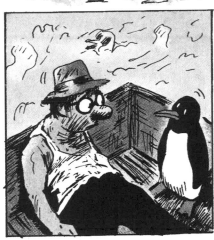
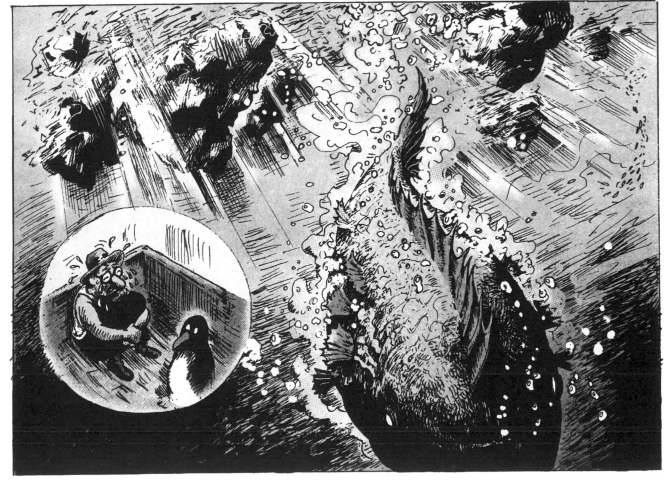

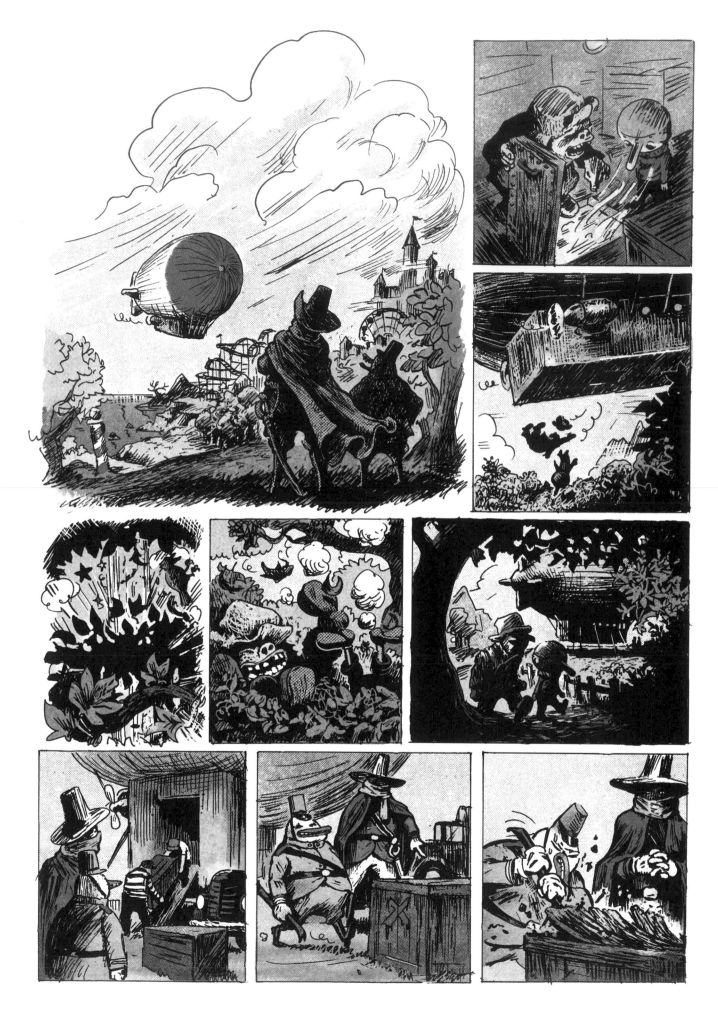

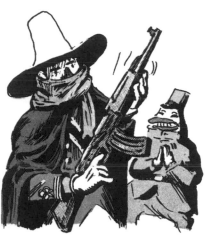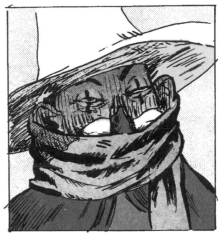

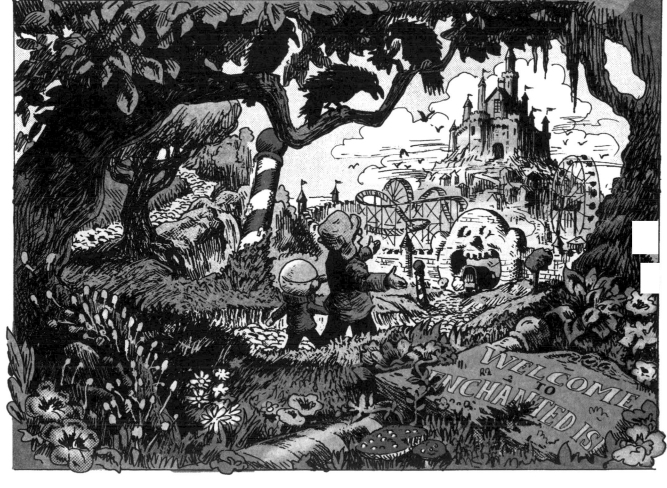

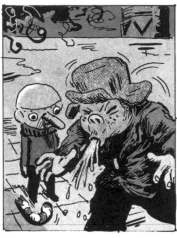

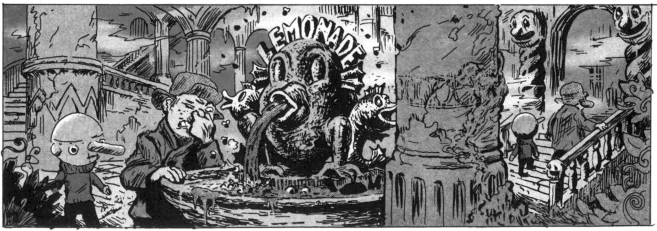

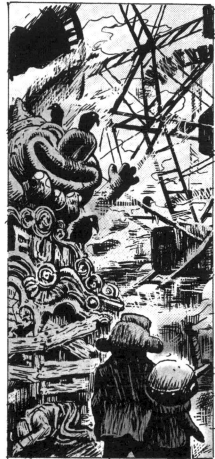
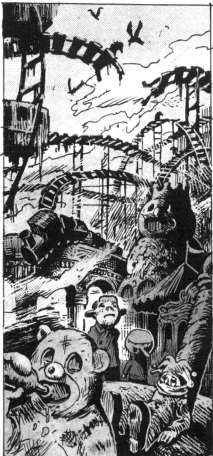
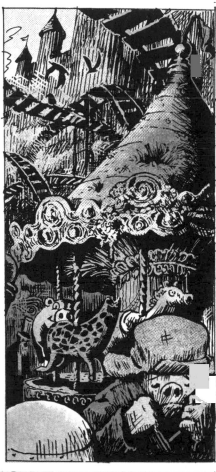

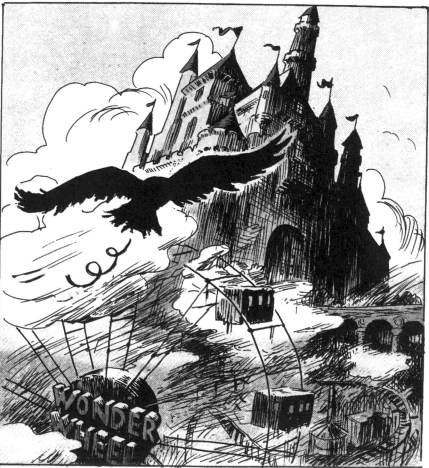

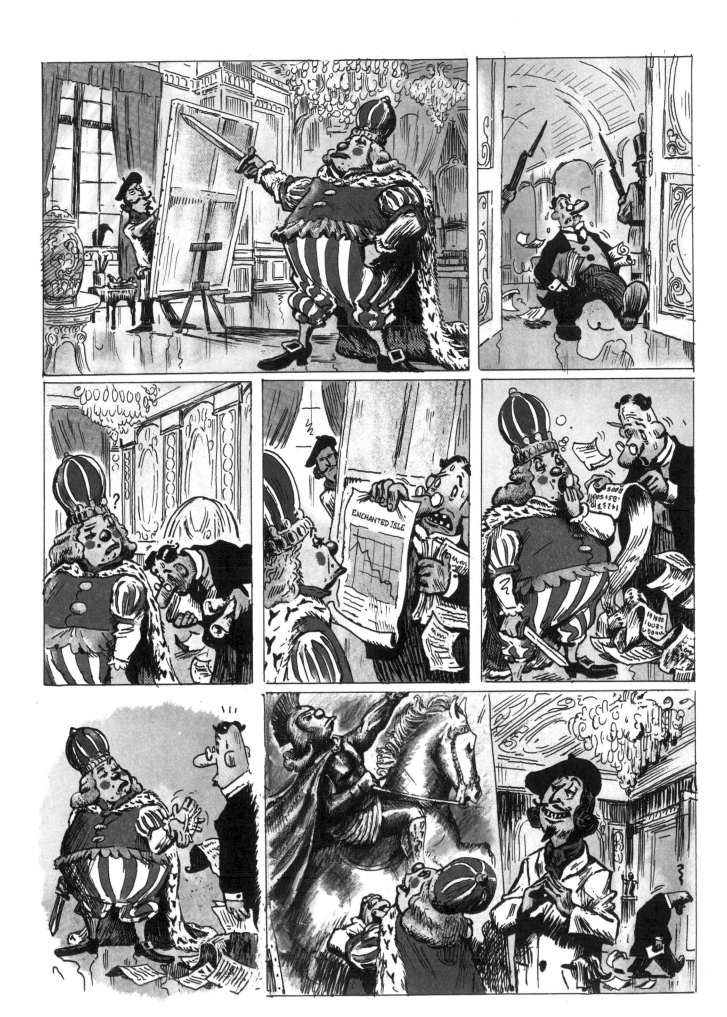

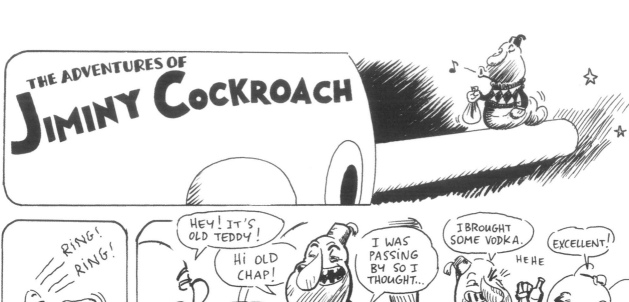

THE ADVENTURES OF JIMINY COCKROACH

RING! RING!

RING!

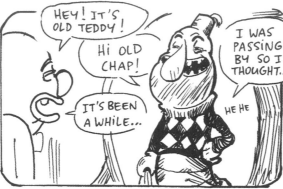

HEY! IT'S OLD TEDDY!

HI OLD CHAP!

IT'S BEEN A WHILE...

I WAS PASSING BY SO I THOUGHT...

HE HE

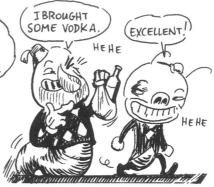

I BROUGHT SOME VODKA.

HE HE

EXCELLENT!

HE HE

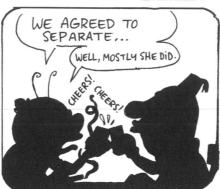

YOUR NEW FLAT ISN'T BAD AT ALL...

YEAH, IT'S ALL RIGHT... IT'S CHEAP

SO THEN IT'S ALL OVER WITH SYLVIE...

YEAH!!

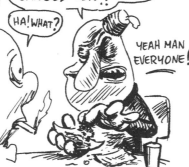

WE AGREED TO SEPARATE...

WELL, MOSTLY SHE DID.

CHEERS! CHEERS!

BETWEEN YOU AND ME I ALWAYS FOUD HER A BIT STUPID...

HA! WELL...

IT DOESN'T PISS YOU OFF ME TELLING YOU THIS?

I COULDN'T CARE LESS!

YOU WOULD TELL ME!

OF COURSE!

I'M MOOCHING A FAG OFF YOU... IT'S FOR A GOOD CAUSE!

HE HE

..BESIDES, EVERYONE BANGED HER!!

HA! WHAT?

YEAH MAN EVERYONE!

SHE WAS ALWAYS HOT FOR ACTION THAT SYLVIE! ONE EVENING, SHE POPPED BY MY PLACE... SHE WAS COMPLETELY SMASHED... SHE LITERALLY JUMPED ON ME, THE CRAZY BITCH!

AFTER THAT I WASN'T REALLY COMFORTABLE WHEN YOU TOLD ME YOU WERE GETTING MARRIED...

..IT DOESN'T PISS YOU OFF AT ALL THAT I'M TELLING YOU ALL THIS?

NOT AT ALL!

PFF! PFF!

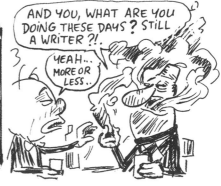

AND YOU, WHAT ARE YOU DOING THESE DAYS? STILL A WRITER?!.

YEAH... MORE OR LESS..

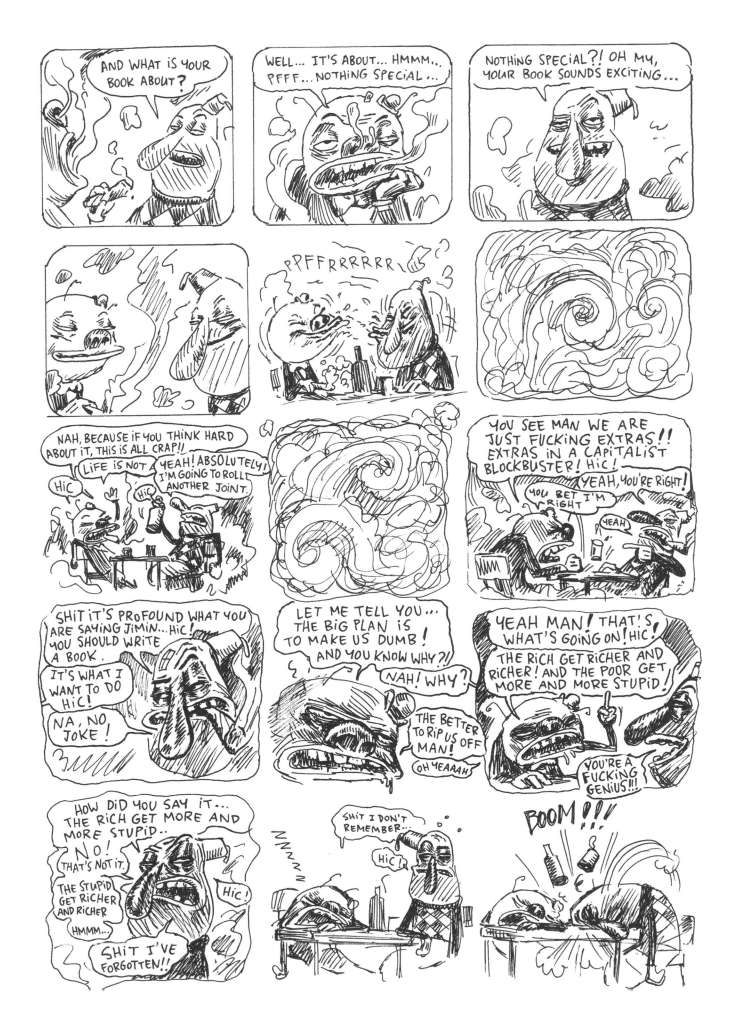

75

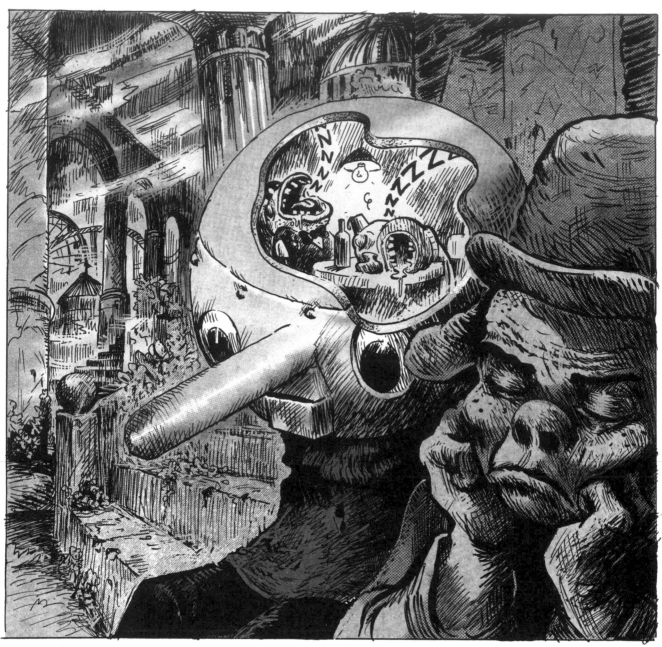

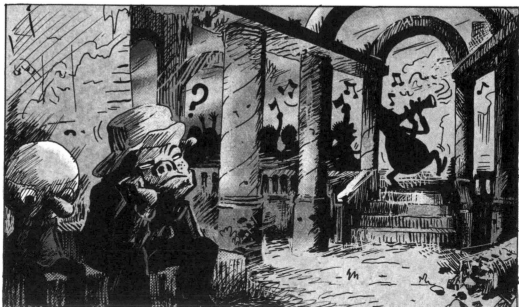

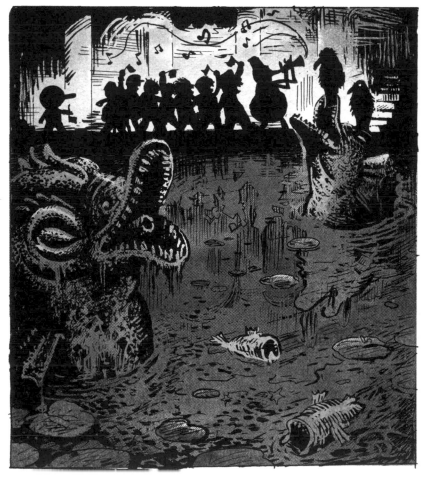

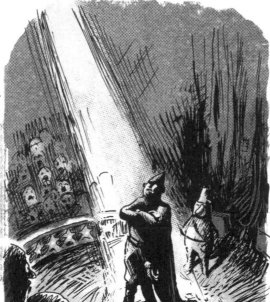

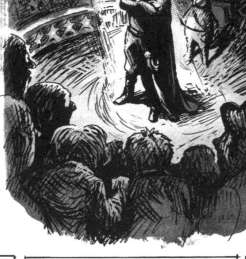
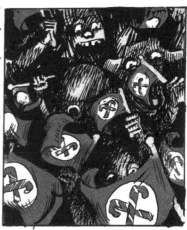

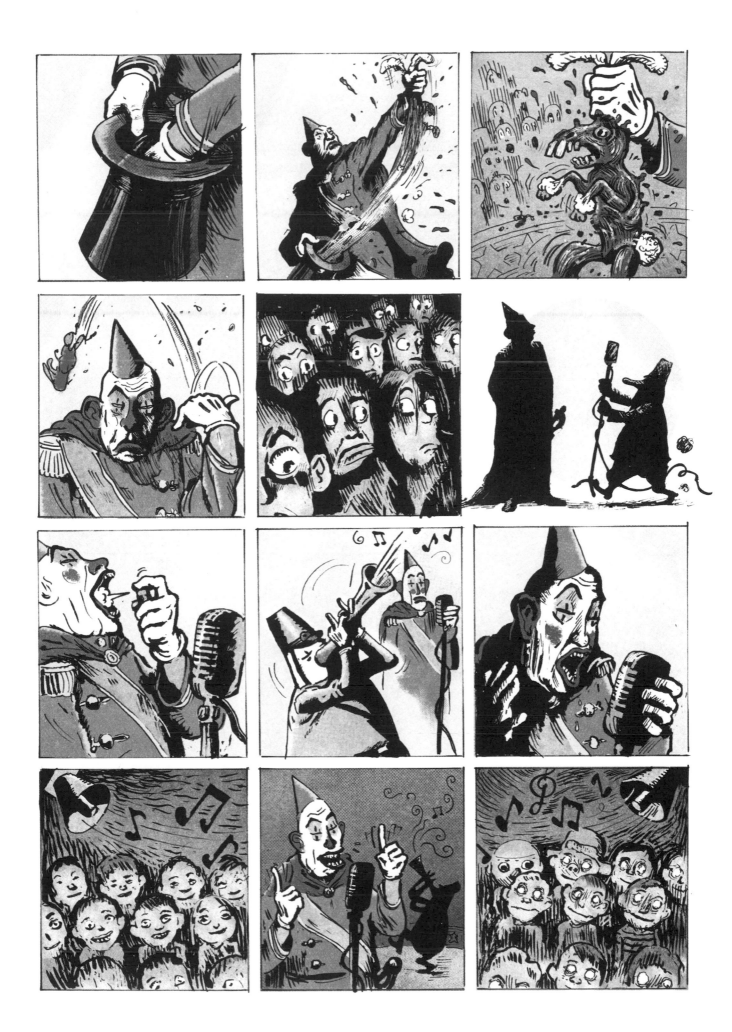

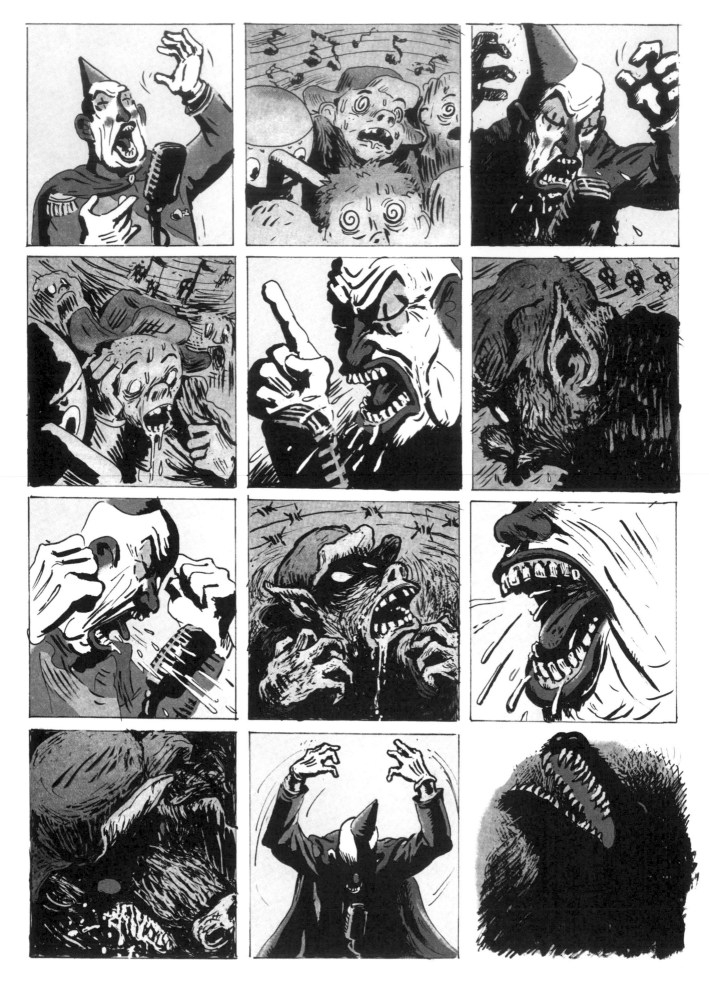

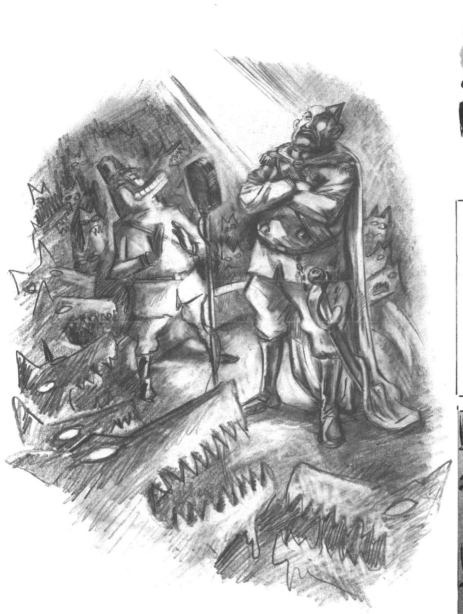

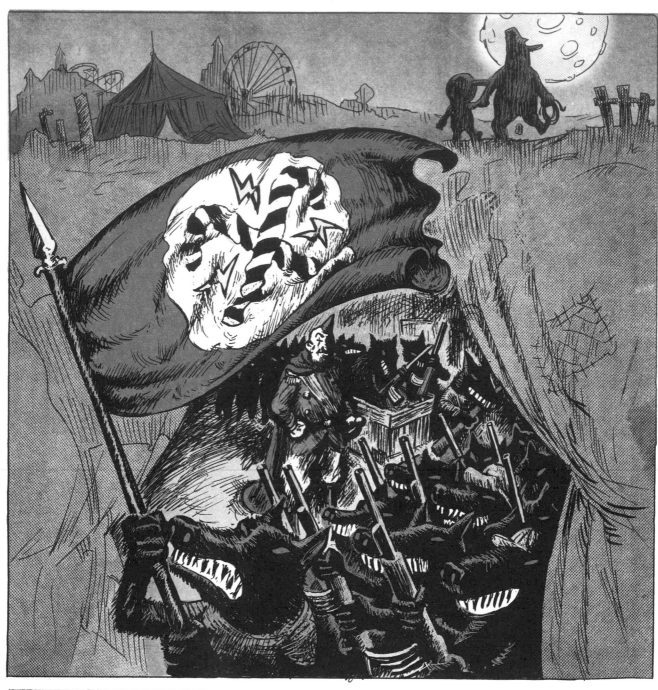

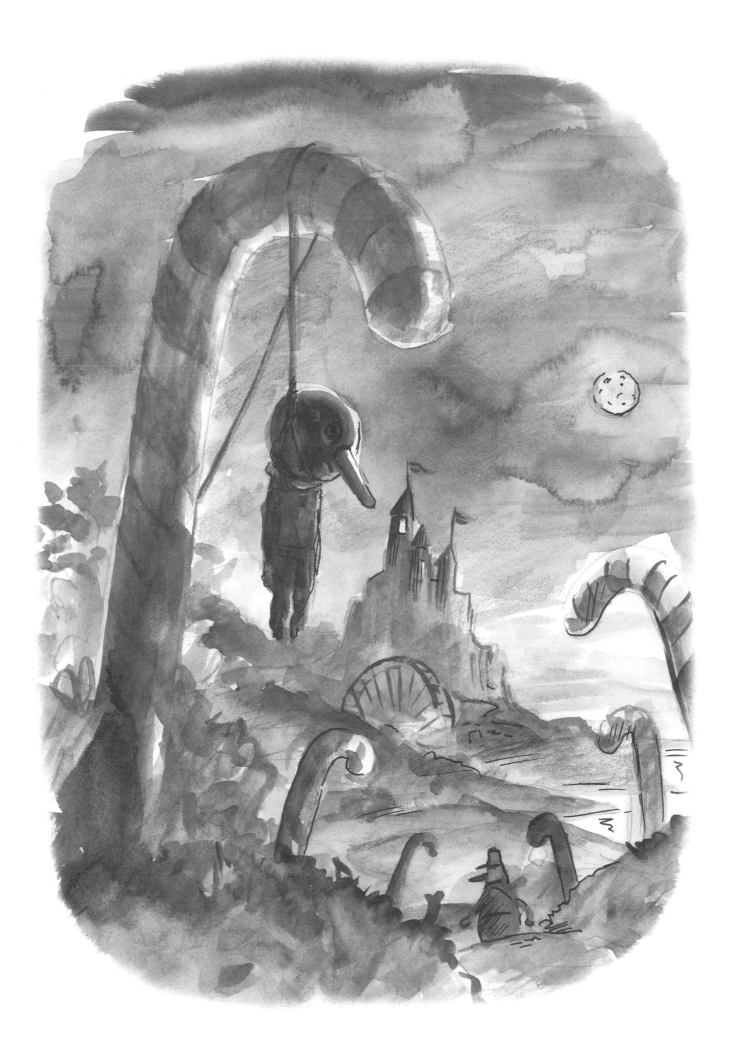

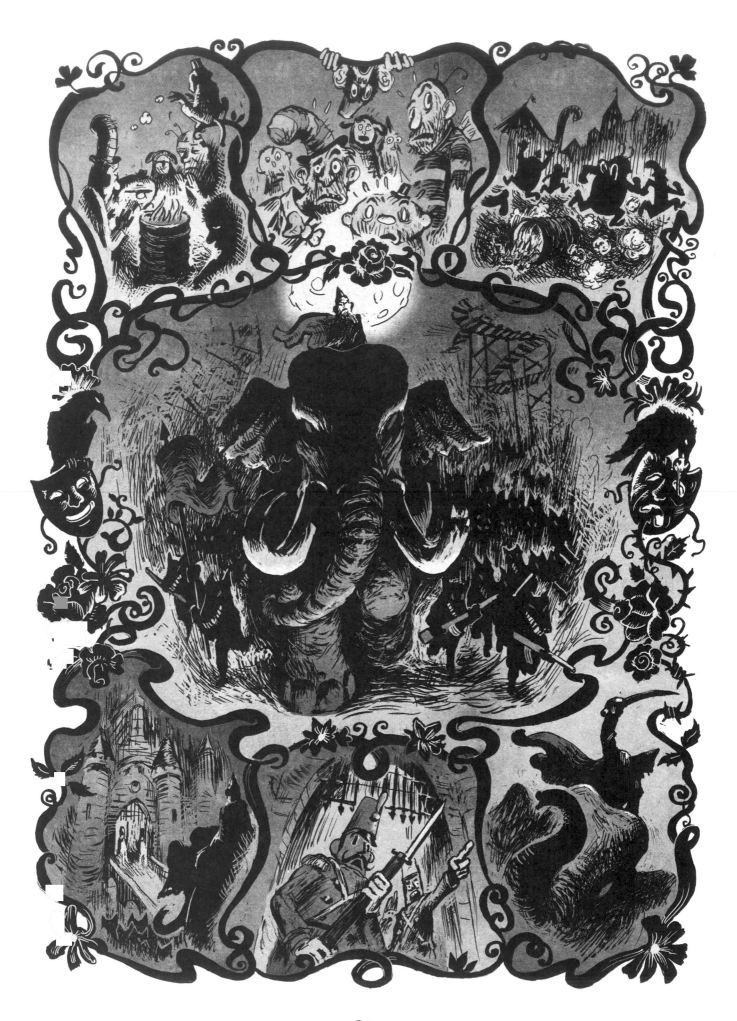

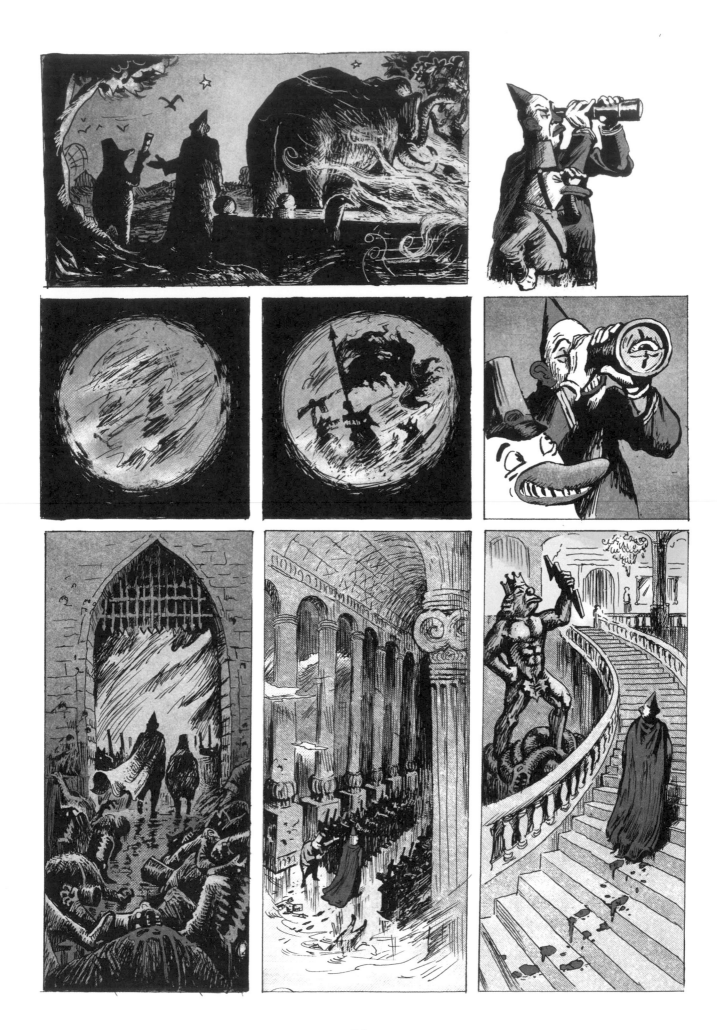

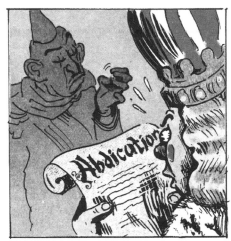

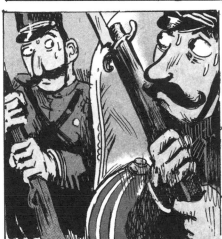

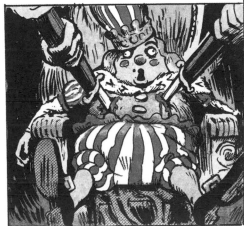

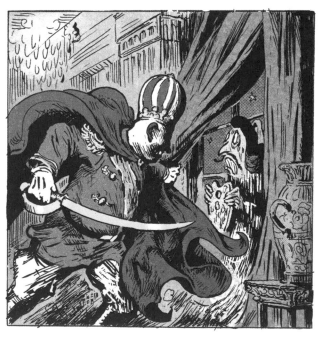

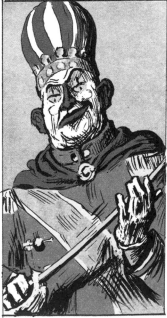

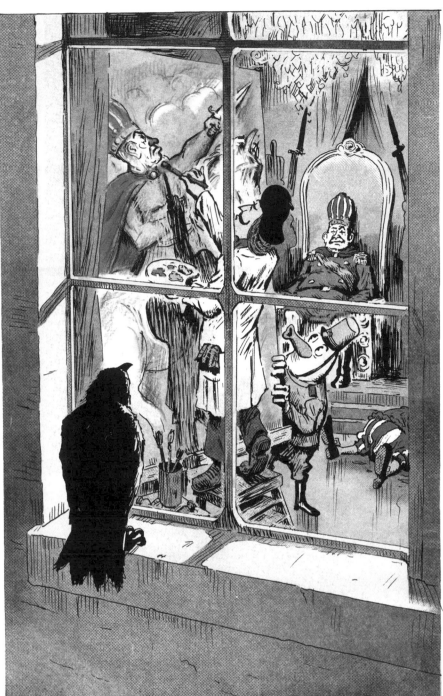

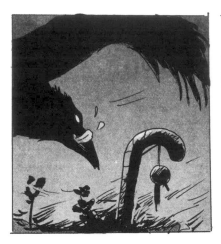

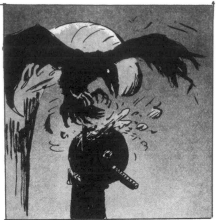

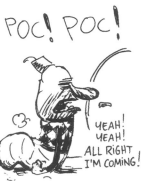

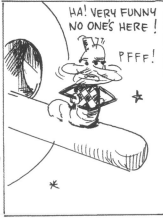

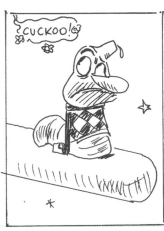

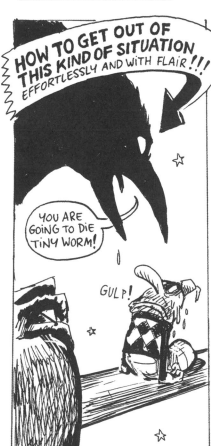

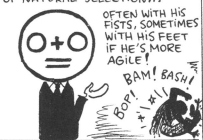

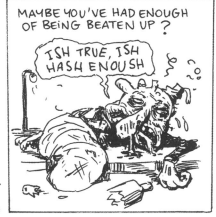

ORDER NOW AND RECEIVE THE **ZEUS**® ELECTRIC BATON WITHIN 48 HOURS!

AT YOUR SERVICE!

BRILLIANT!

AS SOON AS IT'S IN YOUR HAND YOU CAN FEEL ITS POWER!!!

HAHA! I AM INVINCIBLE!

AND THE NEXT TIME SOMEONE PICKS A FIGHT WITH YOU, YOU WILL BE ABLE TO PROCLAIM LOUD AND CLEAR:

2000 VOLTS IN YOUR FACE BITCH!!

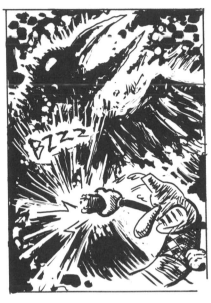

BZZZ

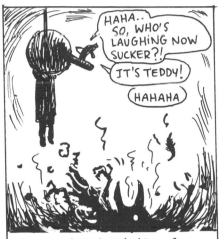

HAHA.. SO, WHO'S LAUGHING NOW SUCKER?!

IT'S TEDDY!

HAHAHA

HOW SATISFYING IT IS TO SEE THIS BIG BULLY WRACKED WITH SPASMS OF PAIN AND CRYING LIKE A SMALL CHILD !!!

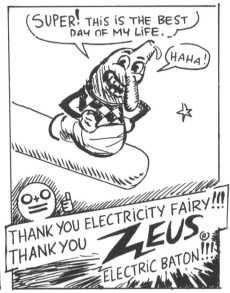

SUPER! THIS IS THE BEST DAY OF MY LIFE.

HAHA!

THANK YOU ELECTRICITY FAIRY!!! THANK YOU **ZEUS**® ELECTRIC BATON!!!

HAAAAAA

GET A FREE PAIR OF RUNNING SHOES WITH EACH **ZEUS**® ELECTRIC BATON!!!

SO, DON'T WAIT ANOTHER MINUTE!!

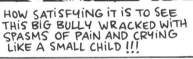

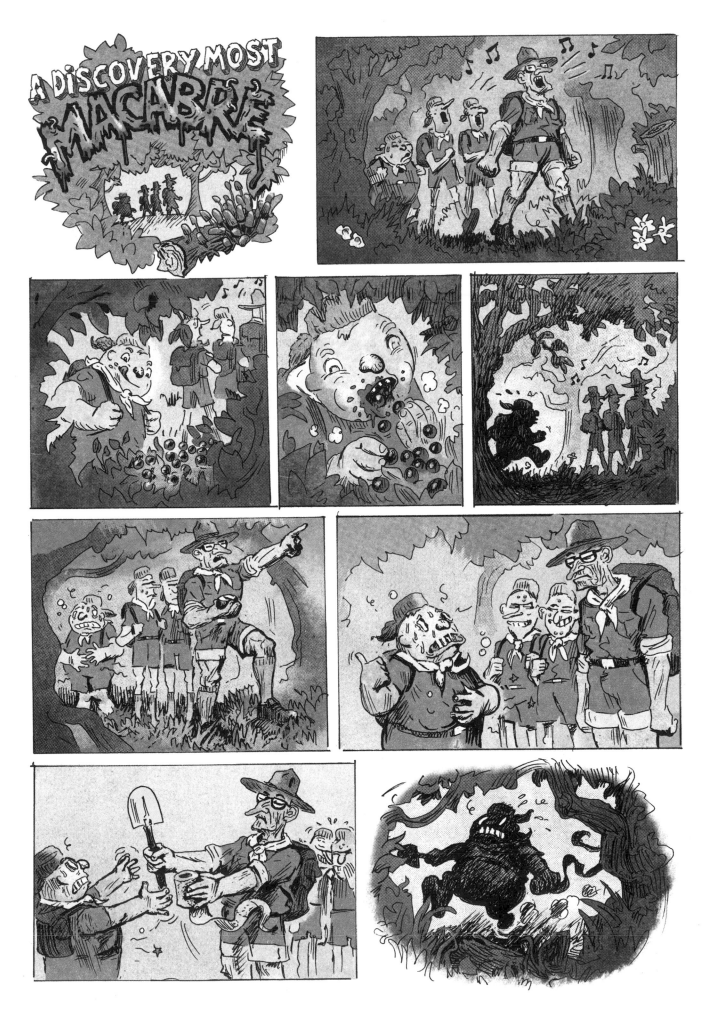

INSPECTOR
BOB JAVER

SVETLANA GEPPETTO

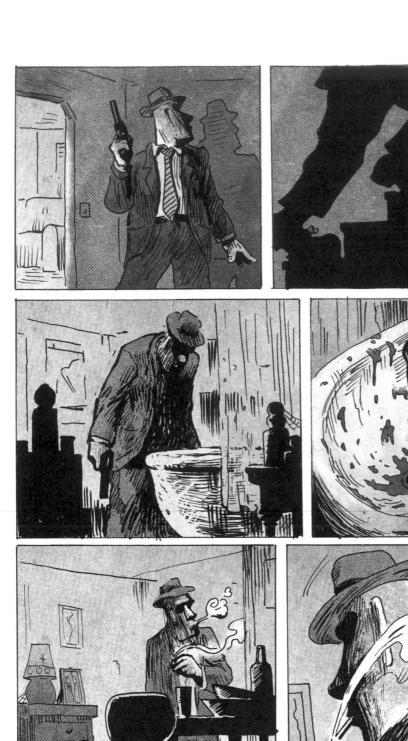

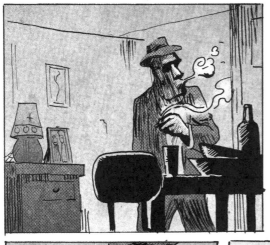

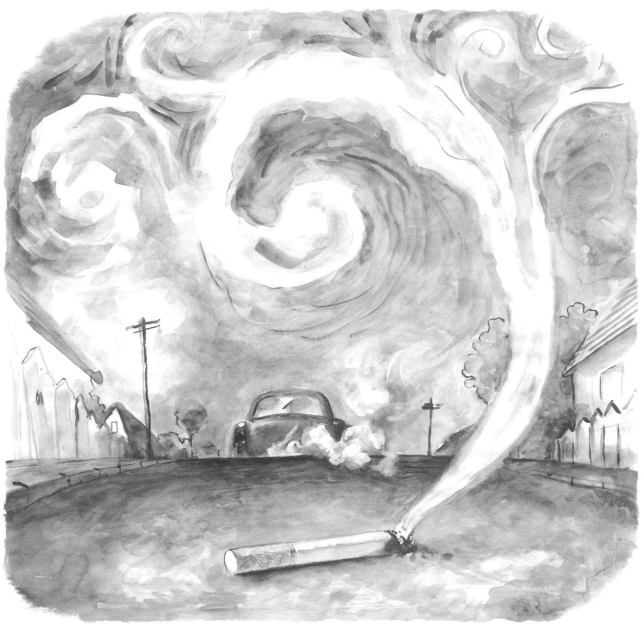

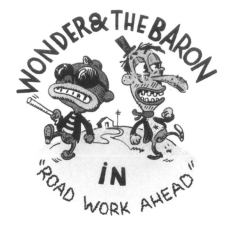

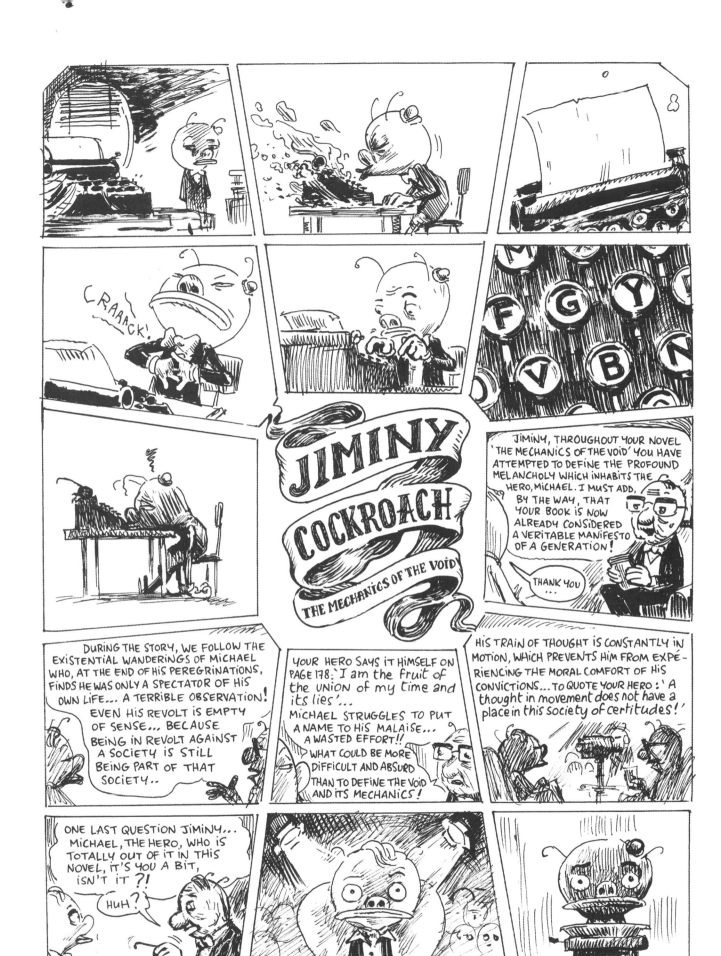

JIMINY COCKROACH

THE MECHANICS OF THE VOID

JIMINY, THROUGHOUT YOUR NOVEL 'THE MECHANICS OF THE VOID' YOU HAVE ATTEMPTED TO DEFINE THE PROFOUND MELANCHOLY WHICH INHABITS THE HERO, MICHAEL. I MUST ADD, BY THE WAY, THAT YOUR BOOK IS NOW ALREADY CONSIDERED A VERITABLE MANIFESTO OF A GENERATION!

THANK YOU ...

DURING THE STORY, WE FOLLOW THE EXISTENTIAL WANDERINGS OF MICHAEL WHO, AT THE END OF HIS PEREGRINATIONS, FINDS HE WAS ONLY A SPECTATOR OF HIS OWN LIFE... A TERRIBLE OBSERVATION! EVEN HIS REVOLT IS EMPTY OF SENSE... BECAUSE BEING IN REVOLT AGAINST A SOCIETY IS STILL BEING PART OF THAT SOCIETY..

YOUR HERO SAYS IT HIMSELF ON PAGE 178:'I AM THE fruit of the union of my time and its lies'... MICHAEL STRUGGLES TO PUT A NAME TO HIS MALAISE... A WASTED EFFORT!! WHAT COULD BE MORE DIFFICULT AND ABSURD THAN TO DEFINE THE VOID AND ITS MECHANICS!

HIS TRAIN OF THOUGHT IS CONSTANTLY IN MOTION, WHICH PREVENTS HIM FROM EXPÉRIENCING THE MORAL COMFORT OF HIS CONVICTIONS...TO QUOTE YOUR HERO :' A thought in movement does not have a place in this society of certitudes!'

ONE LAST QUESTION JIMINY... MICHAEL, THE HERO, WHO IS TOTALLY OUT OF IT IN THIS NOVEL, IT'S YOU A BIT, ISN'T IT ?!

HUH ?

CRAAACK!

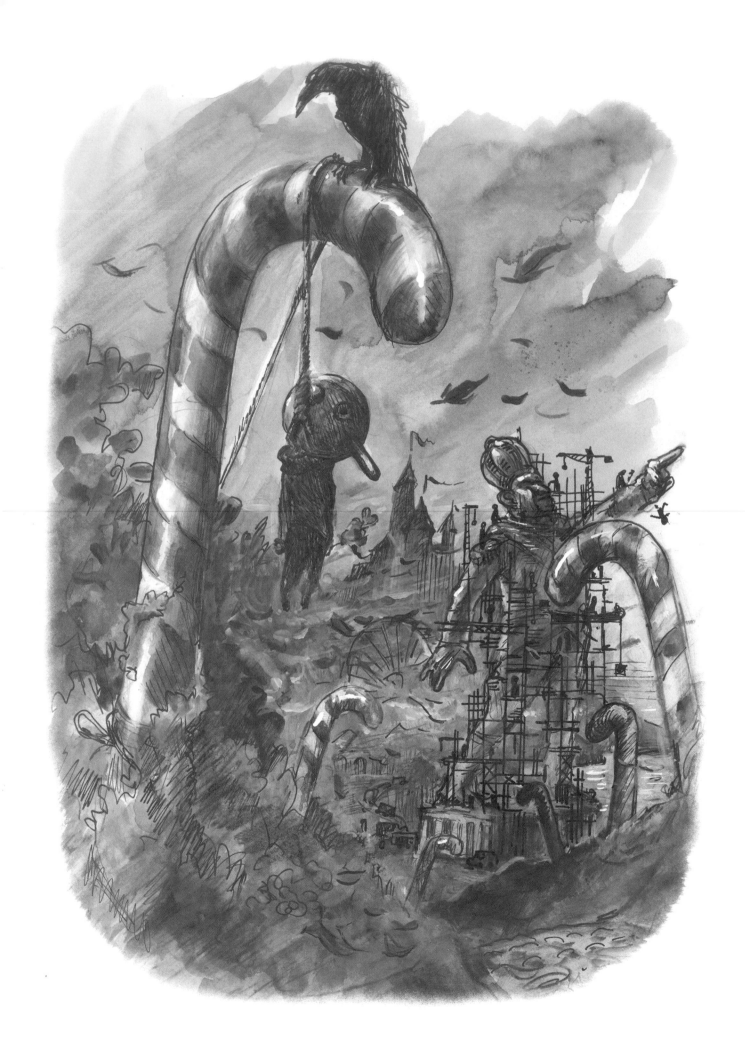

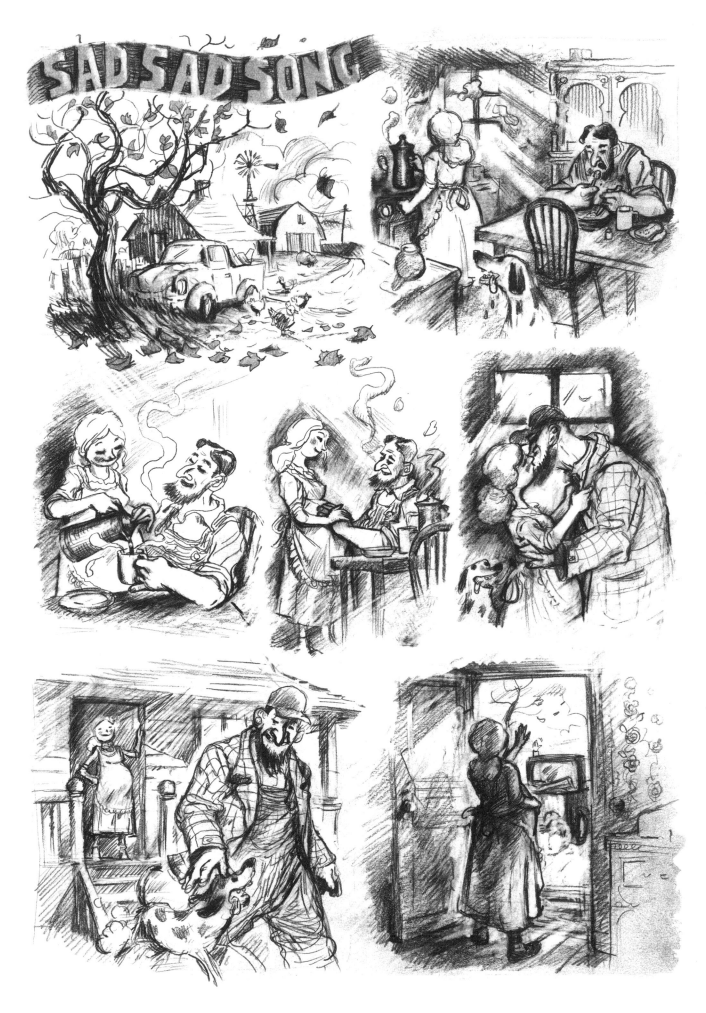

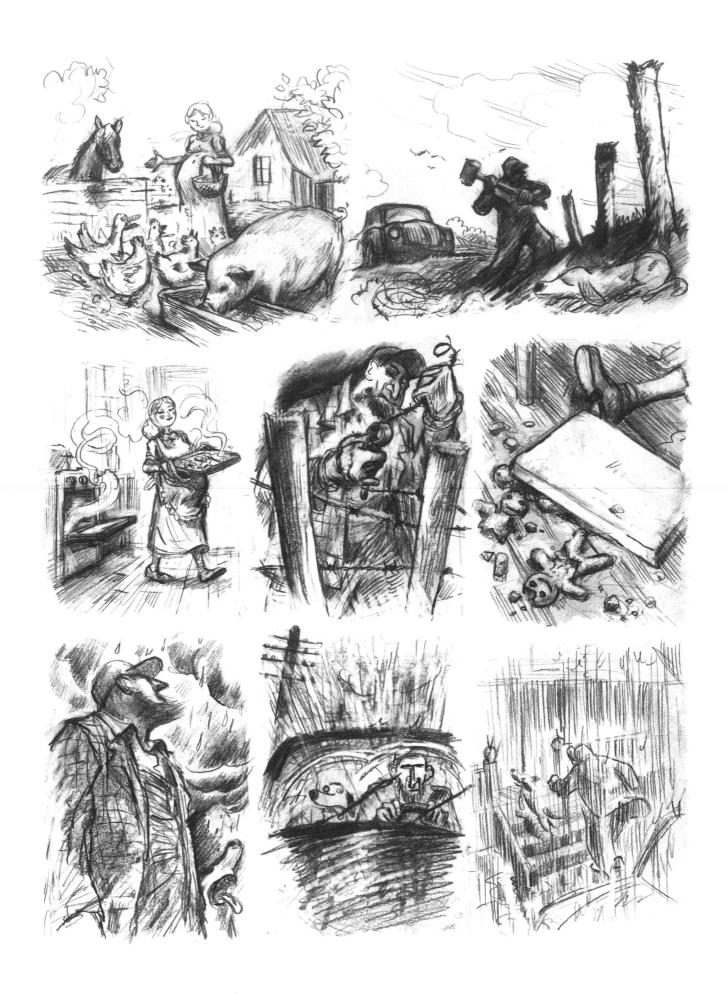

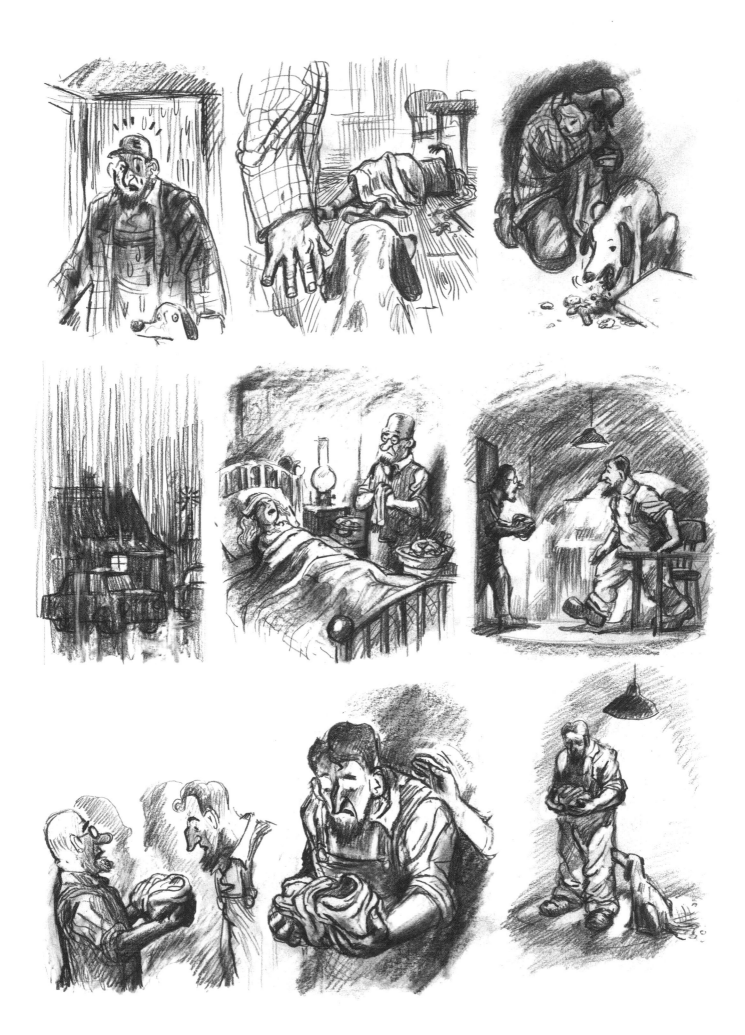

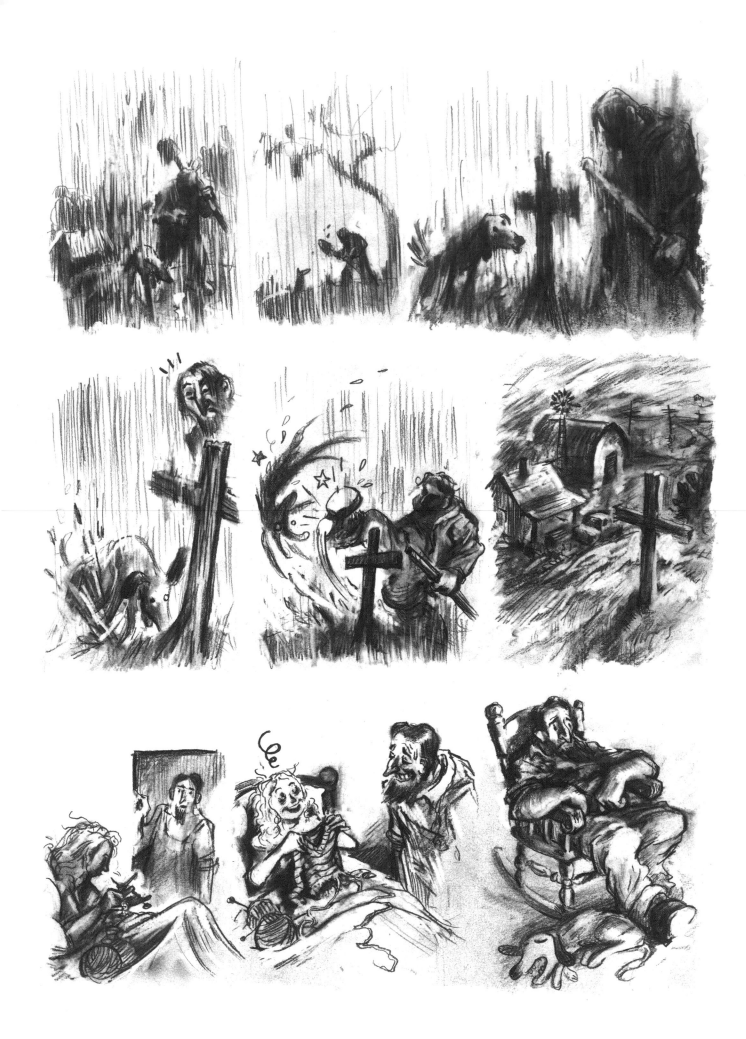

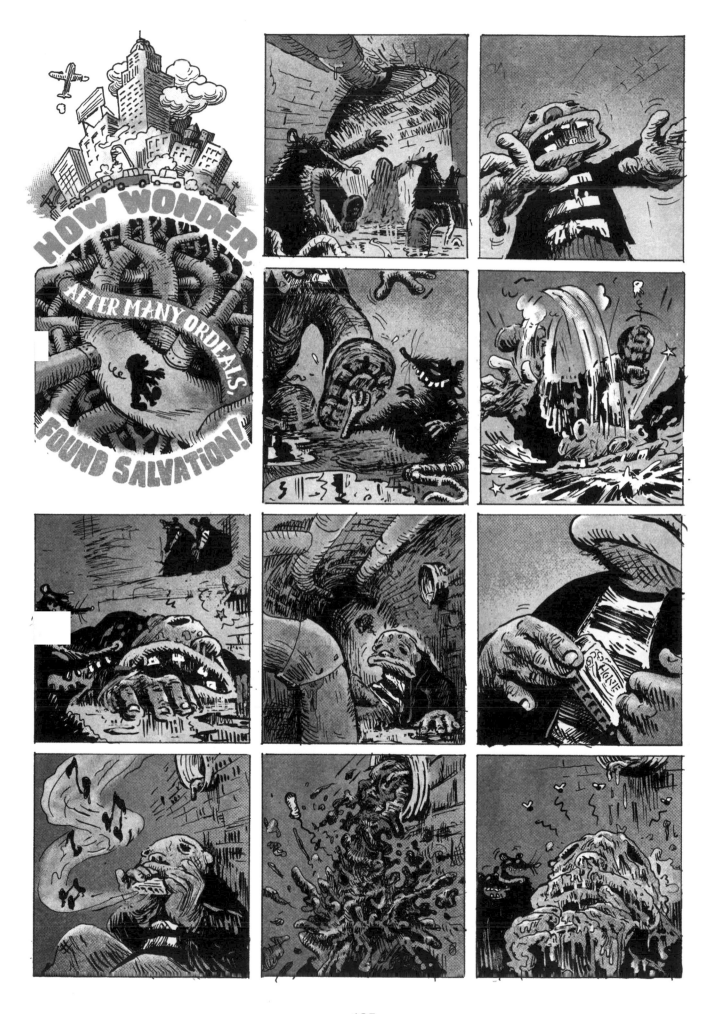

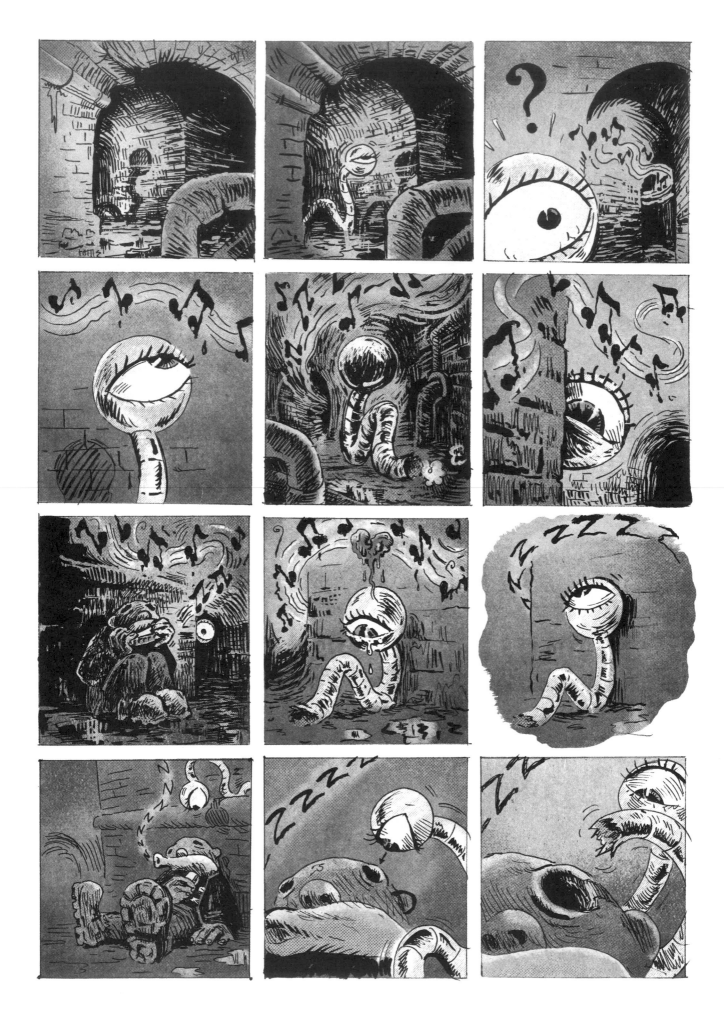

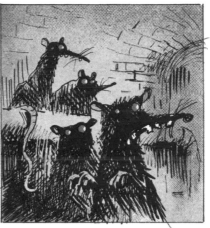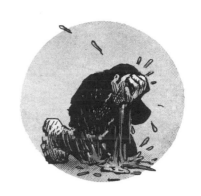
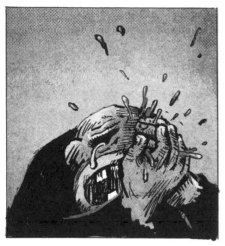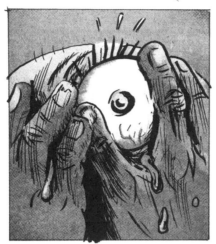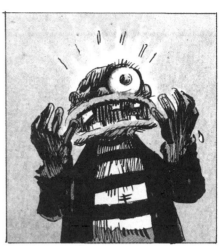
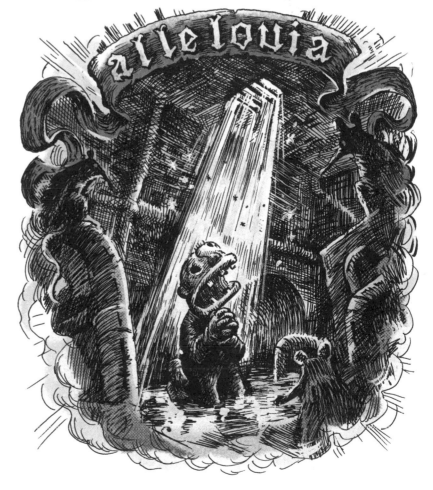

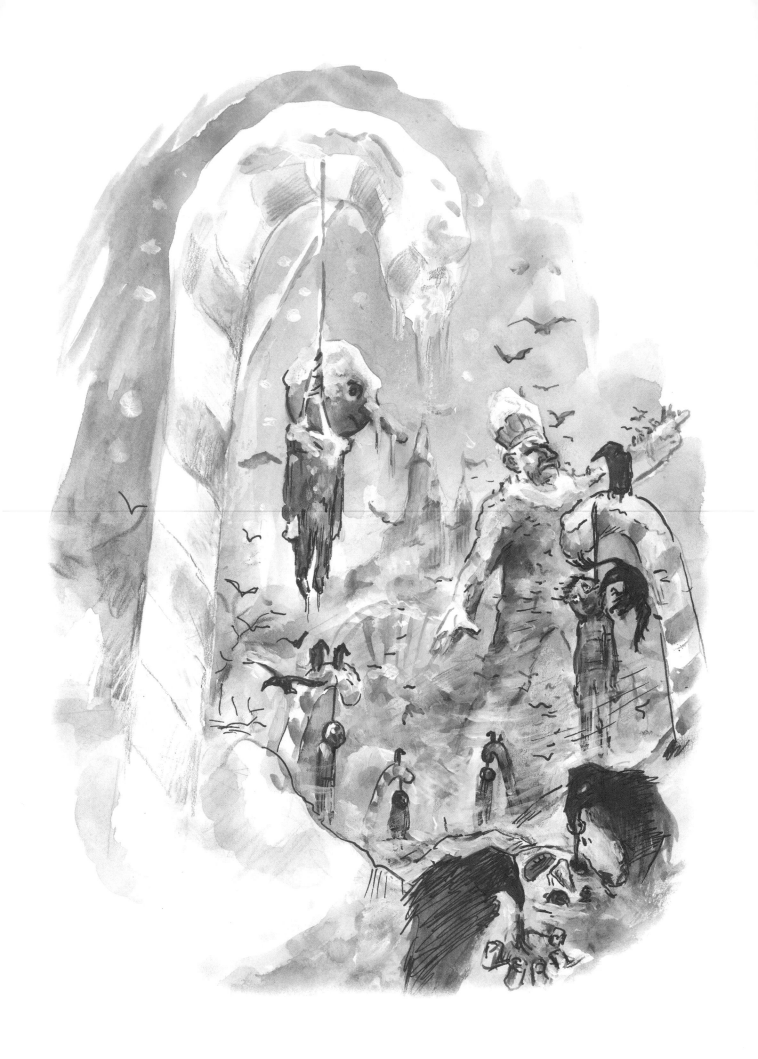

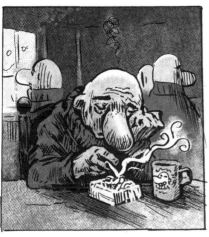

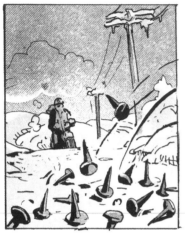
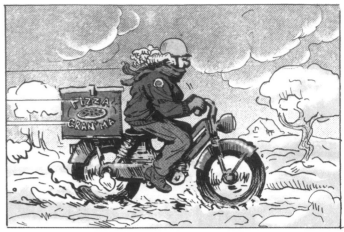

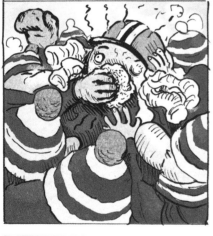

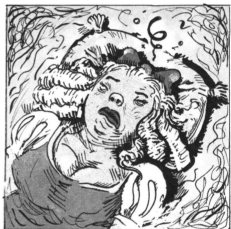
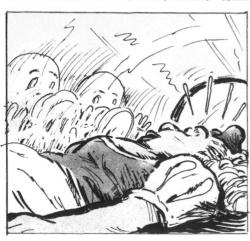

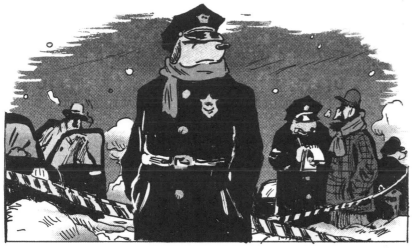

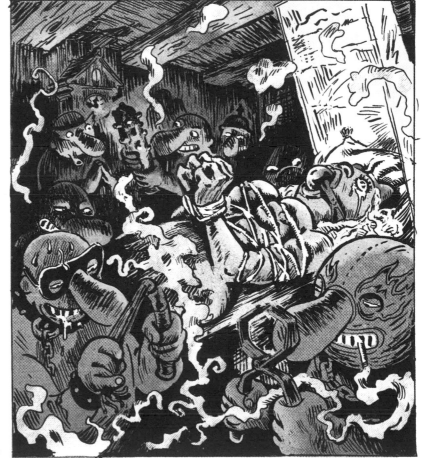

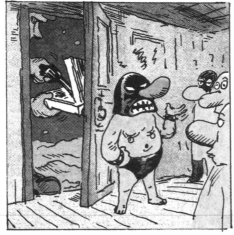

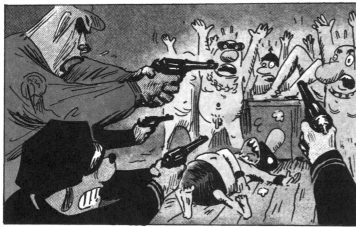

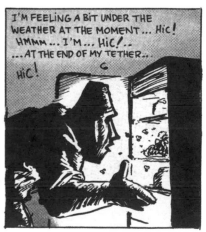

I'M FEELING A BIT UNDER THE WEATHER AT THE MOMENT... HIC! HMMM... I'M... HIC!... ...AT THE END OF MY TETHER... HIC!

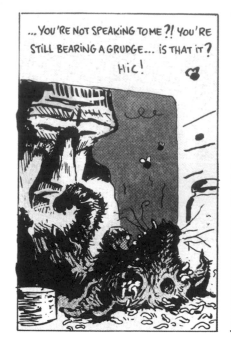

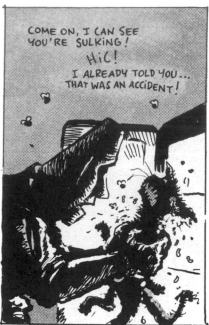

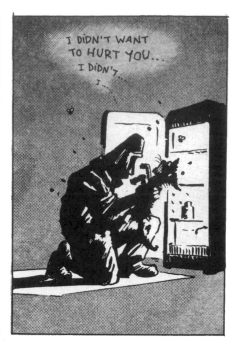

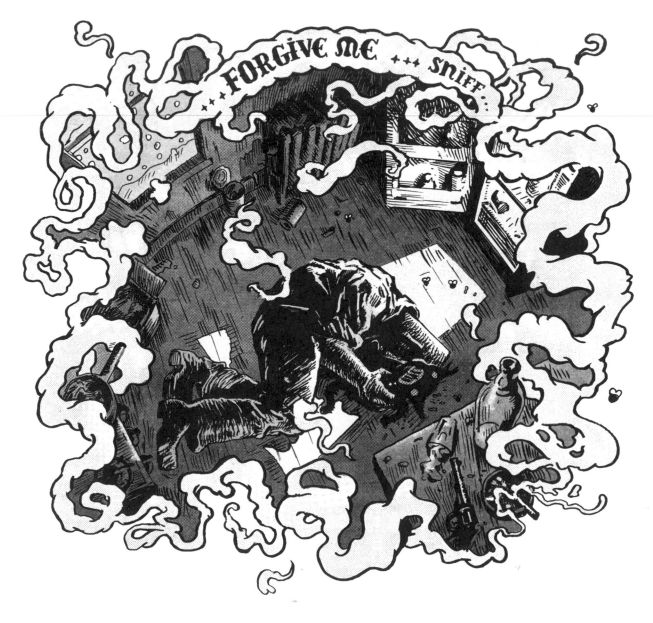

JIMINY COCKROACH

"BECOMING CONSCIOUS OF THE GENIUS OF ANOTHER ALLOWS US AT THE SAME TIME TO MEASURE OUR OWN..."

 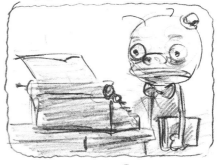

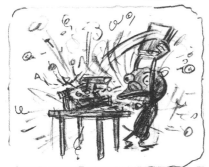 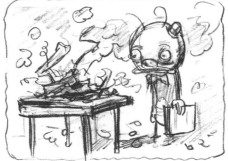

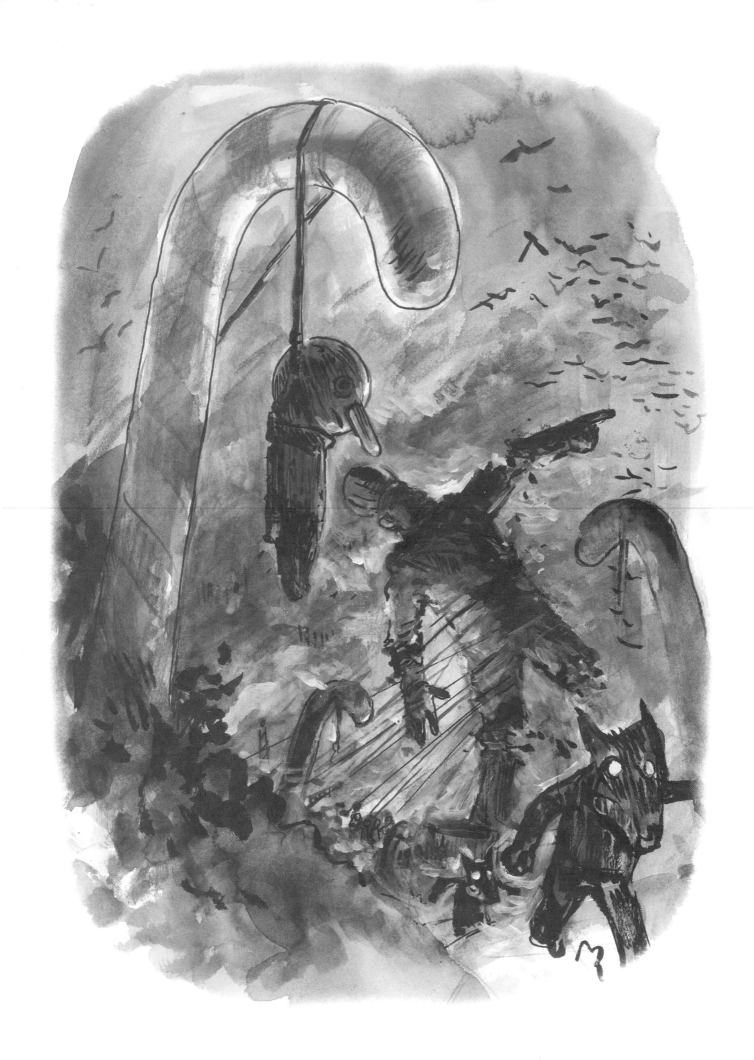

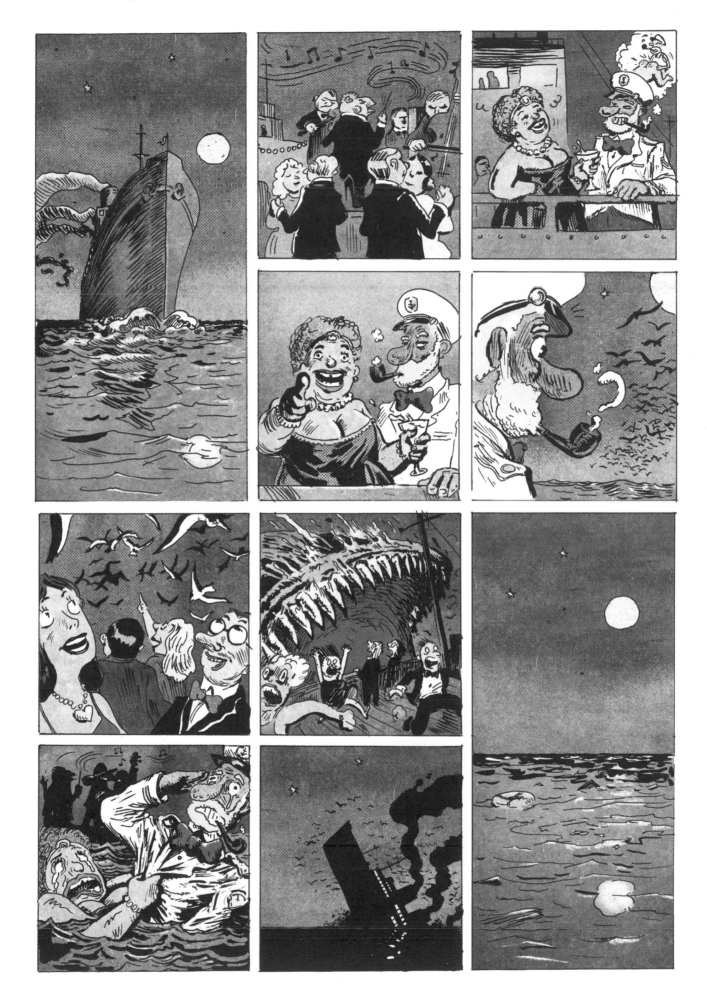

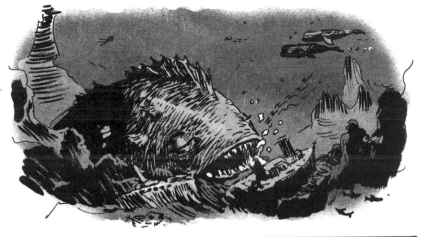

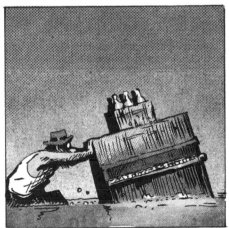

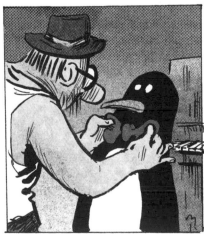

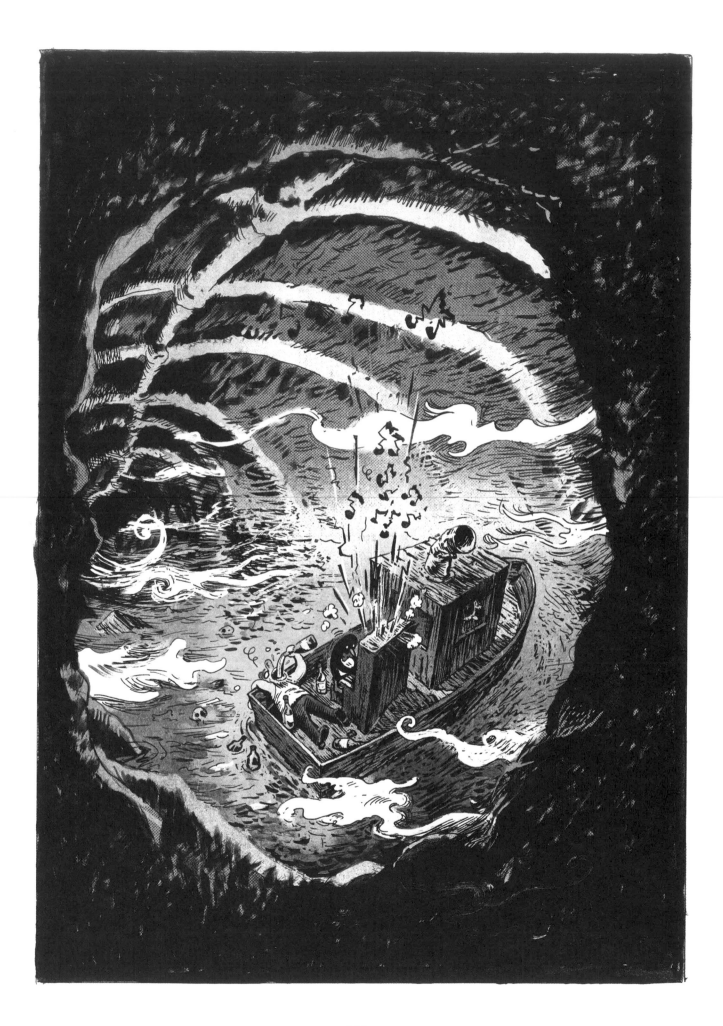

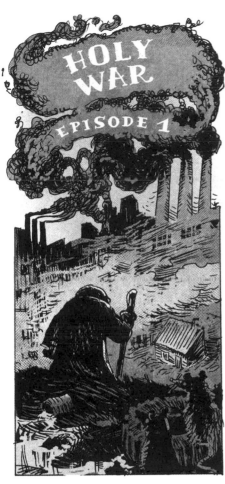

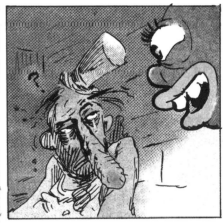

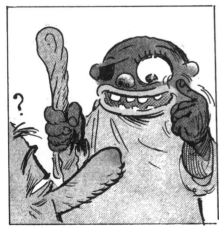

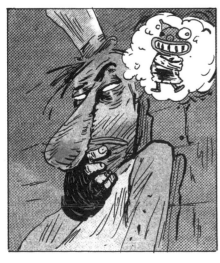

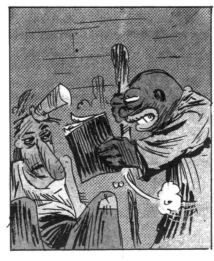

THE END

WONDER HAD FOLLOWED THE PATH TO PERDITION...

THE ONE LEADING TO SIN AND DESTRUCTION!!!

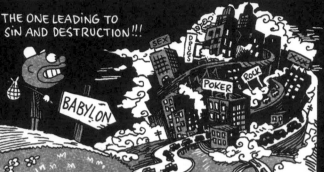

WONDER WAS SPENDING ALL HIS TIME IN DENS OF SIN.
HE WAS GAMBLING, DRINKING, SNORTING COCAINE AND FOOLING AROUND WITH FAST WOMEN...

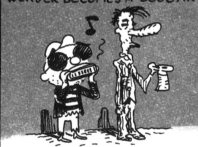

HE DID NOT KNOW IT YET BUT IT WAS **SATAN** WHO WAS GUIDING HIS STEPS!

WONDER IS PUNISHED FOR HIS SINS!

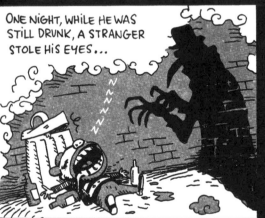

ONE NIGHT, WHILE HE WAS STILL DRUNK, A STRANGER STOLE HIS EYES...

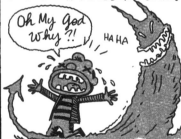

EARLY IN THE MORNING, WONDER IS HORRIFIED TO DISCOVER HIS EYES ARE GONE!

Oh My God Why?!

HA HA

SATAN REJOICES AT THE TRICK HE HAS PLAYED ON WONDER!

WONDER BECOMES A BEGGAR.

HIS MISERABLE LIFE IS GIVING HIM THE OPPORTUNITY TO THINK ABOUT HIS PAST MISTAKES...

GOD PUTS WONDER TO THE TEST!

WITHOUT KNOWING IT, WONDER OPENS HIS HEART TO GOD...
GOD DECIDES TO TEST IF HE IS TRULY REPENTANT...

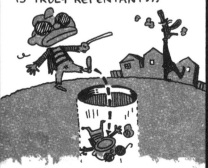

BY GOD'S WILL, WONDER IS THROWN INTO THE DEPTHS OF BABYLON!

WONDER ROAMS FOR 7 DAYS AND 7 NIGHTS IN THE DARKNESS.

Oh My God Why?!

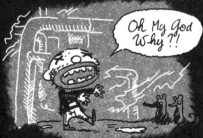

LEARN THAT THE PATH TO REDEMPTION IS LONG AND FRAUGHT WITH PERIL!

ON THE 8TH DAY WONDER THINKS HIS HOUR HAS COME!
HE SINCERELY REGRETS HIS ACTIONS AND ACCEPTS GOD'S WILL...

I put my trust in you lord, and I accept your will!

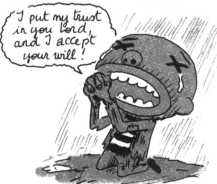

¡IS NIGH!!!!

WONDER COMPREHENDS GOD'S ALL-POWERFUL WILL!

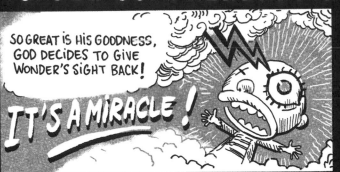

SO GREAT IS HIS GOODNESS, GOD DECIDES TO GIVE WONDER'S SIGHT BACK!

IT'S A MIRACLE!

WONDER NOW UNDERSTANDS HE WAS BLINDED BY SATAN. FROM NOW ON, HE CAN HEAR GOD'S WORD! MANY CLAIM TO SPEAK IN THE NAME OF GOD BUT THEY ARE LIARS! WONDER KNOWS THE ONE AND ONLY GOD! WONDER IS INTIMATE WITH GOD... HE SPEAKS TO HIM OFTEN.

WONDER LISTENS TO GOD'S MESSAGE!

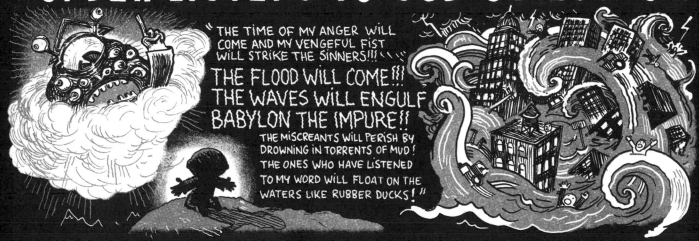

"THE TIME OF MY ANGER WILL COME AND MY VENGEFUL FIST WILL STRIKE THE SINNERS!!! THE FLOOD WILL COME!!! THE WAVES WILL ENGULF BABYLON THE IMPURE!! THE MISCREANTS WILL PERISH BY DROWNING IN TORRENTS OF MUD! THE ONES WHO HAVE LISTENED TO MY WORD WILL FLOAT ON THE WATERS LIKE RUBBER DUCKS!"

AFTER THE END TIMES EARTH WILL BECOME A PARADISE... ALL THOSE WHO HAVE TAKEN GOD INTO THEIR HEARTS WILL BE WELCOMED THERE. THEY SHALL ENJOY THE GOOD LIFE, FOR FREE AND FOR ALL ETERNITY!

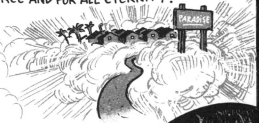

THE OTHERS WILL BURN IN THE FLAMES OF HELL REGRETTING HAVING MOCKED GOD AND HIS MESSENGER WONDER!

GOD ENTRUSTS WONDER WITH A MISSION

"GO ALL OVER THE WORLD OF MEN AND TEACH THEM MY WORD BECAUSE JUDGEMENT DAY IS CLOSE! TEACH THEM ALL THAT THERE IS ONLY ONE GOD AND THAT WONDER IS HIS PROPHET!"

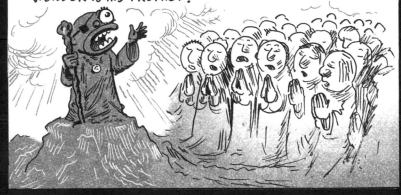

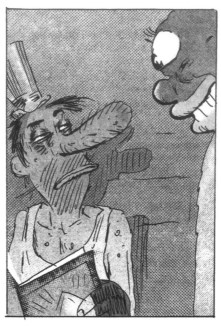
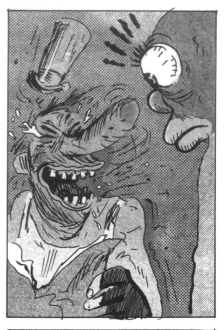
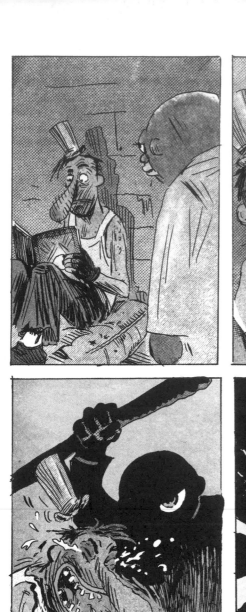

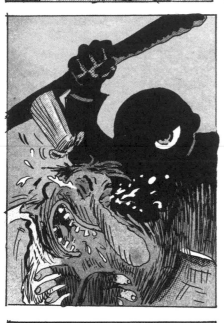
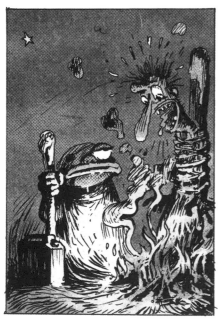

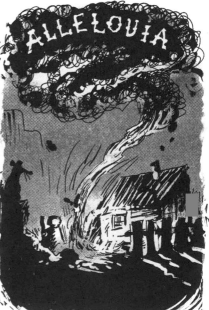

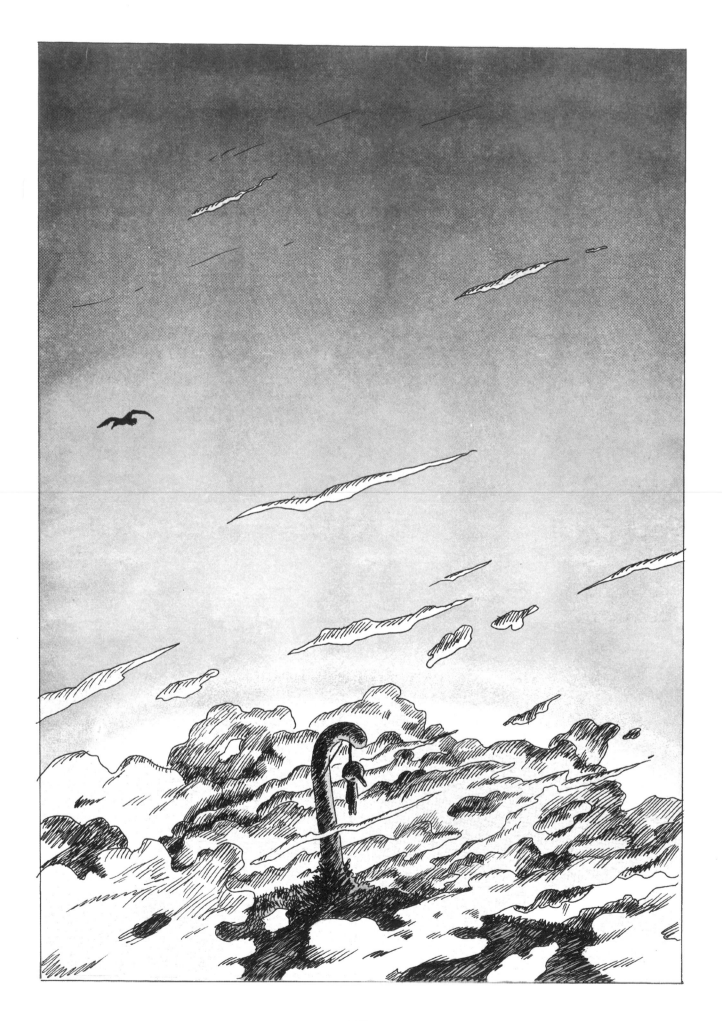

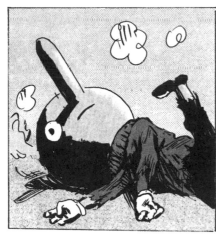

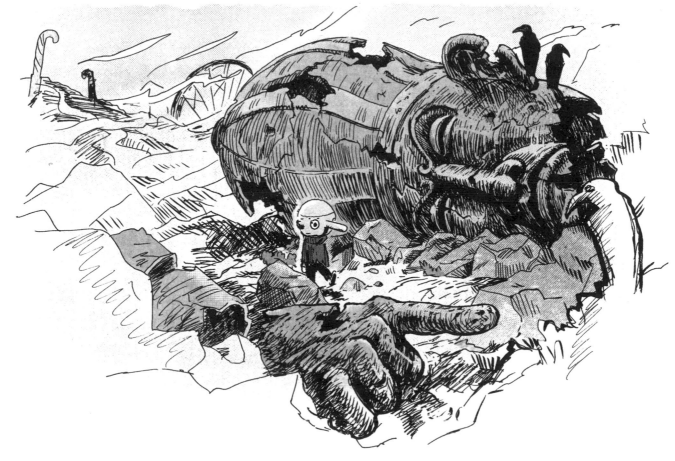

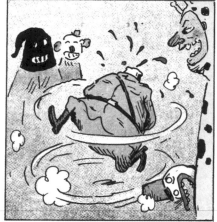

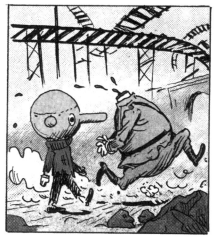

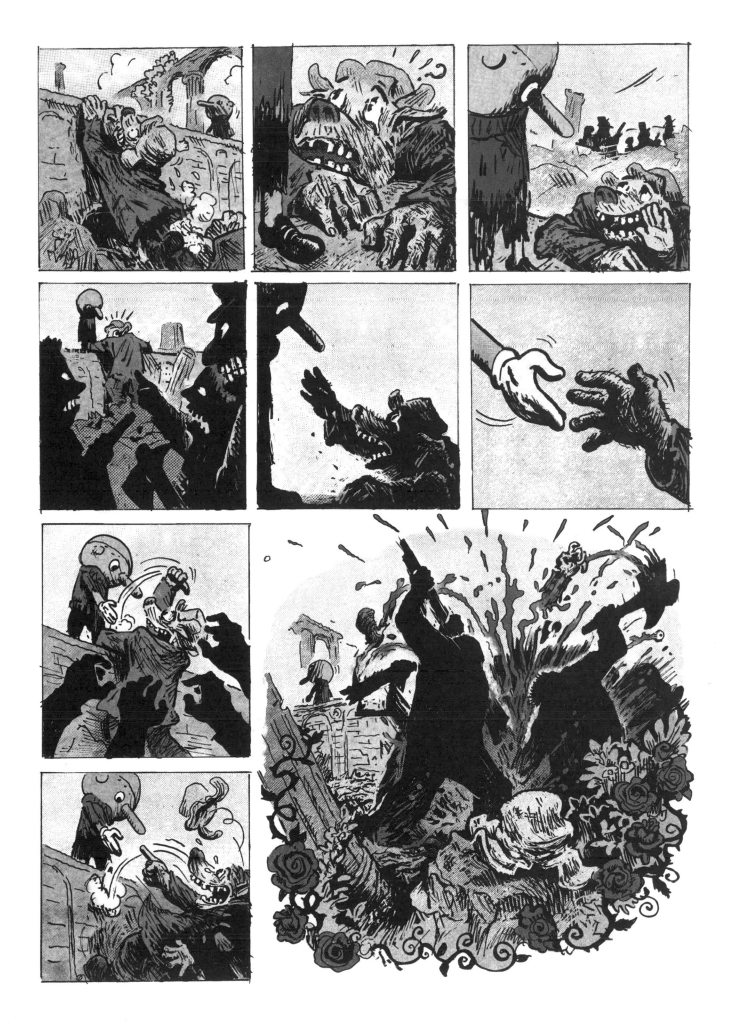

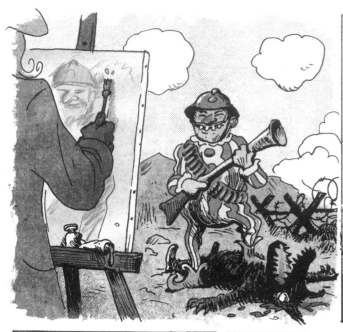

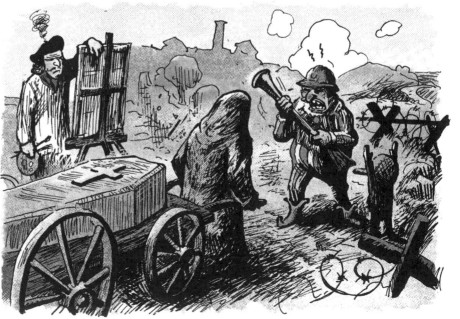

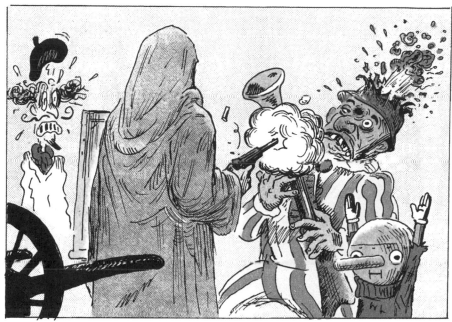

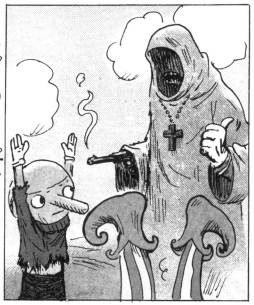

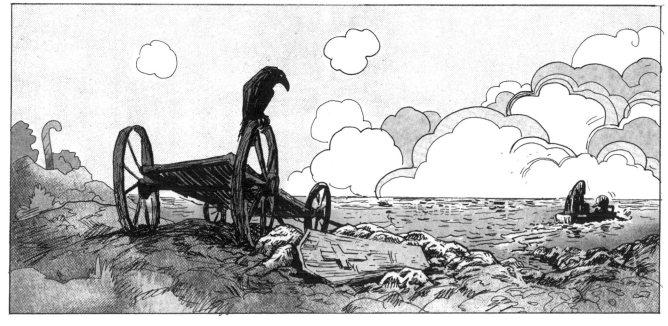

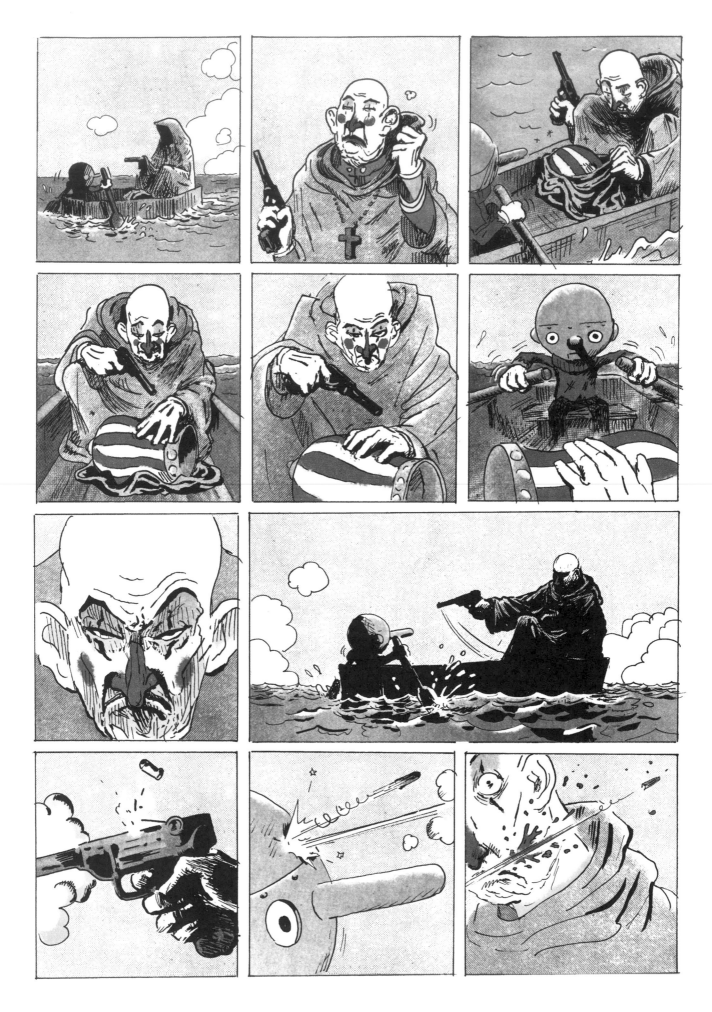

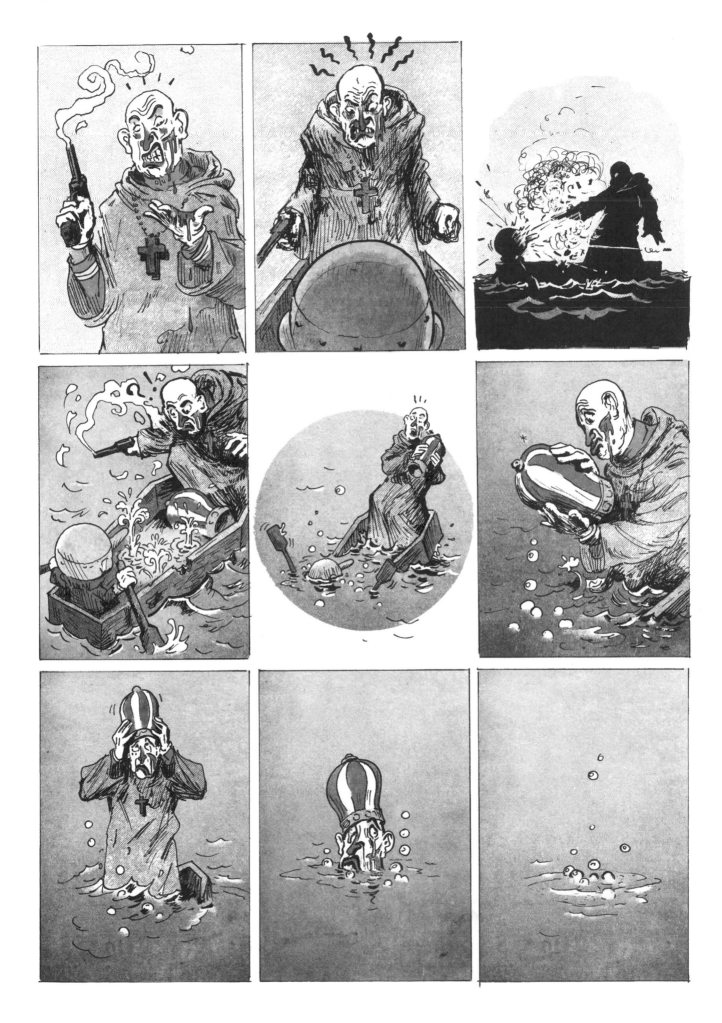

133

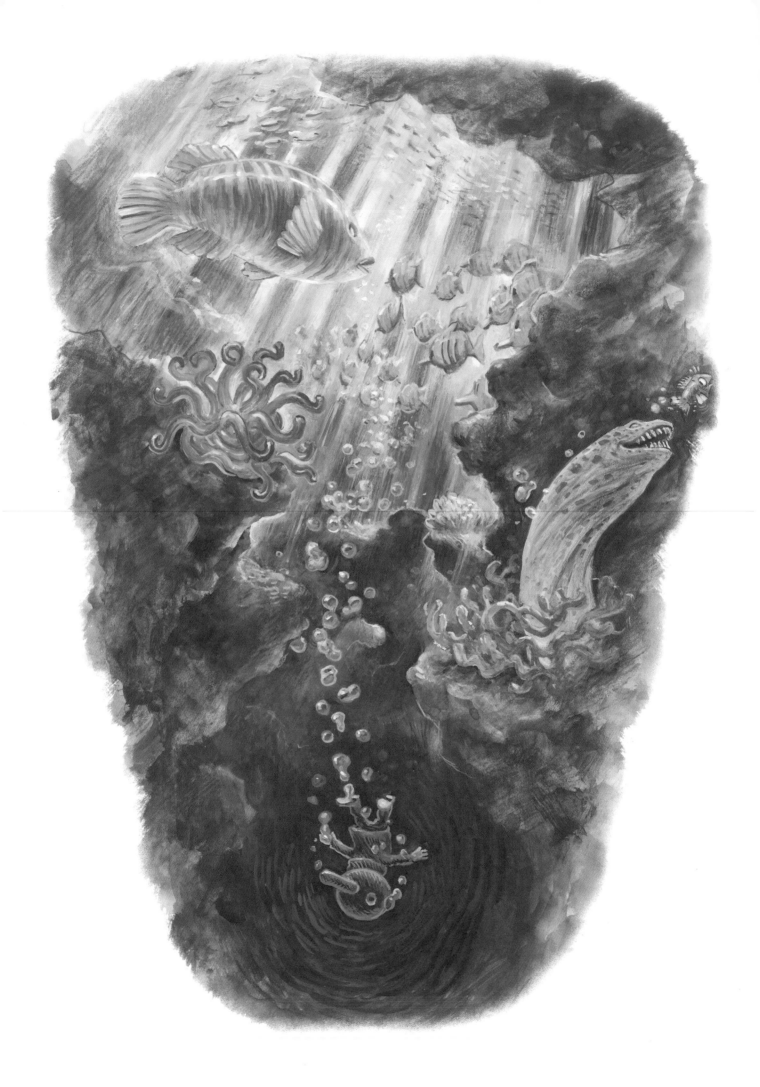

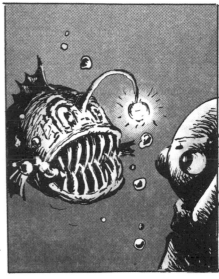
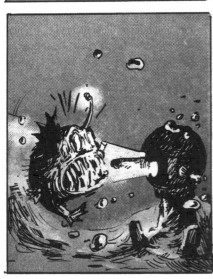

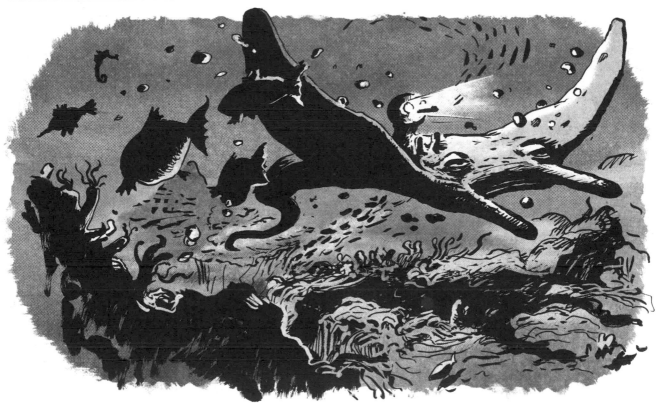

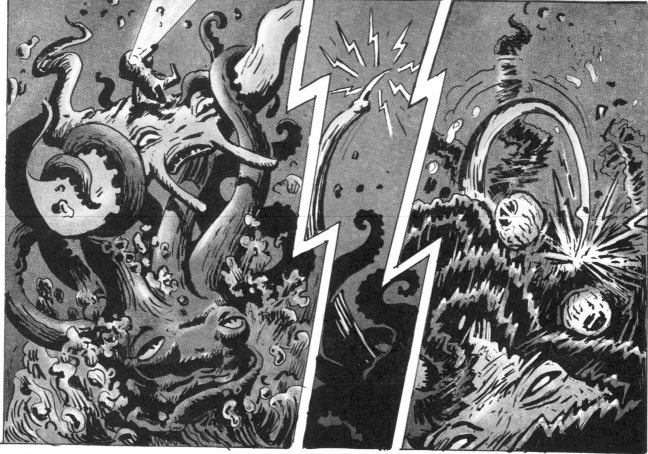

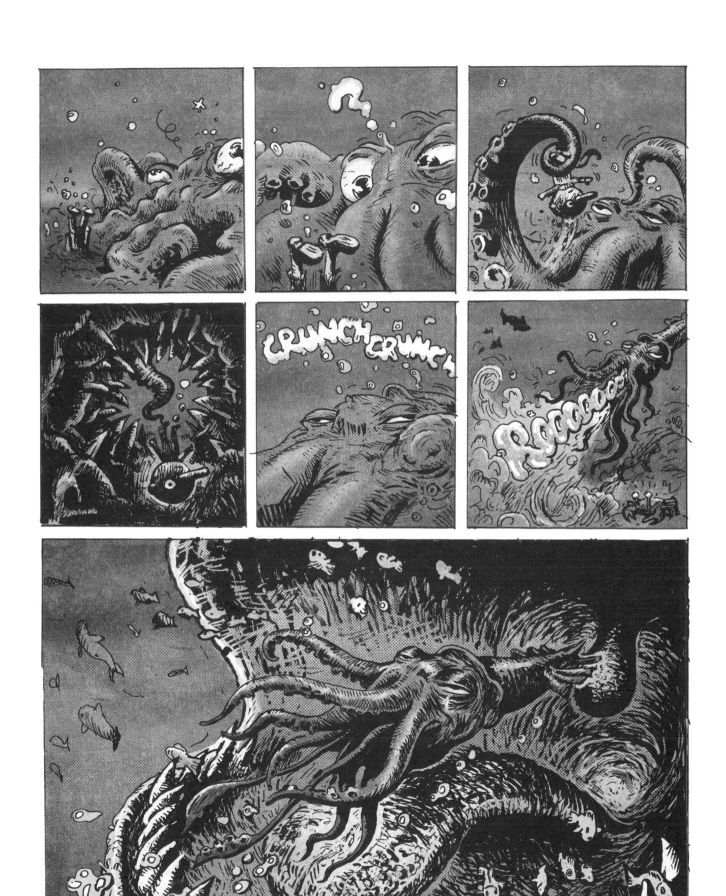

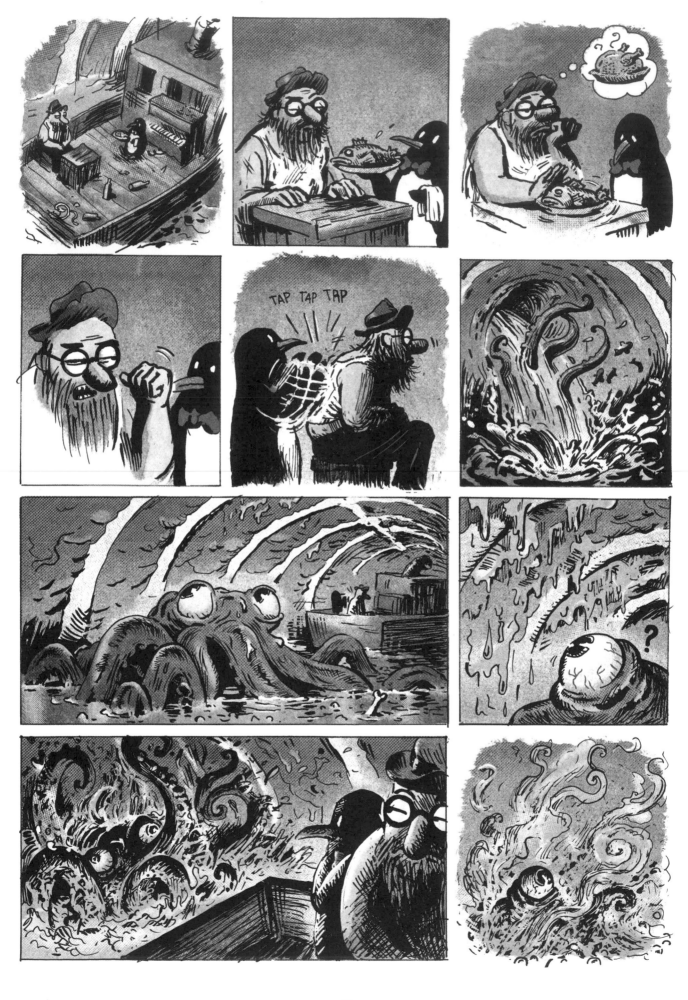

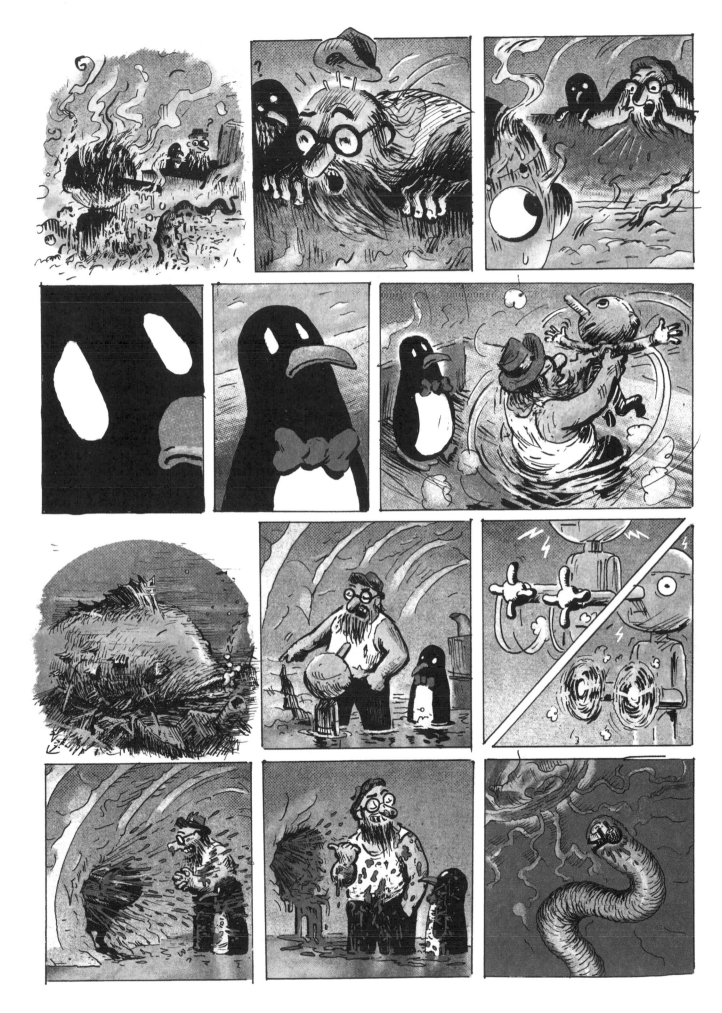

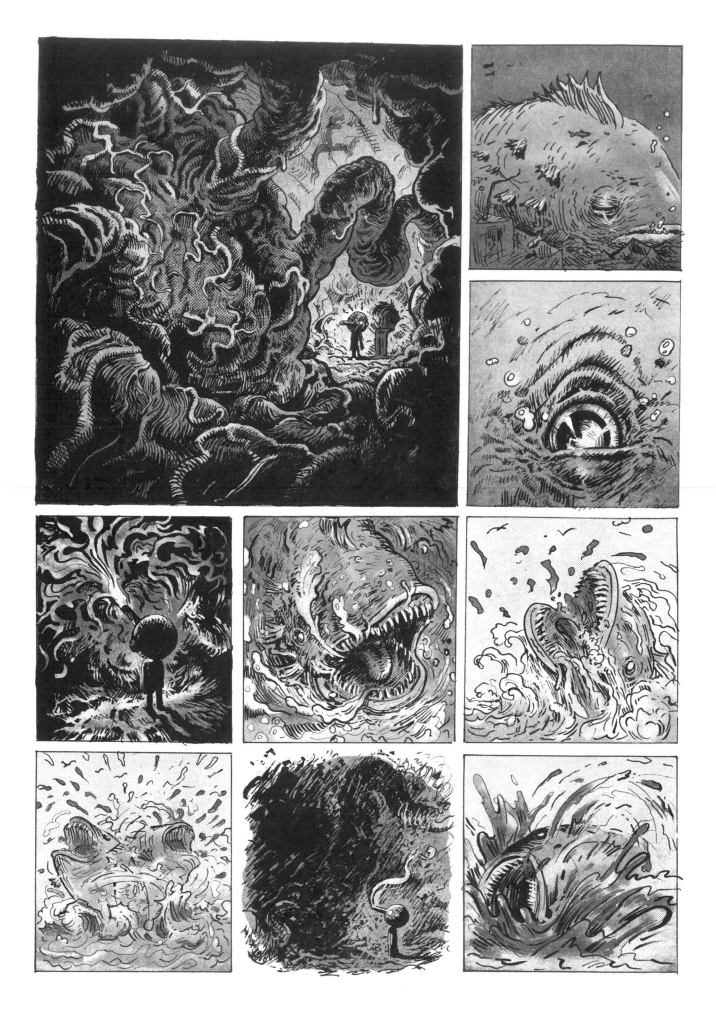

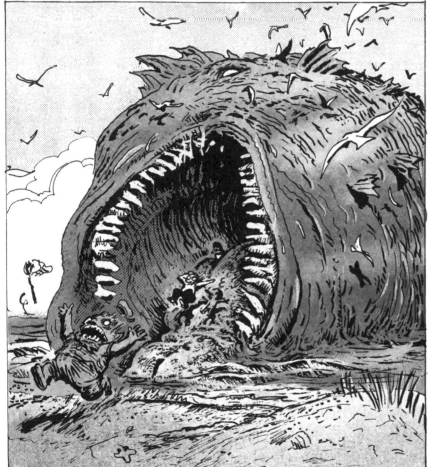

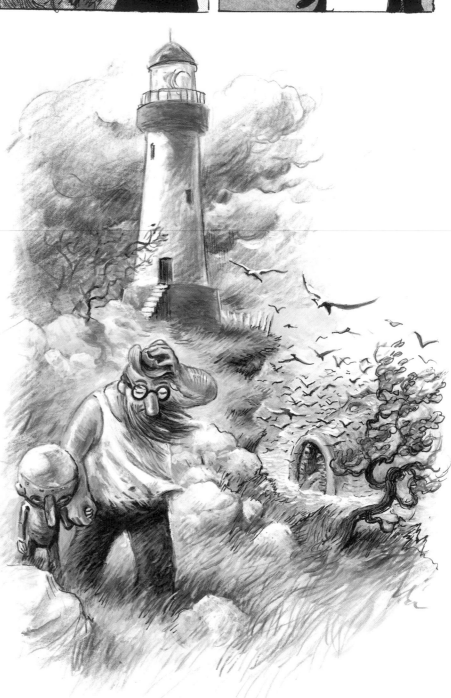

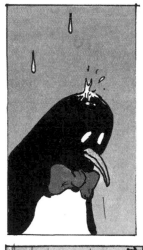

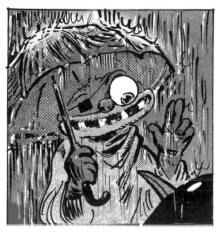

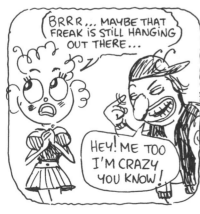

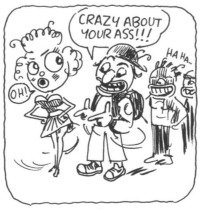

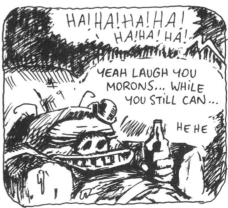

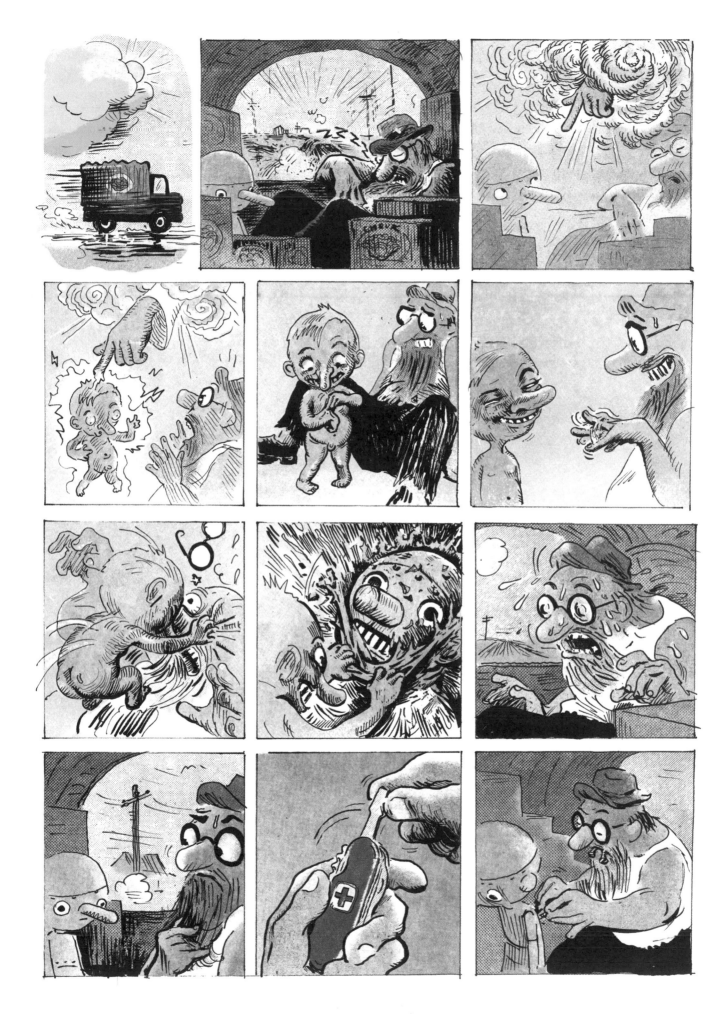

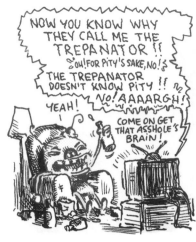

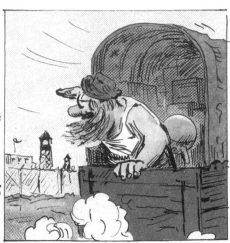

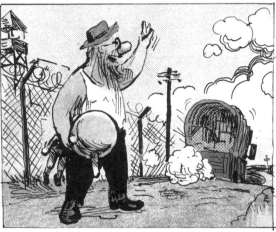

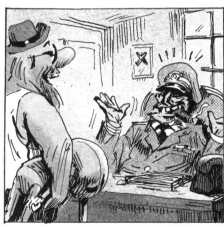

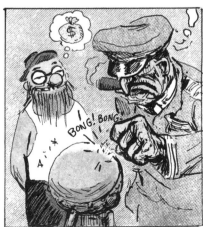

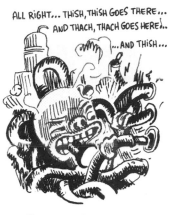

ALL RIGHT... THISH, THISH GOES THERE...
AND THACH, THACH GOES HERE!...
...AND THISH...

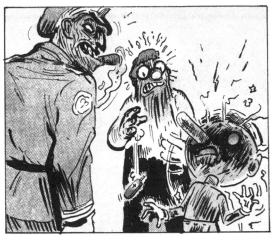
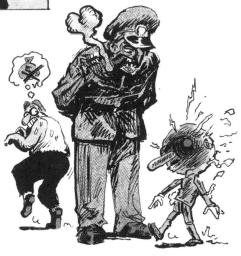

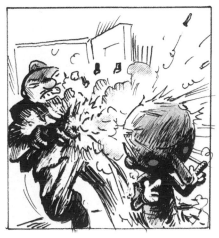
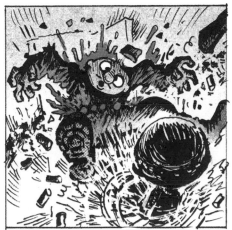

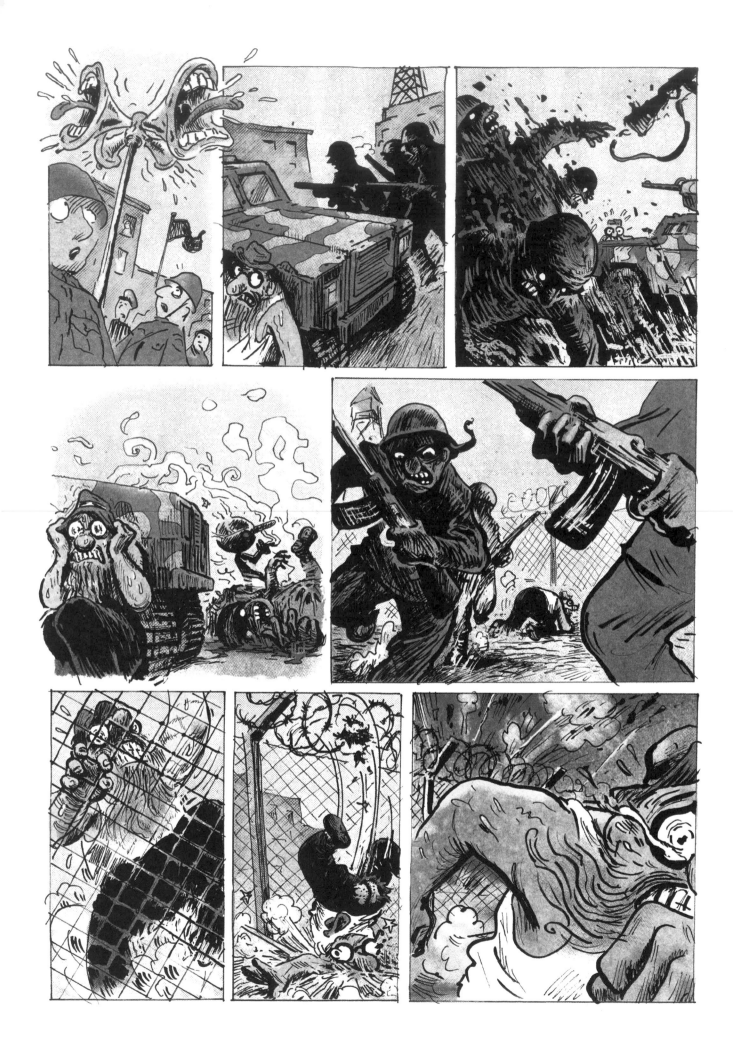

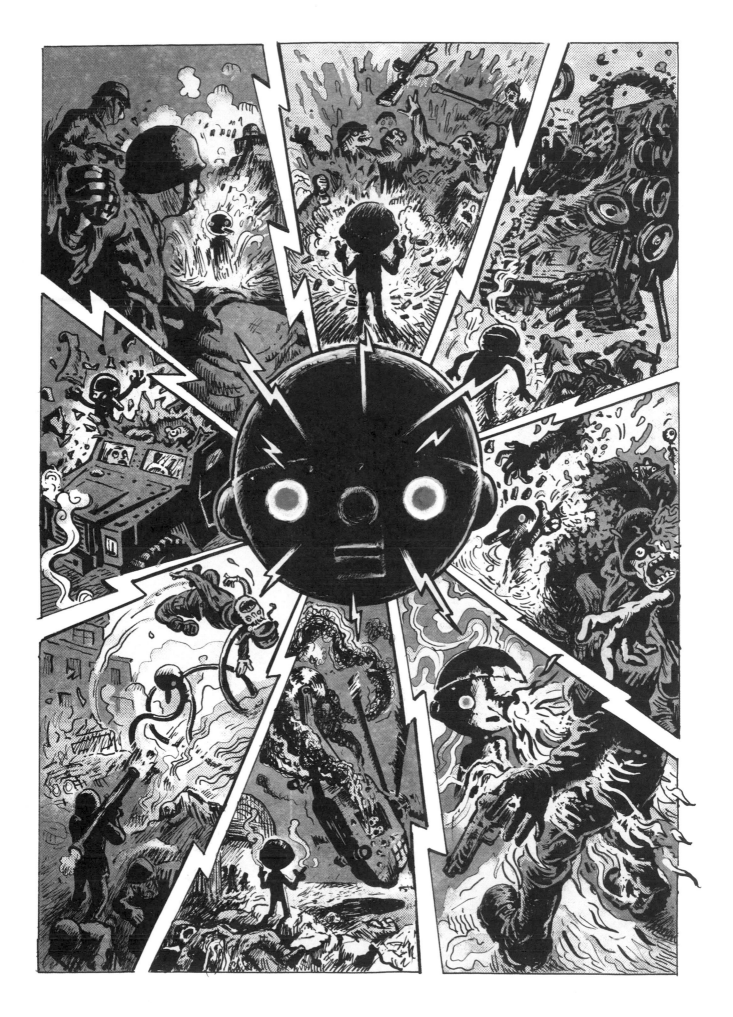

149

WOW!! MY SUPER BRAIN NEEDED ONLY A FEW SECONDS TO SOLVE THIS PROBLEM -

JIMINY KILLS TWO BIRDS WITH ONE BEER!

HA!

ALRIGHT! DOWN THE HATCH!

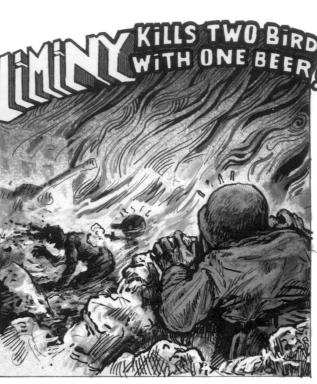

FIRE! FIRE! FIRE! AH! AH!

HEHE! HIC!

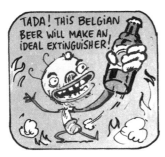

WHAT A FOOL I AM! THE SOLUTION IS RIGHT HERE IN MY POCKET...

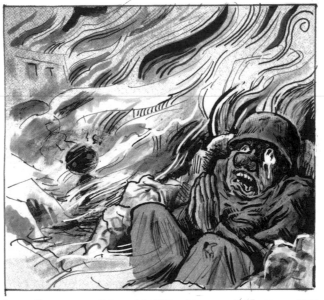

TIC TAC TIC

TADA! THIS BELGIAN BEER WILL MAKE AN IDEAL EXTINGUISHER!

!!DRIIING! NOW! ZZIIIPP!

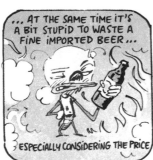

...AT THE SAME TIME IT'S A BIT STUPID TO WASTE A FINE IMPORTED BEER...

ESPECIALLY CONSIDERING THE PRICE

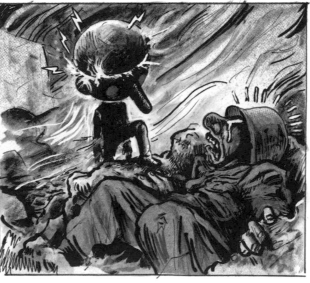

HAAAAAA

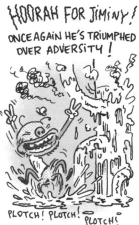
HOORAH FOR JIMINY!
ONCE AGAIN HE'S TRIUMPHED OVER ADVERSITY!

PLOTCH! PLOTCH! PLOTCH!

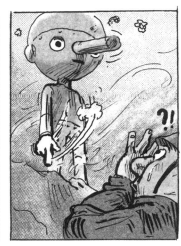
?!

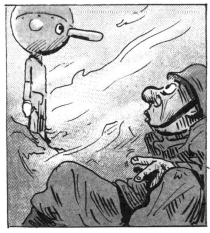

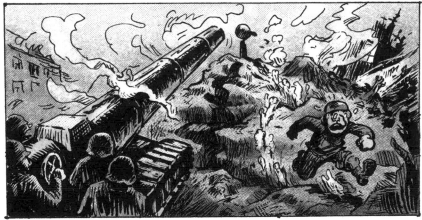

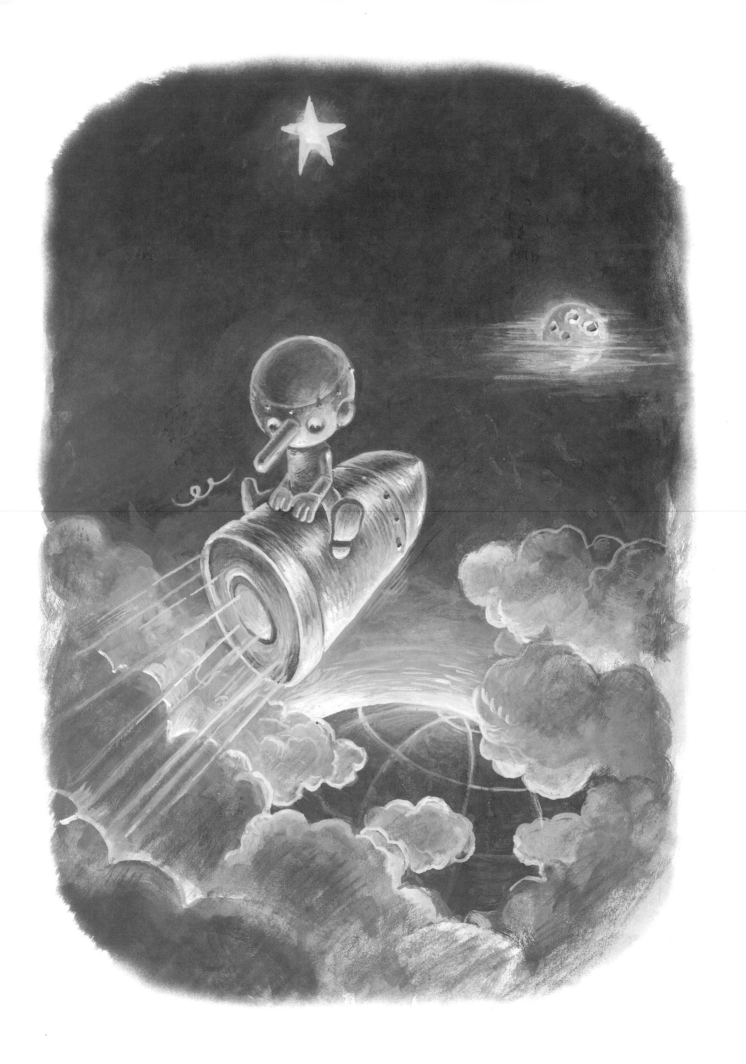

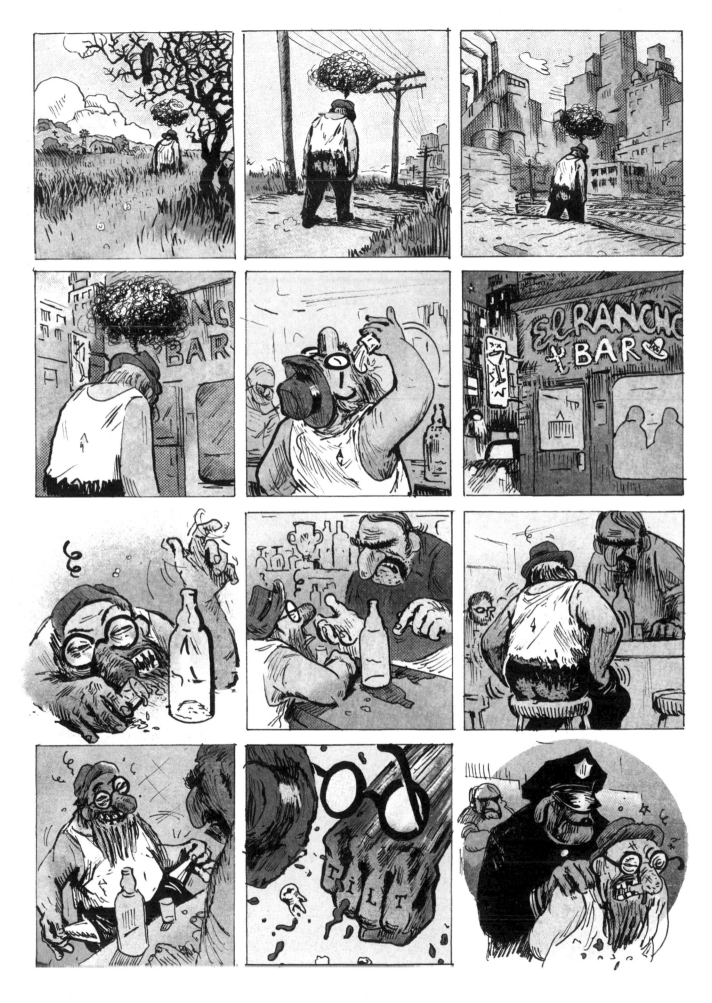

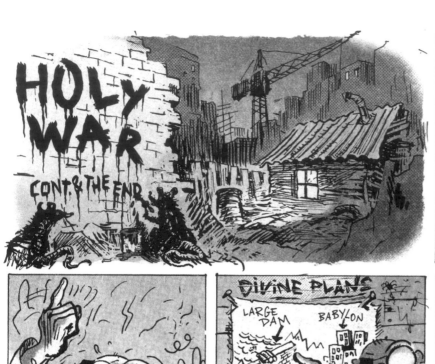

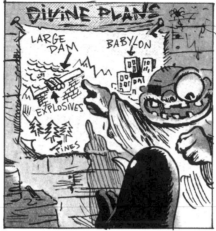

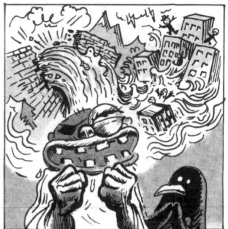

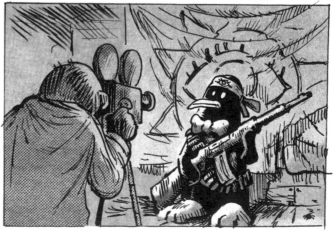

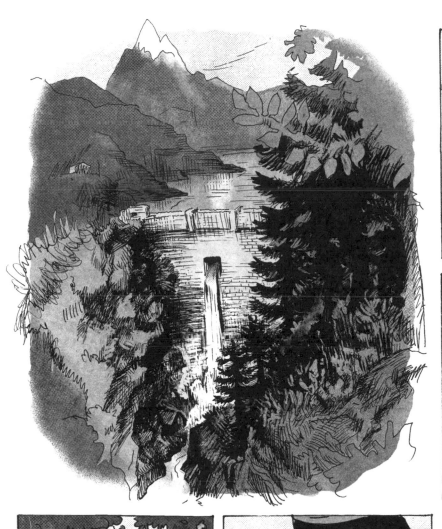

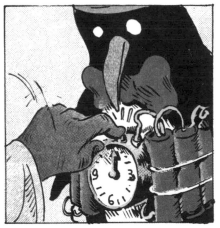

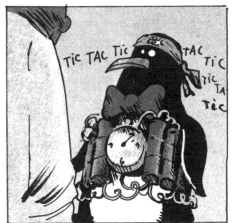

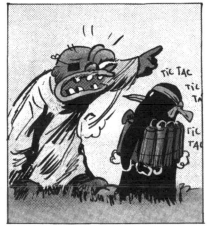

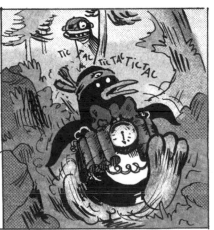

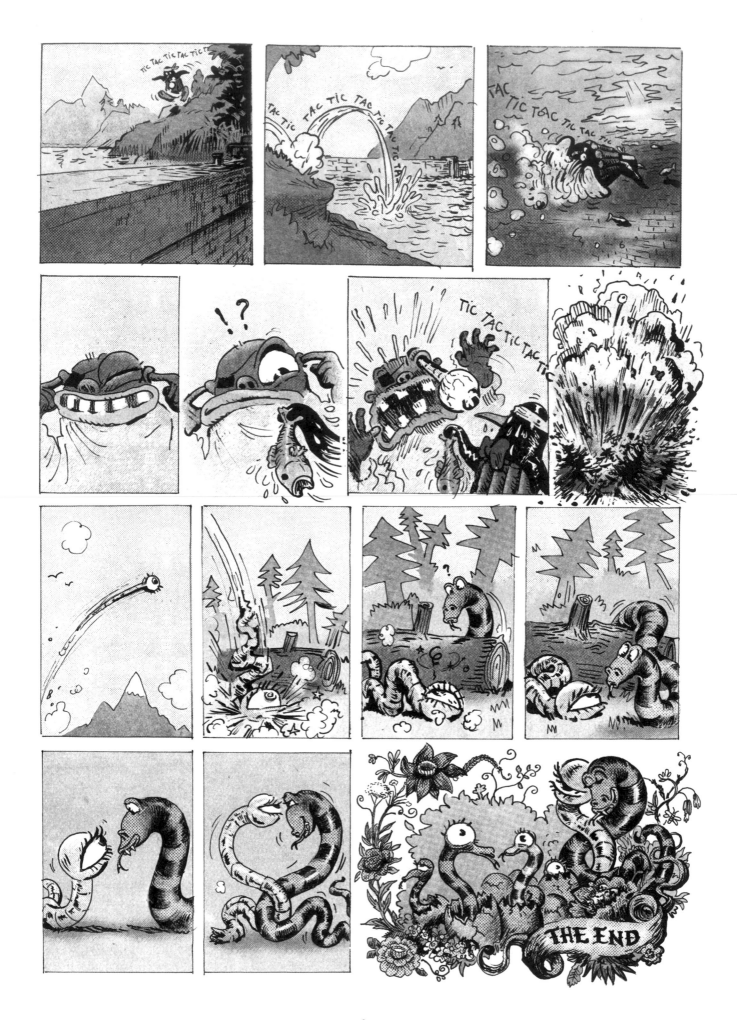

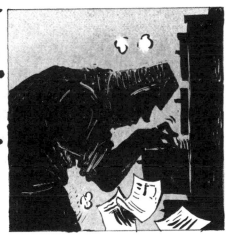

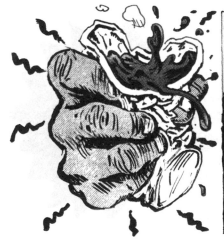
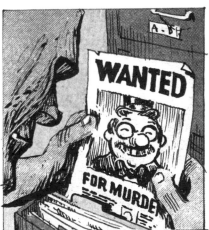

WANTED

FOR MURDER

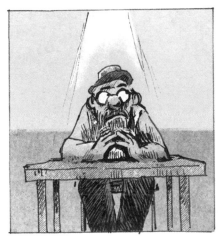

 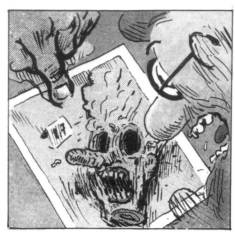

 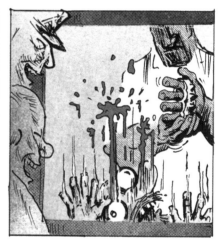

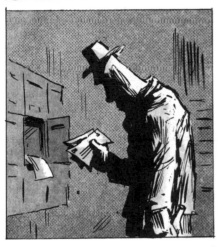

GOODBYE

HARD DAY AMIGO?

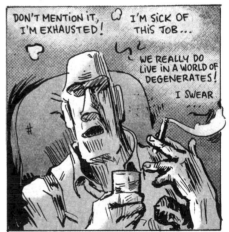

DON'T MENTION IT, I'M EXHAUSTED!

I'M SICK OF THIS JOB...

WE REALLY DO LIVE IN A WORLD OF DEGENERATES!

I SWEAR

YOU KNOW WHAT WOULD BE GOOD... WE SHOULD TAKE A HOLIDAY...

YEAH... SAIL OFF TO A DESERTED ISLAND...

WE COULD SIT OUR ASSES ON A BEACH AND LOOK AT THE SEA ALL DAY...

...TILL THE END OF TIME...

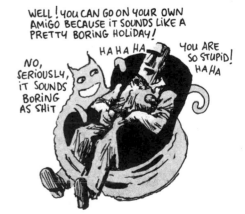

WELL! YOU CAN GO ON YOUR OWN AMIGO BECAUSE IT SOUNDS LIKE A PRETTY BORING HOLIDAY!

NO, SERIOUSLY, IT SOUNDS BORING AS SHIT

HA HA HA

YOU ARE SO STUPID! HA HA

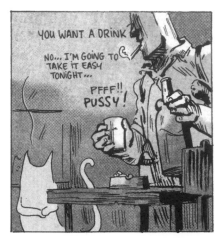

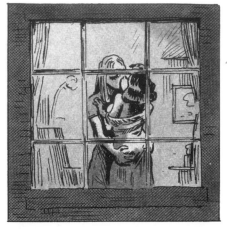

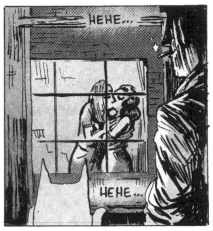

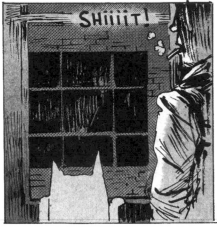

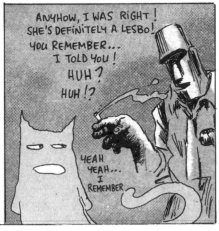

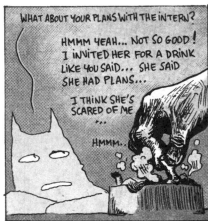

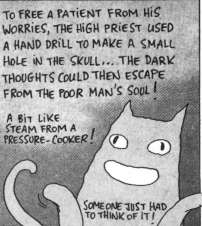

SO?

WHAT DO YOU THINK?

WE CAN TRY IF YOU WANT...

HMMM...

..WE SHOULD SEE...

HIC!

THE PROBLEM IS I DON'T HAVE A DRILL HERE!

HA HA! BUT THAT'S NOT A PROBLEM...

LOOK, YOU HAVE WHAT YOU NEED RIGHT HERE TO MAKE A PERFECT HOLE...

WHERE?

HERE!

HA YEAH YOU'RE RIGHT!

...GETTING ALL THIS SHIT OUT OF MY HEAD!

ABSOLUTELY!

HIC!

LIKE STEAM FROM A PRESSURE-COOKER.

COME ON AMIGO... A LITTLE HOLE IN THE HEAD AND BYE BYE WORRIES...

CLICK!

HE HE HE...

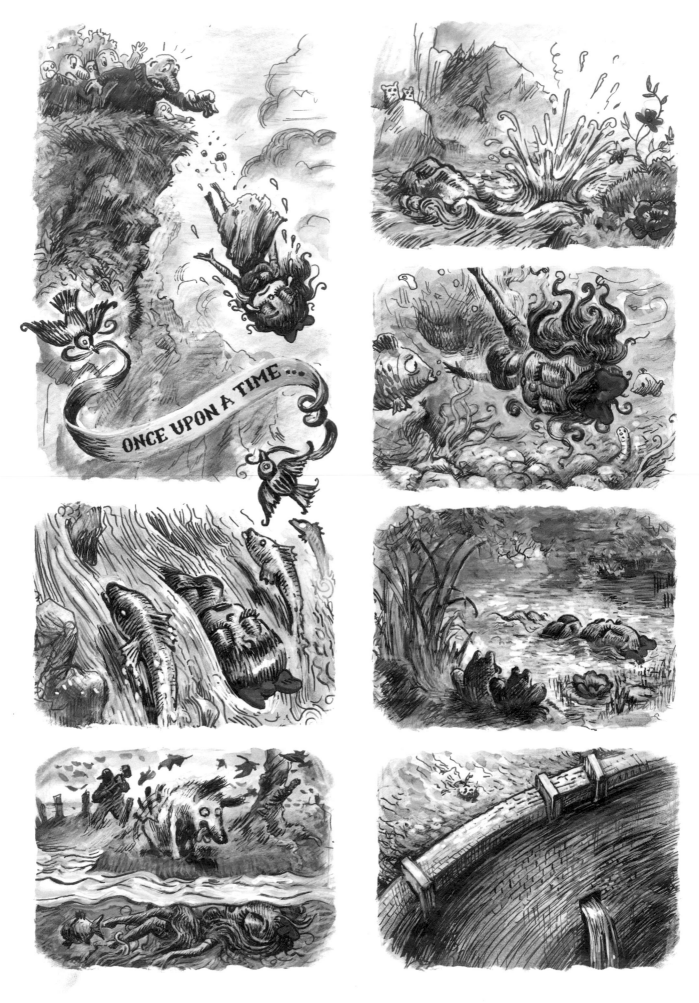

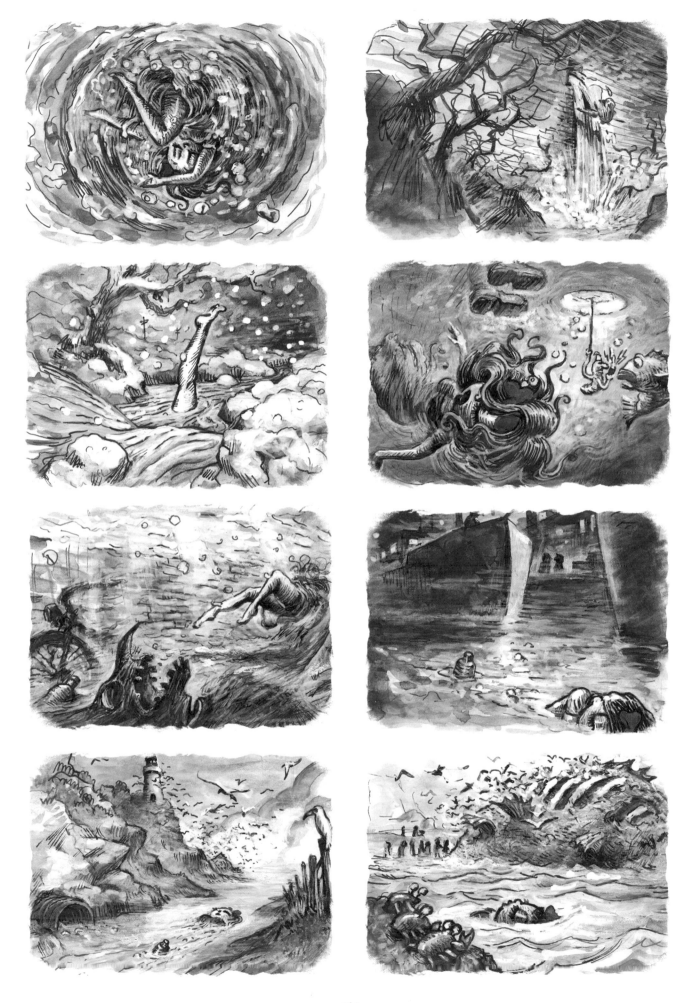

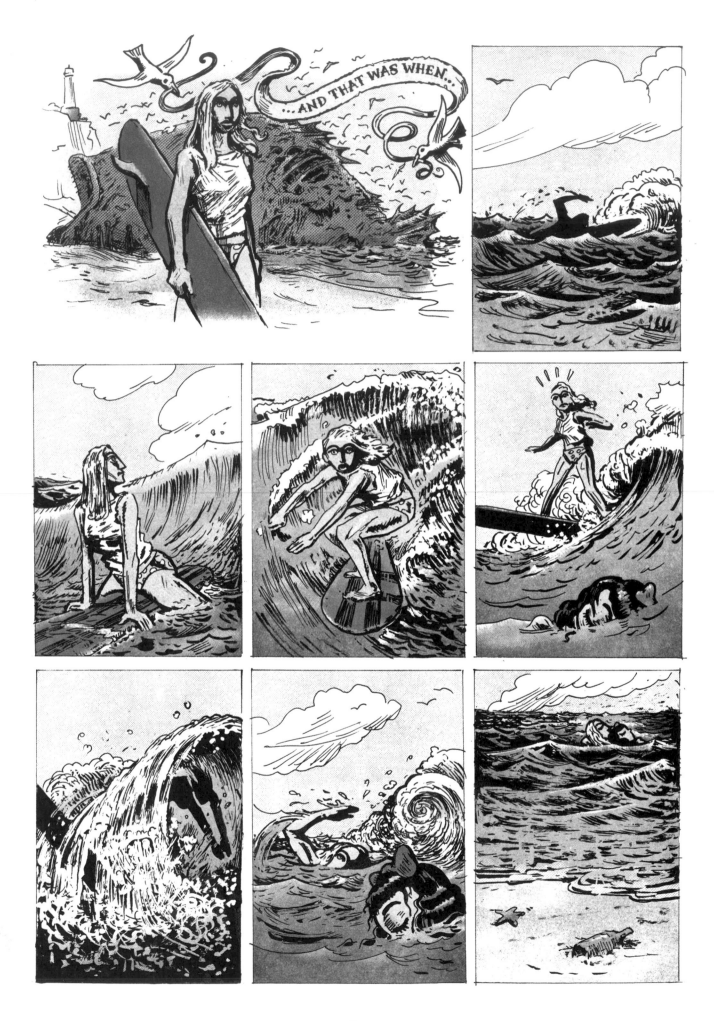

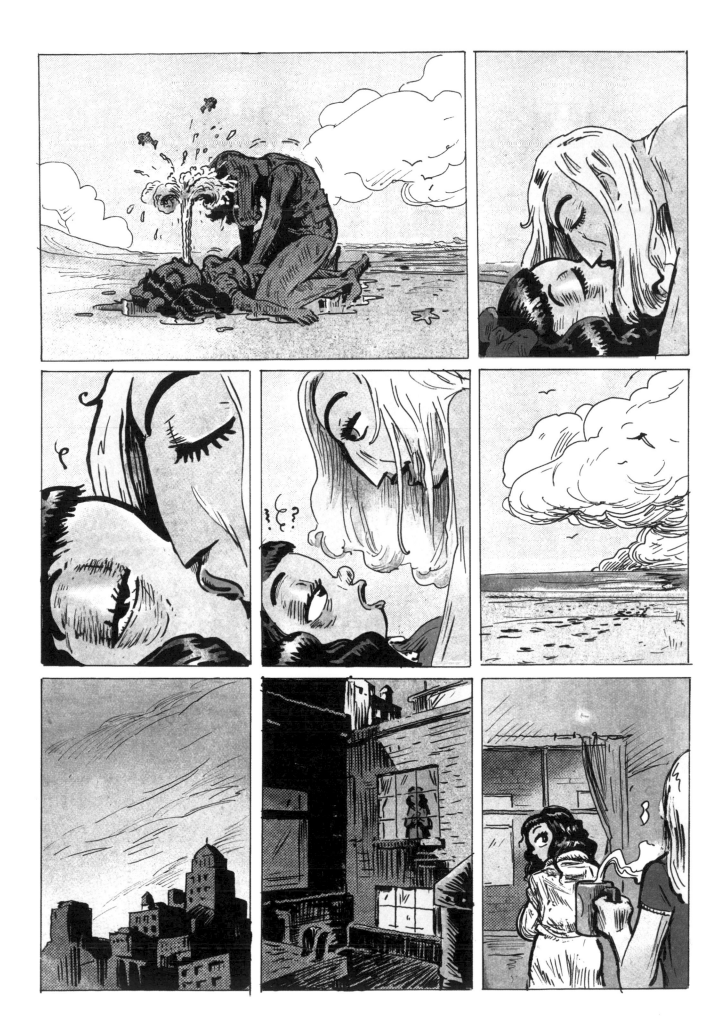

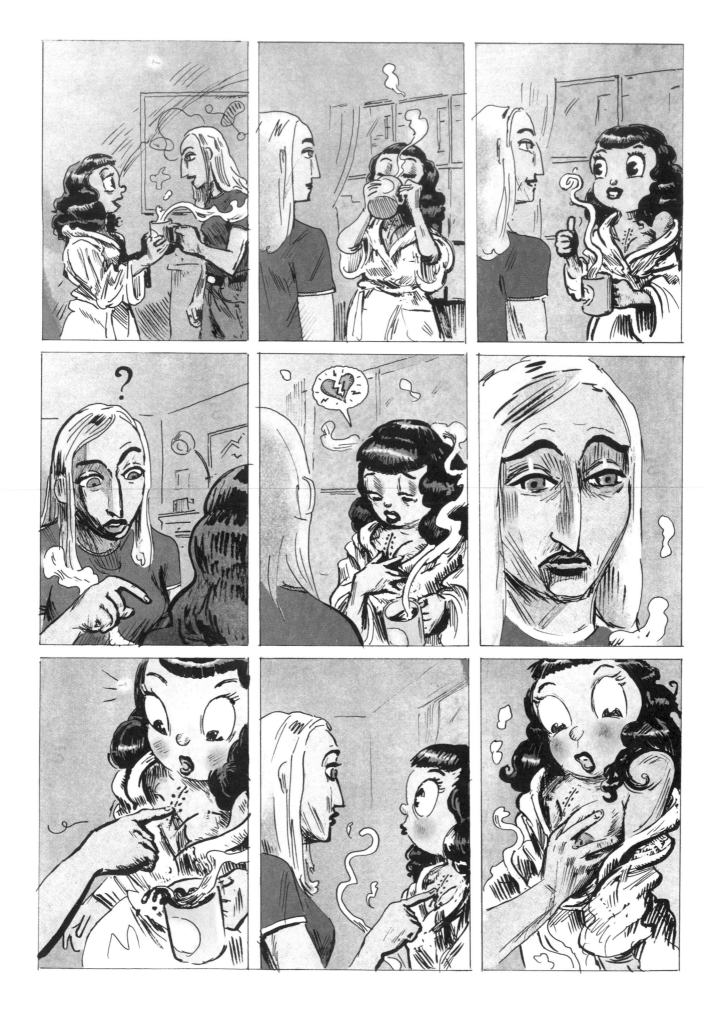

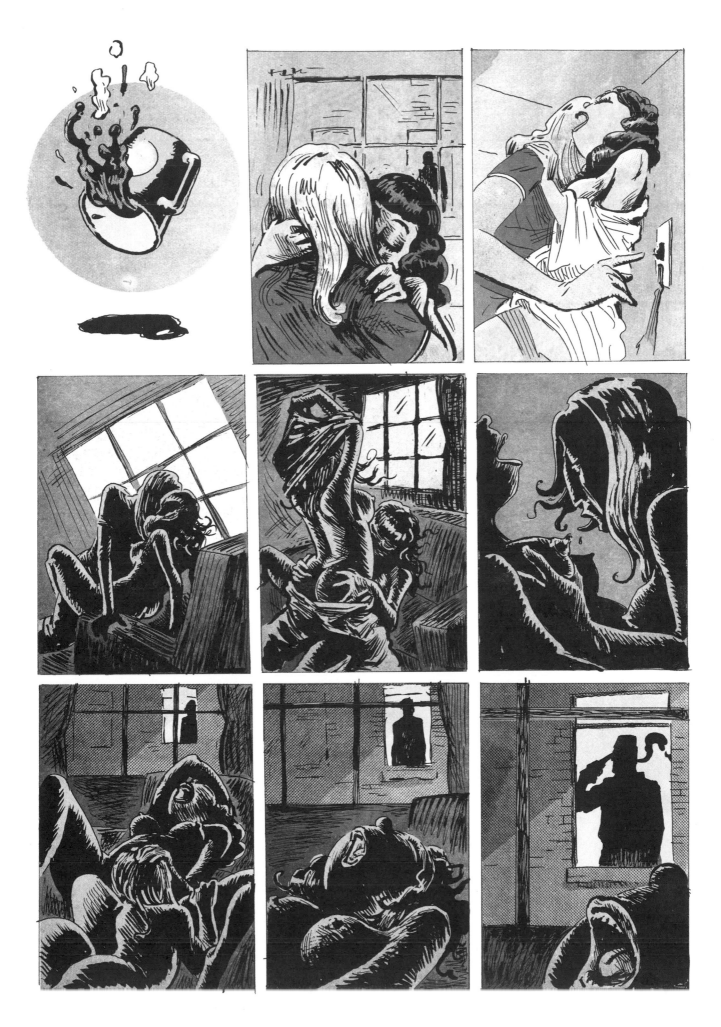

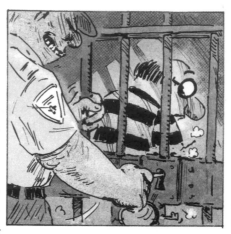

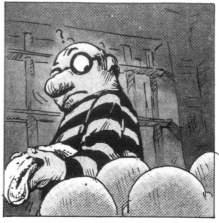

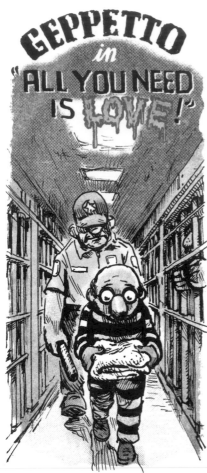

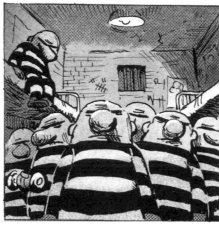

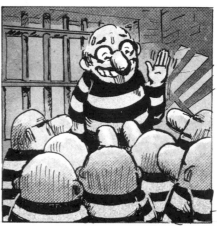

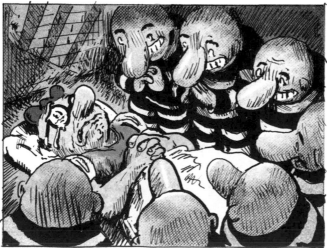

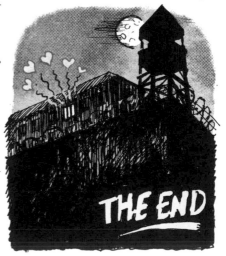

YEAH MY MORALE IS A REAL LOW POINT RIGHT NOW... HMM... YEAH... YOU COULD SAY THAT...

SIGH

BUT WELL, THAT'S NORMAL... ARTISTS GENERALLY DON'T FEEL GOOD ABOUT THEMSELVES

I'M A WRITER! DID I TELL YOU?

YES!

IT'S BEEN A WHILE, I KEEP HAVING THIS DREAM... ALWAYS THE SAME...

I'M WALKING DOWN THE STREET... I FEEL AS THOUGH SOMETHING HORRIBLE HAS HAPPENED...

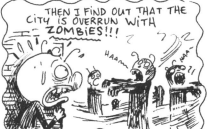
THEN I FIND OUT THAT THE CITY IS OVERRUN WITH ZOMBIES!!!

HAAA

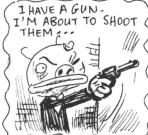
I HAVE A GUN. I'M ABOUT TO SHOOT THEM...

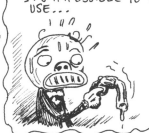
BUT IT GOES LIMP! IT'S IMPOSSIBLE TO USE...

I DECIDE TO PRETEND TO BE ONE OF THEM... I WALK AMONG THE LIVING DEAD...

HAAAA

BUT I KNOW IT WON'T TAKE LONG FOR THEM TO NOTICE THE IMPOSTOR... AND THAT THEY'LL THROW THEMSELVES ON ME AND DEVOUR ME...

WOW!!! TOO FREAKY!

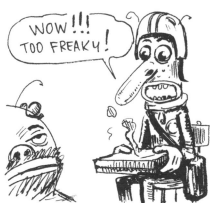
SO WELL, NOT TO CHANGE THE SUBJECT BUT I HAVE TO GO! IT WILL BE $8 FOR THE PIZZA!..

HMM...

I HAVE SOME DISCOUNT COUPON

I HOPE THERE'S SOME CHILLI FLAKES!

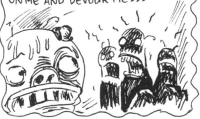
YOU KNOW I HAVE SOME FREAKY DREAMS TOO!

FASCINATING...

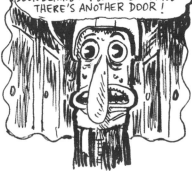
I HAVE TO DELIVER A FOUR CHEESE... I'M WALKING DOWN A CORRIDOR!!. THERE ARE LOTS OF DOORS... WHEN I OPEN ONE DOOR, THERE'S ANOTHER DOOR BEHIND IT! SO I OPEN IT AND THERE'S ANOTHER DOOR!

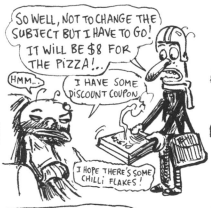
..IF I DON'T DELIVER MY PIZZA ON TIME IT'S FREE! AND IT GETS TAKEN OUT OF MY PAY! SO I RUN AND OPEN DOORS AND BEHIND THEM THERE ARE OTHER DOORS AND DOORS DOORS DOORS

HERE, LOOK! ANOTHER DOOR!

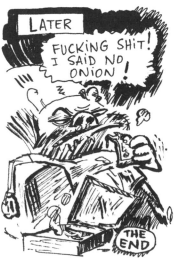
LATER

FUCKING SHIT! I SAID NO ONION!

THE END

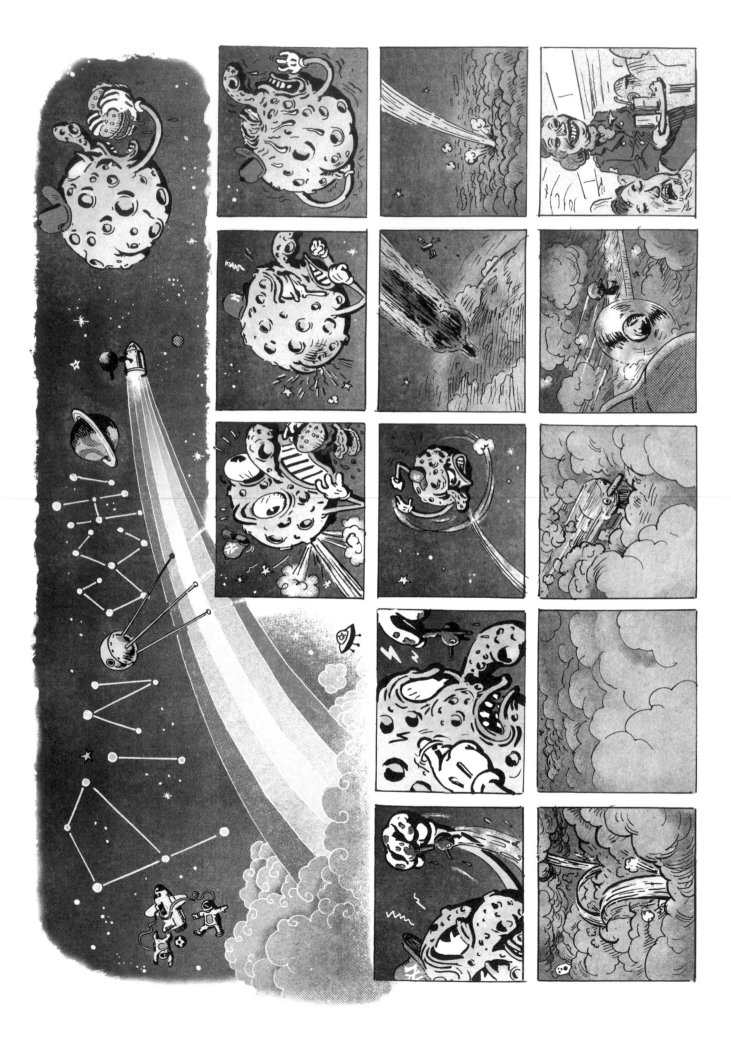

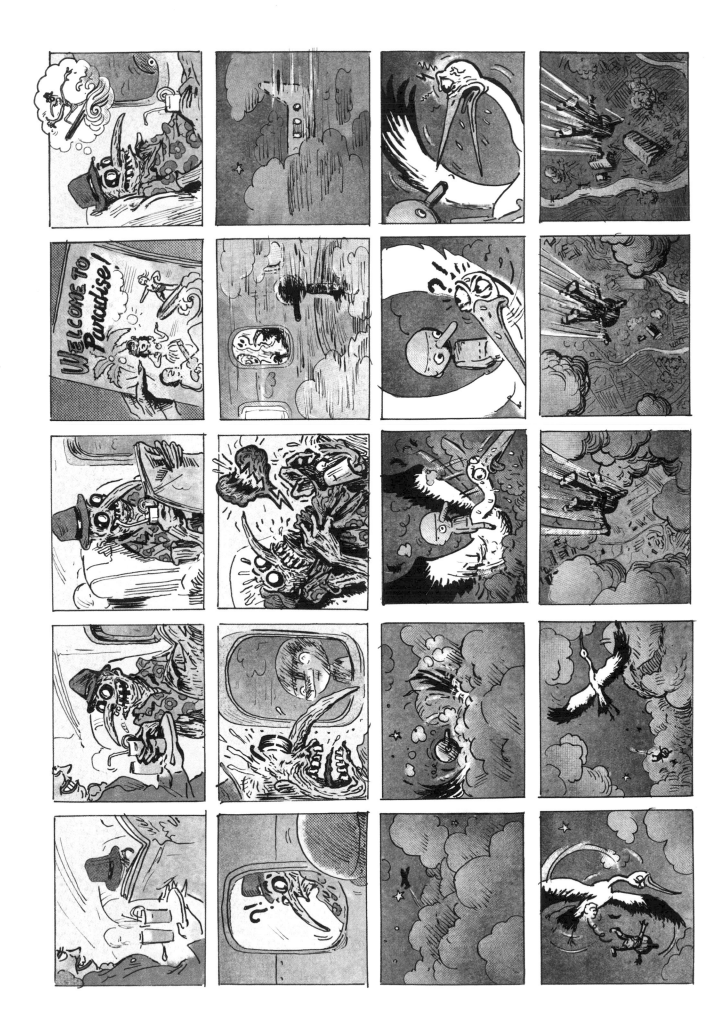

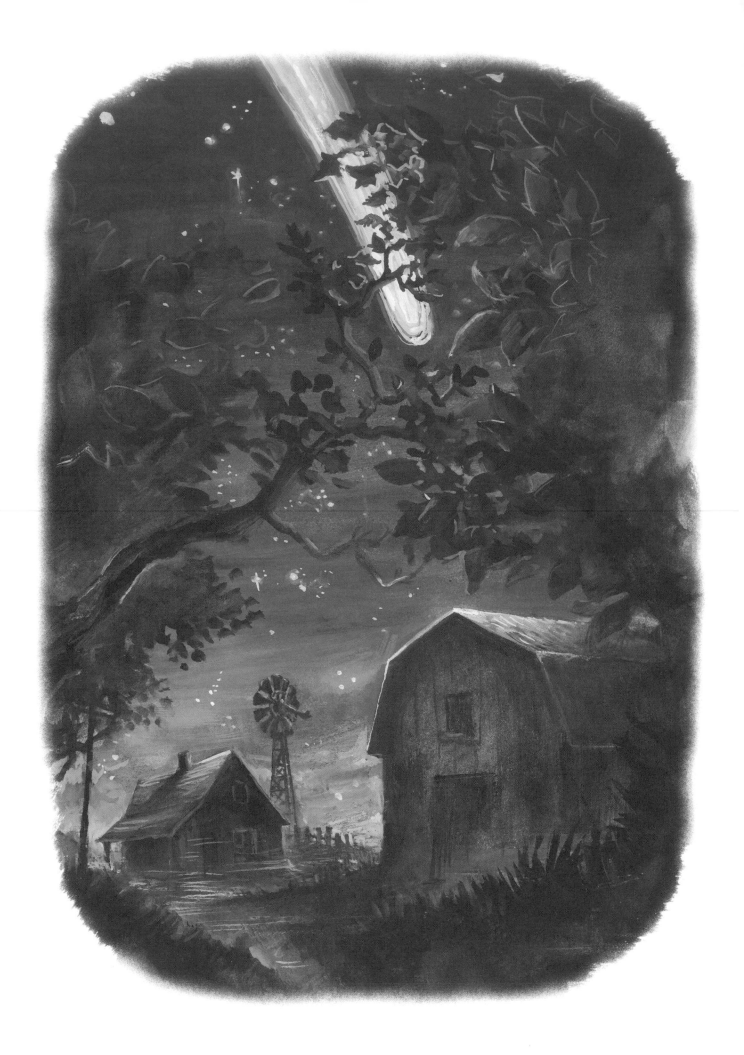

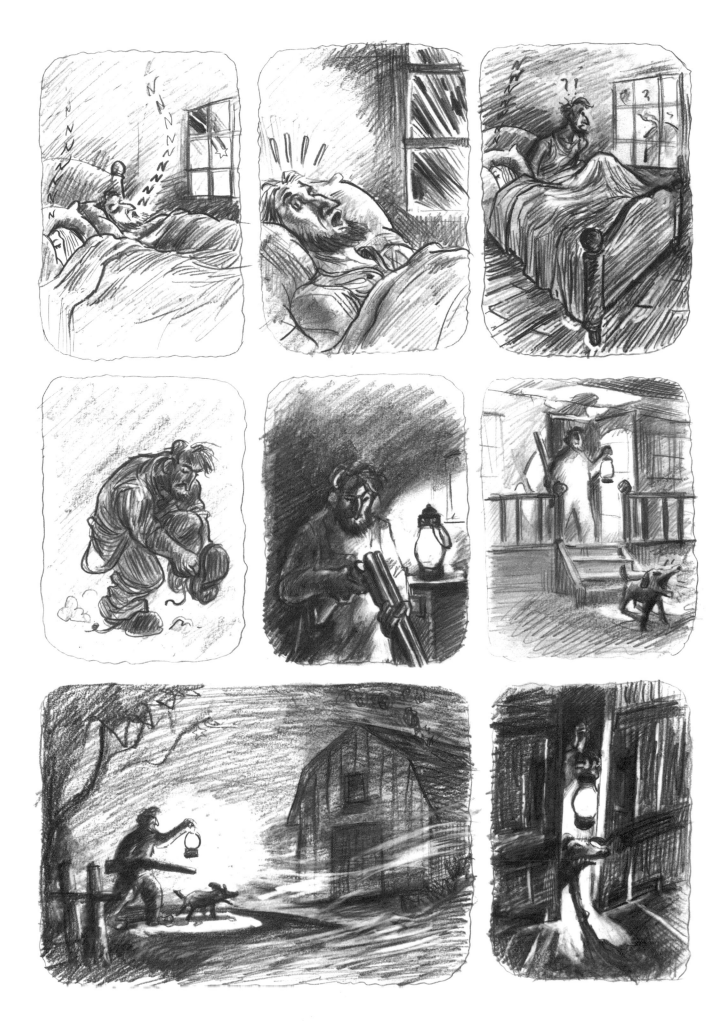

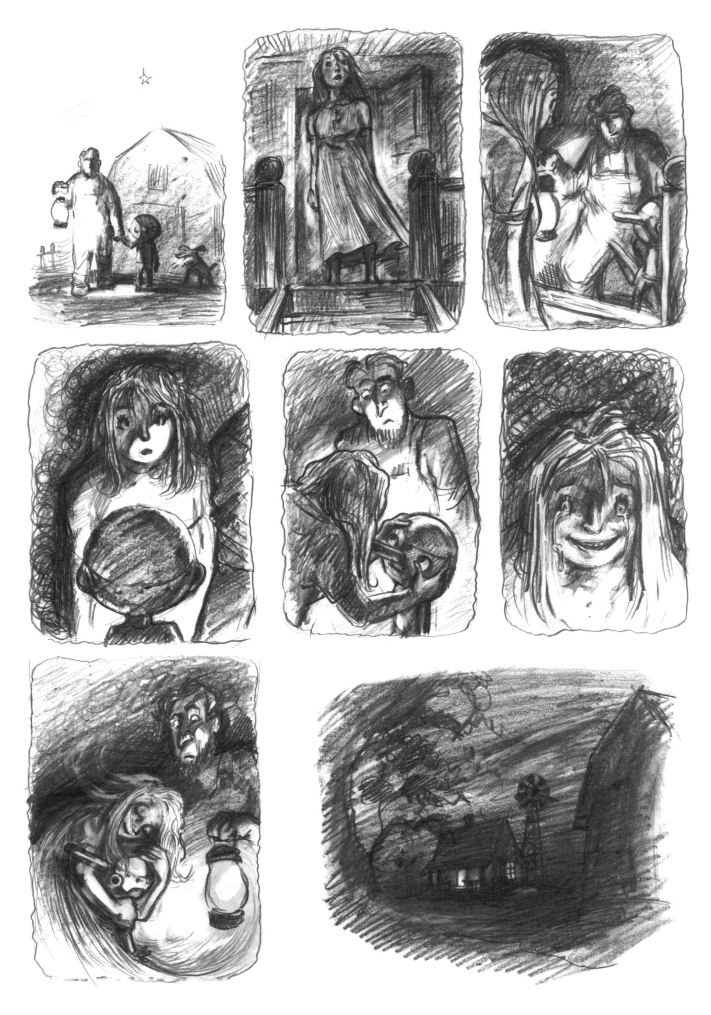

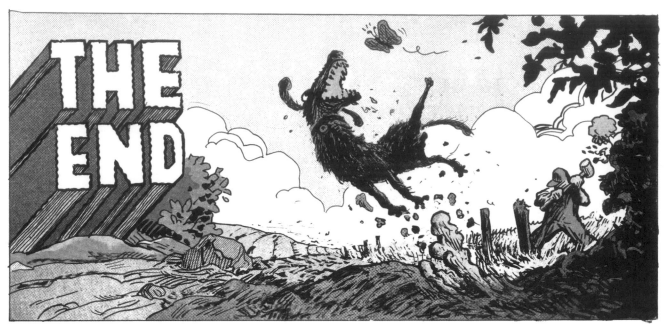

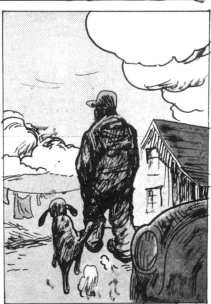

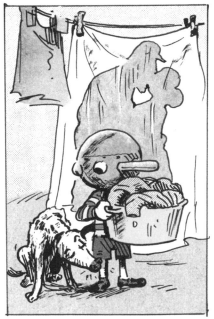

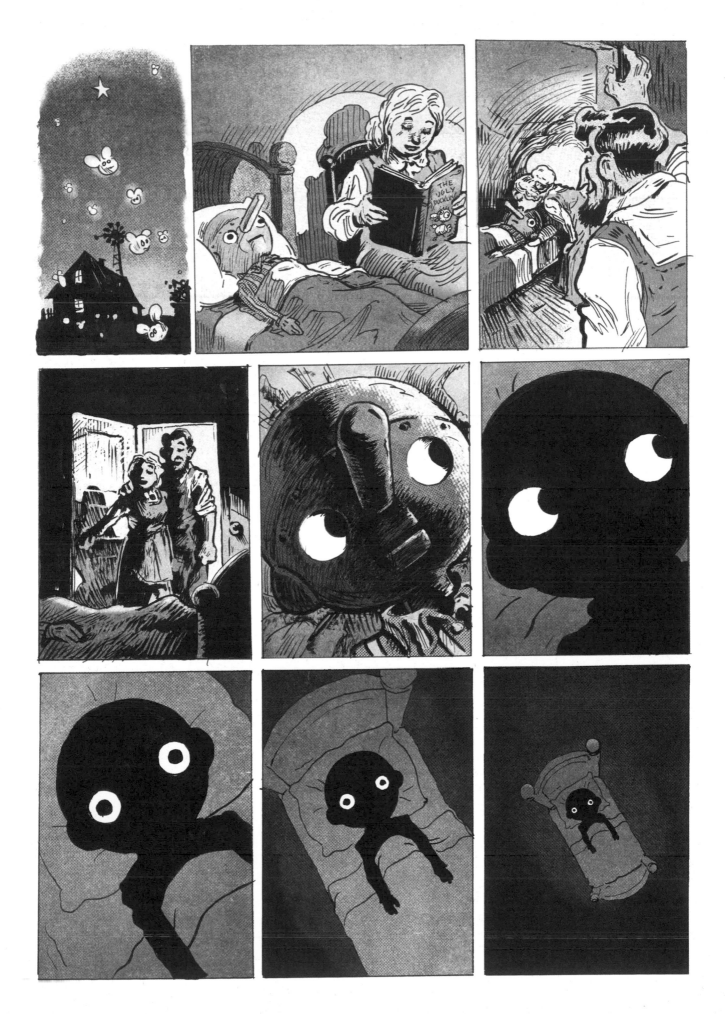

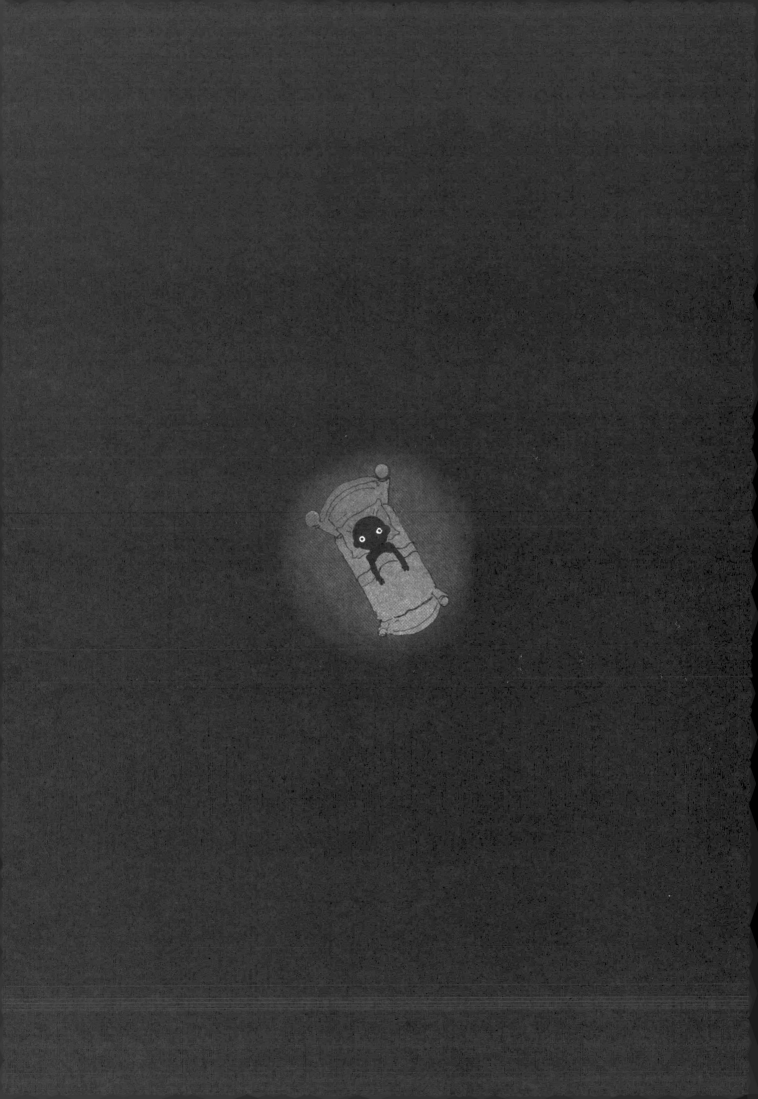

EPIL GUE

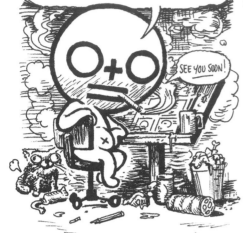

HERE WE ARE MY FRIENDS, THIS ADVENTURE IS COMING TO AN END... NOW, AS IS CUSTOMARY, WE ARE GOING TO LEAVE THE CONCLUSION TO JIMINY COCKROACH!... THEN IT WILL BE UP TO YOU TO LEARN A LESSON FROM THIS STORY!

SEE YOU SOON!

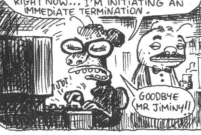

IT ALL BEGAN AT THE COCKROACH WELFARE OFFICE...

WELL, WELL... WHAT DO WE HAVE HERE?... MR JIMINY HAS FORGOTTEN TO FILL IN HIS RENEWAL FORM! I'M GOING TO PROCESS THIS INFRACTION RIGHT NOW... I'M INITIATING AN IMMEDIATE TERMINATION.

GOODBYE MR JIMINY!!

WELL DONE MISS JOHNSON. THANKS TO YOU THIS COUNTRY CAN COUNT ONE LESS UNEMPLOYED PERSON!

WOULD YOU LIKE A COFFEE? IT'S ON ME!

OH THANKS! THAT'S NICE!

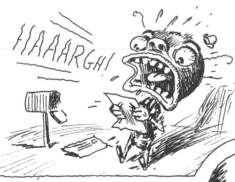

IT DOESN'T TAKE LONG FOR JIMINY TO RECEIVE THE HORRIBLE MISSIVE INFORMING HIM OF THE END OF HIS UNEMPLOYMENT BENEFITS!

HAAAARGH!

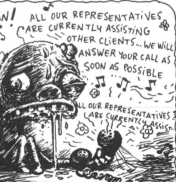

JIMINY TRIES TO APPEAL... IN VAIN! HE IS NOT MATCH FOR THE ALL-POWERFUL ADMINISTRATIVE MACHINE! ITS ULTRA-SOPHISTICATED TECHNIQUES CAN DESTROY ANY INDIVIDUAL...

ALL OUR REPRESENTATIVES ARE CURRENTLY ASSISTING OTHER CLIENTS... WE WILL ANSWER YOUR CALL AS SOON AS POSSIBLE

ALL OUR REPRESENTATIVES ARE CURRENTLY ASSIST...

JIMINY SINKS DEEP INTO DESPAIR... AND SOON A HORRIFYING REALITY APPEARS TO HIM...

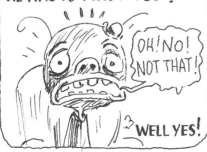

HE HAS TO FIND A JOB!

OH! NO! NOT THAT!

WELL YES!

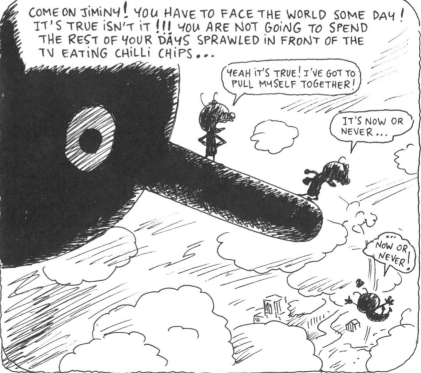

COME ON JIMINY! YOU HAVE TO FACE THE WORLD SOME DAY! IT'S TRUE ISN'T IT!!! YOU ARE NOT GOING TO SPEND THE REST OF YOUR DAYS SPRAWLED IN FRONT OF THE TV EATING CHILLI CHIPS...

YEAH IT'S TRUE! I'VE GOT TO PULL MYSELF TOGETHER!

IT'S NOW OR NEVER...

NOW OR NEVER!

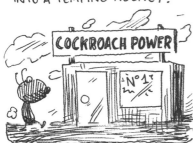

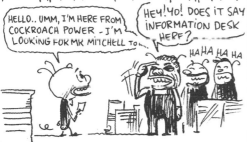
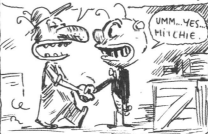
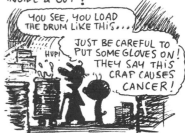

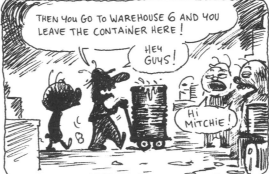
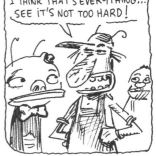
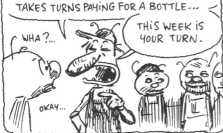

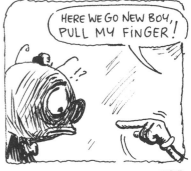
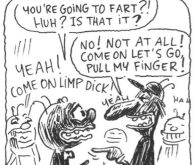

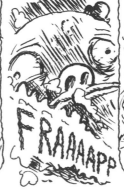
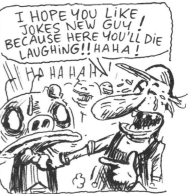

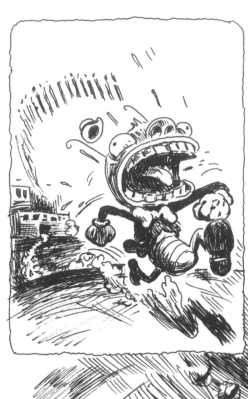

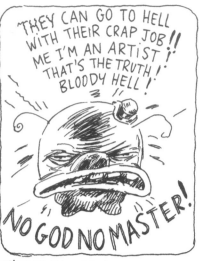

THEY CAN GO TO HELL WITH THEIR CRAP JOB!! ME I'M AN ARTIST?! THAT'S THE TRUTH! BLOODY HELL!

NO GOD NO MASTER!

YOU CAN SAY WHATEVER YOU WANT JIMINY, BUT OBVIOUSLY YOU HAVE FUCKED UP AGAIN... A LITTLE VOICE INSIDE YOUR HEAD WON'T STOP SINGING: "LOSER ♫ LOSER ♪ ♫ YOU ARE JUST A LOSER LOSER ♫ LOSER ♪ A LOSER YOU WILL STAY ♫

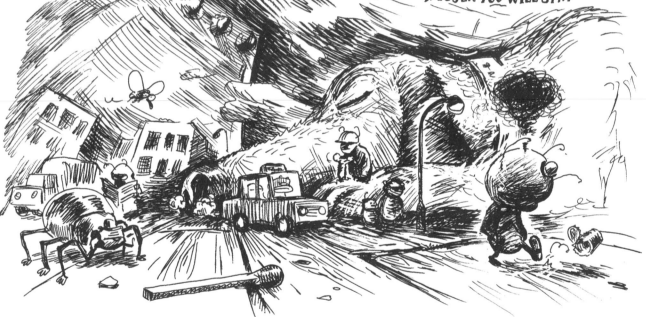

YOU SEEM UNABLE TO FIND A CONNECTION TO THIS WORLD...

NOTHING

...

EXCEPT LOVE PERHAPS?!

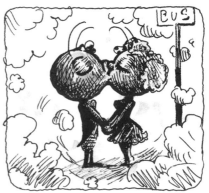

FOR JIMINY HIS PRESENCE ON EARTH FINALLY MAKES SENSE: HIS WHOLE LIFE WAS BUT A PRELUDE TO THIS ENCOUNTER...

HE FEELS AN UNCONTROLLABLE NEED TO BE NEXT TO HER, EVERY SECOND OF THE REST OF HIS LIFE...

AND THIS INSTANT COULD LAST FOR ETERNITY, EXCEPT FOR THE DAMNED CRAMP IN HIS JAW...

OH! JIMINY, IT'S WONDERFUL! I DIDN'T THINK I WOULD BE ABLE TO LOVE AGAIN...

I'VE BEEN SO OUT OF IT... SINCE FRANCIS... ..LEFT ME... SNIFF...

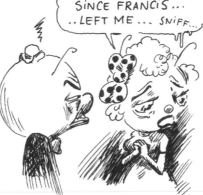

GRR!! THAT GUY CAN GO TO HELL! I'VE NEVER MET HIM BUT IF I DO I'LL KICK HIS ASS!

NO! JIMINY!

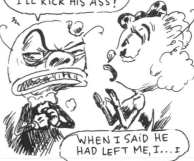

WHEN I SAID HE HAD LEFT ME, I...I

I MEANT TO SAY HE WAS DEAD... A TERRIBLE ILLNESS TOOK HIM AWAY.

BOOHOO!

UH OH! WELL DONE JIMINY!

LISTEN LINDA, I'M SURE THAT IF FREDERICK WERE HERE UMM...YES IF FRANCIS WERE HERE HE WOULD TELL YOU TO... TO... UMM...

HE WOULD WANT THAT

Umm.

FRANCIS!

SNIFF

SNIFF.

SAY SOMETHING MORON! SAY SOMETHING!

Umm.

Umm.

Uhm.

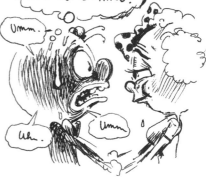

OOOH! JIMINY YOU ARE SO KIND...TONIGHT, I WANT TO BE YOURS!

DON'T SAY ANYTHING! JUST DON'T SAY ANYTHING!

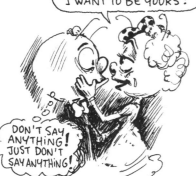

...BUT BEFORE WE GO ANY FURTHER IN THIS RELATIONSHIP, THERE'S SOMETHING ABOUT ME I HAVE TO TELL YOU...

?

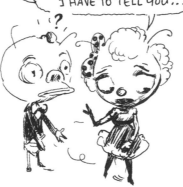

WHAT IS IT?...

I'M A MAN!

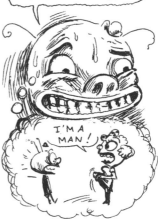

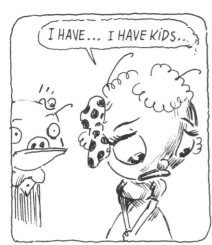

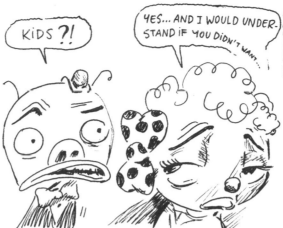

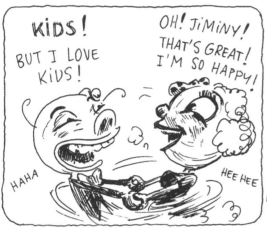

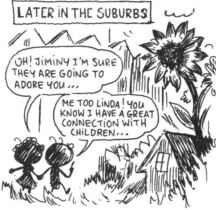

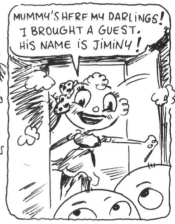

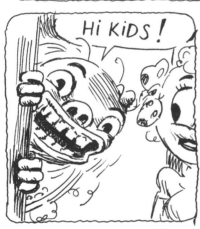

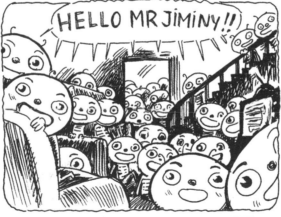

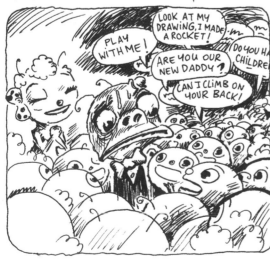

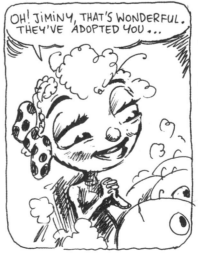

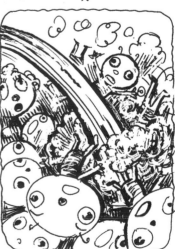

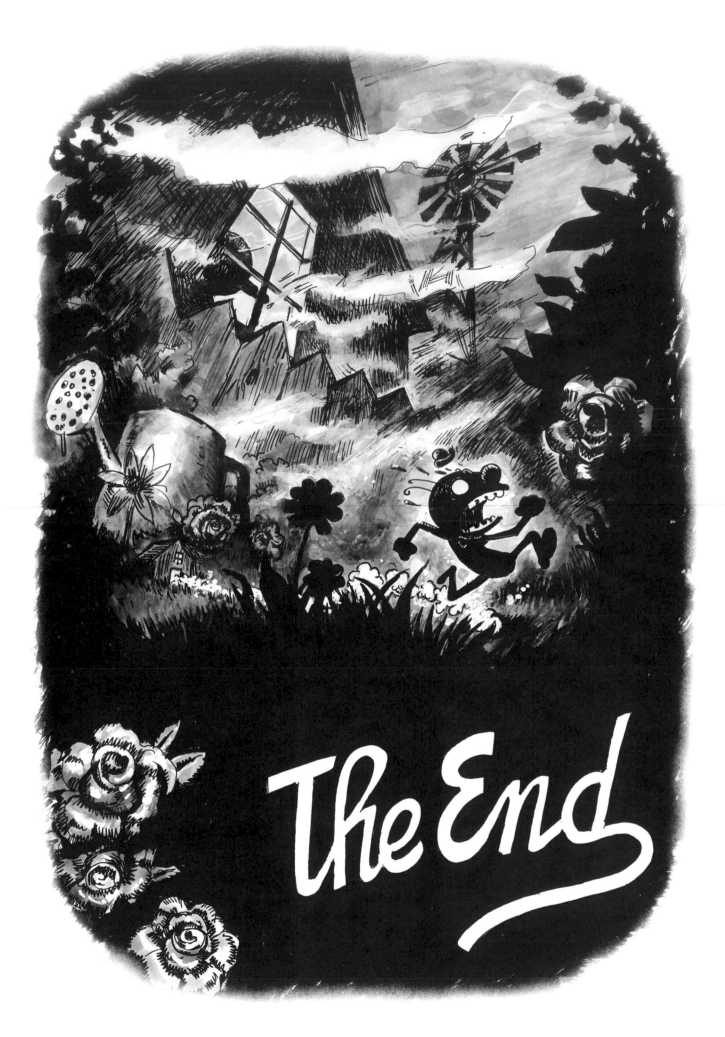

By the same Author:

PAT BOON
Éditions l'Association

SMART MONKEY
Éditions Cornélius

WELCOME TO THE DEATH CLUB
Éditions 6-pieds-sous-terre

SUPER NEGRA
MONSIEURE FERRAILLE (WITH CIZO)
Le Requins Marteaux

WIZZ & BUZZ (WITH CIZO)
(2 volumes)
Éditions Delcourt

Pinocchio ©2010 by Winshluss

Translation © 2011 **Last Gasp** and **Knockabout**. All Rights Reserved.

No part of this book may be reproduced or transmitted in any form or by
any means, electronic or mechanical, including photocopying,
recording, xerography, scanning, or any information storage
or retrieval system now available or developed in the future
without permission in writing from the publisher.

isbn 978-0-86719-751-8

Printed in China.

First printing 2011